I Canaletto (No. 114)

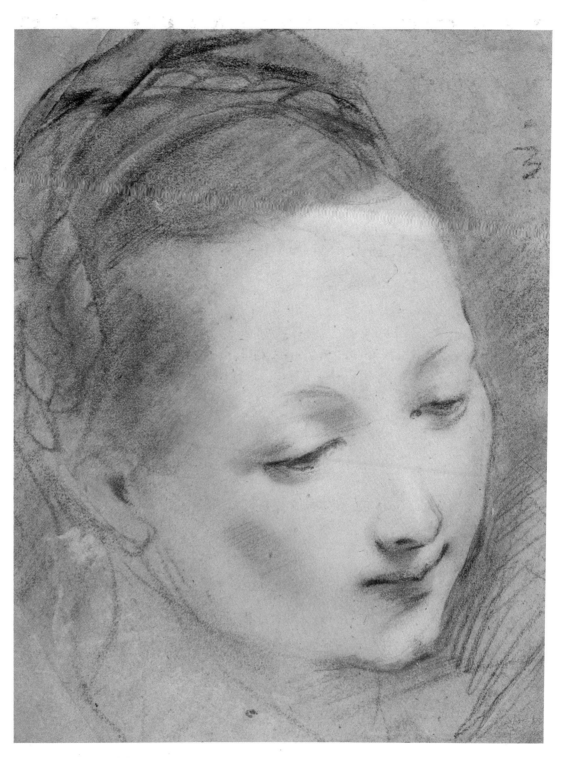

II Federico Barocci (No. 26)

MASTER DRAWINGS
IN THE ROYAL
COLLECTION

From Leonardo da Vinci to the present day

JANE ROBERTS

COLLINS HARVILL
8 Grafton Street, London W1
in association with The Queen's Gallery

Cover illustration: *Head of a Young Woman*
by Michelangelo (CAT. 23)

The Queen's Gallery times of opening:
Tuesday – Saturday (and Bank Holidays) 11am-5pm
Sunday 2pm-5pm
Closed Monday (except Bank Holidays)

William Collins Sons and Co Ltd
London · Glasgow · Sydney · Auckland
Toronto · Johannesburg

01545591

BRITISH LIBRARY CATALOGUING IN PUBLICATION DATA

Master drawings in the royal collection: from
Leonardo da Vinci to the present day.
1. Drawing, European——Catalogs
I. Roberts, Jane, II. Hughes-Onslow, Olivia
741.94 NC225

ISBN 0 00 272156 2 (Hbk)
ISBN 0 00 272154 6 (Tpb)

First published by Collins Harvill 1986
© Her Majesty Queen Elizabeth II, 1986

Photoset in Meridien by Wyvern Typesetting Limited, Bristol
Made and printed in Great Britain by Balding & Mansell Ltd, Wisbech

List of Contents

Acknowledgements

Comparative illustrations for the relevant catalogue numbers have kindly been supplied by the following: Ajaccio, Musée Fesch (3); Austin, Texas, Iconography Collection, The Harry Ransom Humanities Research Center, The University of Texas at Austin (147–9); Bologna, A. Villani e Figli, Laboratori Fotografica (82, 94 and 95); Basel, Kuperstichkabinett, Oeffentliche Kunstsammlung (47); Detroit, Institute of Arts (71); Edinburgh, National Gallery of Scotland (74 and 102: reproduced by kind permission of the Duke of Sutherland); Florence, Archivi Alinari (2 and 7); Forlì, Giorgio Liverani (90); Hamburg, Professor Dr Rolph Stödter (59); London, British Museum (29, 31, 33, 57, 58, 100: reproduced by courtesy of the Trustees); London, Sir Brinsley Ford (121); London, National Gallery (45, 72, 81: reproduced by courtesy of the Trustees); London, National Portrait Gallery (138: reproduced by kind permission of the Trustees); London, National Trust (78); London, Tate Gallery (139); Milan, Soprintendenza, Laboratorio Fotoradiografico (13); Modena, Accademia Militare (86); New York, Metropolitan Museum of Art (11, 59); Ottawa, National Gallery of Canada (109); Paris, Réunion des musées nationaux (12 and 20); Rome, Biblioteca Apostolica Vaticana (38); Rome, Biblioteca Hertziana (18 and 87); Rome, Gabinetto Fotografico (37); Rome, Museo Nazionale di Castel S. Angelo (36); Rome, Monumenti, Musei e Gallerie Pontificie (21, 26 and 80); Rome, Reveranda Fabbrica di S. Pietro (89); Venice, Accademia (8 and 35); Venice, Museo Civico Correr (52); Vienna, Albertina (37); Vienna, Kunsthistorisches Museum (28); Washington, National Gallery of Art (10, 11 and 46).

The extracts from H. Spurling, *Secrets of a Woman's Heart*, related to No. 147, and from V. Glendinning, *Edith Sitwell*, related to No.149, are quoted by permission of Hodder and Stoughton Ltd. and of Weidenfeld Publishers Ltd., respectively.

All items in the Royal Collection and documents in the Royal Archives are reproduced by Gracious Permission of Her Majesty the Queen.

Preface

This catalogue has been written to accompany the exhibition at the Queen's Gallery, Buckingham Palace, from April 1986. The exhibition is the first to include items from the full chronological range of drawings represented in the Royal Collection. Her Majesty The Queen and His Royal Highness The Duke of Edinburgh have graciously consented to the loan of a small number of drawings from their own private collection, in addition to the display of some of the best pieces from the Royal Library at Windsor Castle. Previously unpublished material in the Royal Archives has also been included, by gracious permission of Her Majesty the Queen. All the illustrations in this catalogue are of items in the Royal Collection, unless otherwise stated.

Without the co-operation and help of colleagues in the Royal Library and Archives, and in the Lord Chamberlain's Office, this exhibition could never have taken place, nor could this catalogue (in its extended form) have been produced. My thanks to them could never be adequately expressed. All the drawings have been remounted and (where possible and necessary) lifted from their old backing paper, cleaned and restored, by the drawings conservation staff at Windsor. This operation has revealed an important additional compositional study on the *verso* of No.83, and a seventeenth-century inscription (with date) on the *verso* of No.93. It also has enabled the watermarks to be studied with (comparative) ease, and tracings of these marks, with brief commentary, are included as an Appendix to the catalogue. The work on the watermarks has been carried out by Olivia Hughes-Onslow, who has assisted me at all stages in the preparation of this exhibition.

The foundation to any study of the Windsor drawings was laid in the great series of catalogues of the collection published by the Phaidon Press over the last half century. These catalogues are included in the *List of works referred to in abbreviated form* below (p.16). The authors of the remaining catalogues have been unhesitating in making available to me their thoughts on the relevant drawings, and in correcting my own entries. Thus Christopher White has assisted with the Dutch and Flemish drawings, Denis Mahon and Nicholas Turner with the Guercino drawings, and Delia Millar with the nineteenth-century material. Jenny Stratford, who is preparing a study of the two sheets called the 'Fly Missal' (Nos. 41 and 42), wrote the commentary for these illuminations and has assisted me in numerous other ways. Those living artists represented in the exhibition (Norman Blamey, Feliks Topolski and John Ward) have kindly discussed their work with me, and have thus added a touch of reality and certainty where there might only have been supposition.

Other colleagues and friends who have assisted in various ways include the following: Noël Annesley, Charles Avery, Giulia Bartrum, Jean-Marie Bruson, Linda Cabe, Diana De Grazia, Peter Dewar, Shelley Fletcher, Susan Foister, Julian Gardner, John Gere, Lotte Hellinga, Rupert Hodge, François Macé de Lepinay, Stanley Martin, Constance Messenger, John Murdoch, Konrad Oberhuber, Benedict Read, Claire Robertson, Diane Russell, Francis Russell, Roy Strong, Sarah Wimbush and Linda Wolk. As usual, we are indebted to the staff of A. C. Cooper, and to our own photographic staff at Windsor, for providing the photographic material on which the illustrations in the present catalogue are based. A number of private collectors and public institutions have kindly given permission for items in their possession to be reproduced in this catalogue for comparative purposes, for which we are most grateful.

Finally, I must thank my family for their unstinting patience and constant support during what developed into months of last-minute work.

JANE ROBERTS
Windsor

Introduction

This catalogue includes a selection of 149 of the principal drawings in the Royal Collection. At the outset it must be said that this selection, like the Collection itself, is no well-balanced chronological series representing all the highways (and some of the byways) of the history of European art. For unlike the great national museums and art galleries, where curators have a public duty to acquire a broad range of all that was and is the best, the British monarchs, by whom and for whom the Royal Collection was formed, have acquired what it pleased them (and their advisers and donors) to acquire, no more and no less. Nevertheless, in arranging an exhibition of this nature it has seemed sensible to select a few of the best drawings from each school and century, and to present these chronologically. The history and development of European art (or at least of draughtsmanship) can thus be suggested, using the unparalleled holdings of drawings by Leonardo and other early Italian masters, by Holbein, the French and Italian artists of the seventeenth century, and the masters of the eighteenth-century Venetian school. A comprehensive picture can thus, I believe, be given, in spite of the absence of works by artists such as Rembrandt, Guardi, Tiepolo, Constable or Turner. A small group of miniatures and manuscript illuminations is also included in this exhibition, to add a touch of colour where there would otherwise be none. A conscious decision has been taken to exclude watercolours, in the hope that they may form the subject of a subsequent exhibition.

The chronological range presented here runs from the head of a youth attributed to Fra Angelico, c.1449, to two of the items in the Royal Academy's Silver Jubilee gift to Her Majesty (Nos. 141 and 145), which are separated by over five hundred years.

Function and purpose

The drawings in this exhibition were executed at very diverse times and places, and were used for a wide variety of purposes. In some cases they may have been studies from nature, subsequently used in finished works of art, but possibly not specifically intended for such a purpose. Leonardo's drawing of a sprig of acorns (No. 15) and Dürer's greyhound (No. 53) are cases in point. The acorns belong to a series of more or less botanical studies connected with Leonardo's lost paintings of *Leda*, in which the landscape foreground was totally composed of different plants and flowers, such as the dyer's greenweed shown at the top left of the sheet. Dürer's greyhound reappears (in reverse) in the engraving of *St Eustace*. When lifted from its old backing paper during restoration for this exhibition, the *verso* of the greyhound sheet was found to be covered with dense black chalk, presumably to assist in the transfer of the outlines of the drawing to the page bearing the compositional study of the subject to be engraved.

In other instances the drawings are the compositional studies for a finished painting, which may or may not have survived. During the Renaissance, the painting was frequently a mural executed in the *fresco* technique. Raphael's ceilings of the Farnesina loggia and the Stanza della Segnatura, and Perino's work in S. Marcello al Corso (all in Rome), for which preparatory studies are exhibited (Nos. 18, 21 and 37), are important High Renaissance fresco paintings. The latter two drawings were squared for transfer, either to a cartoon, or for enlargement on to the surface of the plaster to be painted. Leonardo's mural painting of the *Last Supper* in Milan was unfortunately executed in an experimental medium, the plaster of which has crumbled so badly that the preparatory studies, such as that for *St James the Greater* (No. 13), are now vital pieces of evidence as to the original appearance of the painting.

Several of the drawings are preliminary studies for independent panel paintings or canvasses, whether altarpieces, devotional pictures, paintings with allegorical, mythological or genre subject-matter, portraits or landscapes. Vivarini's altarpiece design (No. 9) is a rare survival indicating the unified architectural setting involved, incorporating both the fictive architecture in the painting and the real architecture of the frame. Leonardo's

head of St Anne (No. 12) was used in his painting of the *Virgin and Child with St Anne* in the Louvre. Barocci's two heads (Nos. 26 and 27) are preparatory studies for two different canvases, of the *Annunciation* and *Aeneas and Anchises* respectively. Tintoretto's drawing of the back view of a man (No. 35) is likewise a study for that artist's *Crucifixion* in the Accademia, Venice.

The painting of a portrait will inevitably involve the making of a number of preliminary studies of the sitter's particular features or clothing. Leonardo's study of arms (No. 11) has been convincingly shown by Müller-Walde to be for the (now missing) hands of *Ginevra dei Benci* (Washington, National Gallery of Art). Holbein's drawn portraits were all, one assumes, preparatory studies for painted works, whether group portraits (such as that of the More family, for which Cecily Heron, No. 47, was portrayed), or individual paintings such as that of the unknown man (No. 48).

In addition to its preparatory role for paintings, naturally the drawing medium is also used in preparation for engravings, works in sculpture or architecture, and small-scale decorative objects. Raphael's unfinished study of the *Massacre of the Innocents* (No. 19) and Franco's drawing of a man (No. 40) are directly related to engravings, and were presumably specifically made for that purpose. The same is the case with Stradanus' drawing of *Printers at work* (No. 57), which was reproduced very exactly in his *Nova Reperta* series. The companion drawing of *Engravers at work* (No. 58) was evidently discarded before publication in favour of a more up-to-date view of an engraver's studio. Boucher's ornamental design (No. 100) was made for the frontispiece of one of the volumes of engravings after drawings by Watteau, published in 1728.

Designs for sculpture, architecture or the decorative arts would normally fall outside the chosen title and theme for this exhibition. However, Polidoro's drawing of *The Betrayal of Christ* (No. 38) was the basis for a crystal plaque engraved by Valerio Belli, and on the *verso* of Raphael's drawing of the *Massacre of the Innocents* (No. 19) there is a design for an elaborate salver, doubtless to be made from some precious metal. Bernini's study for the *Fountain of Neptune* (No. 86) is one of a number of his sculptural designs in the Royal Collection. Michelangelo's 'presentation drawings' (e.g. Nos. 22, 23, and in particular No. 24) occupy a special place in the history of draughtsmanship for many reasons, but notably because they were considered (by the artist) of sufficient quality to present to his devoted friend, Tommaso de'

Cavalieri, in the same way as another artist might have given a painting or a piece of sculpture. In his letter of thanks for two such drawings, Cavalieri informed Michelangelo that he was spending at least two hours each day in contemplating them. A further reference to the serious appreciation of drawings at this early date occurs in a letter of c.1538–41 from Vittoria Colonna to Michelangelo, in which she describes one of the artist's drawings of *Christ on the Cross* in the following words: 'It is not possible to see an image better made, more alive and more finished and certainly I could never explain how subtly and marvellously wrought it is. . . . I have looked at it carefully in the light, with the glass, and with the mirror and I have never seen a more finished thing' (*BM Michelangelo*, No. 200).

The concept of the drawing as a work of art in its own right has endured in the field of portraiture until the present day. The tradition can be traced through the self-portraits of Annibale Carracci and Bernini (Nos. 84 and 85) to the much-repeated heads of Piazzetta (Nos. 103–7), the highly polished studies of members of King George III's family by Edridge (Nos. 124 and 125), and the more recent works of Strang, Sargent and Topolski (Nos. 135, 138 and 147–9).

By the early seventeenth century the art of the Italian Renaissance was becoming fully accepted in England, and Isaac Oliver (who had been trained on the Continent before moving to London) produced a large number of portrait 'limnings' (or miniatures) for the Court and other prominent Englishmen. He also made drawings such as the *Nymphs and Satyrs* (No. 68) which were works of art in their own right.

The tradition of collecting drawings

The appreciation of drawings as objects worthy of admiration and acquisition dates back to the Italian Renaissance, and thus to the very earliest items in this exhibition. Because of their preparatory nature, most drawings perished in the studios in which they were made. We should not therefore ask why there are now – for instance – so few fifteenth- and sixteenth-century drawings for the many paintings and other works of art of that era, but wonder why there are so many. The circumstances of a drawing's survival are only rarely documented. For instance, we know that at the time of Leonardo's death in 1519, most of his drawings and papers were with him, that they were bequeathed to his favourite pupil Francesco Melzi,

and thereafter were acquired by the sculptor Pompeo Leoni. The volume containing the Leonardo drawings which are now at Windsor was purchased from Leoni by the great English collector, Thomas Howard, Earl of Arundel, and was transported by him to England (Figs. A and B).

Artists must always have been among the chief collectors of drawings, both by inheritance from their masters, and by design. Giulio Clovio (1498–1578) is known to have been an assiduous collector of works by Michelangelo, and may once have owned both the *Archers* and the *Resurrection* in the present exhibition (Nos. 22 and 25). Many of the Italian seventeenth-century drawings at Windsor were once owned by Carlo Maratta (1625–1713) who 'succeeded in building up one of the finest collections of drawings by artists of Seicento Rome that have ever been made' (BM, p.9). Maratta's collection depended very largely on that formed by Domenichino's pupil and heir, Francesco Raspantino, which included a vast group of drawings by Domenichino (e.g. No. 88), in addition to around 550 drawings by members of the Carracci family. It would be surprising if the 200 drawings by Maratta himself (including Nos. 89 and 90), and the group of studies by his master Sacchi, had not entered the Royal Collection by this same route. The Maratta collection was purchased by the Albani Pope, Clement XI in 1703, and thus entered the Royal Collection in 1762 with other drawings from the Albani family.

Another notable collection was formed by Sir Peter Lely (1618–80), the greatest portraitist of the Restoration years. Lely may have acted as intermediary in finally securing both the Leonardo and the Holbein drawings for the Crown. Among the artists particularly well-represented in his collection was Parmigianino, and it may be no coincidence that four volumes of drawings by this artist are also included in the early eighteenth-century inventory of the Royal Collection. The outer bindings of three volumes survive at Windsor today (Figs. D and E). One of these was inscribed and dated by the engraver Wallerant Vaillant in 1655 (and therefore could not have entered the collection before this date), while another contains a note in a hand normally ascribed to William Gibson. No artist of this name is now known, although Walpole discusses William Gibson as a miniaturist, taught both by his uncle, the better known Richard Gibson (c.1605–90), and by Lely, part of whose collection he purchased; he died of lethargy in 1702 (H. Walpole, *Anecdotes*, III, 2nd. ed., 1765, p.68).(This information cannot be confirmed.) Richard Gibson, who held an appointment

as miniaturist in the household of the Duke of York, was an executor for Nicholas Lanier's will, and a friend of Lely's. His own will does not mention a collection of drawings, but it would seem to be inherently more likely that 'Mr Gibson ye Painter' (whose collection relied heavily on purchases made at Lely's sale in 1688), was Richard rather than the lesser-known William (cf. F. Watson, 'On the early history of collecting in England', *Burl. Mag.*, LXXXV, 1944, p.224). The Gibson hand has been identified on a group of sheets now at Windsor, including two drawings in the present exhibition (No. 7 by Fra Bartolommeo, Fig. C, and No. 23 by Michelangelo). Another artist, Jonathan Richardson (1665–1745) owned at least two of the drawings in the exhibition: the 'stray' Holbein (No. 49), and Visscher's portrait (No. 61). According to his son, Richardson bought extensively from Gibson's widow, but only after the Duke of Devonshire had made his own selection from the drawings.

During the eighteenth century, Paul Sandby formed a fine collection of old master and modern drawings, many of which later passed into the collection of Sir Thomas Lawrence. Polidoro's design for the crystal plaque (No. 38) and Dürer's study of a greyhound (No. 53) share this provenance.

The history of the Royal Collection

The history of the formation of the Royal Collection is a long and complicated one, which has already been recounted in some detail (BM, pp.1–18). The introductions to the individual volumes in the series of catalogues of the Collection (formerly published by the Phaidon Press) likewise include full discussions on the provenance of the drawings in each category. Briefly, the first major groups of drawings to enter the Collection were those for which it is most famous, by Holbein and by Leonardo. Holbein's 'great booke', in which each of the 81 Holbein drawings now at Windsor (with the exception of No. 49) were formerly mounted, first entered the Royal Collection very soon after the artist's death in 1543. However, it subsequently departed into the collections of the Lords Arundel, Lumley, Pembroke and Arundel (again), with a brief intermission in the libraries of Prince Henry and of King Charles I, before finally settling in the Royal Collection shortly before 1676.

The binding of the volume containing the 600 or so drawings by Leonardo (including Nos. 11–17) has survived in the Royal Library, empty except for

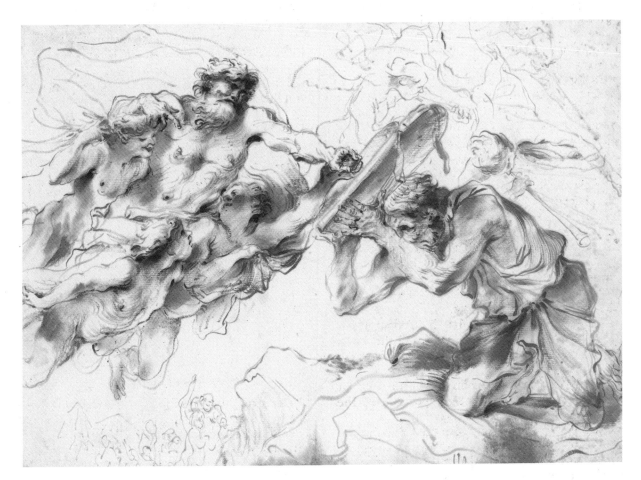

III Giovanni Benedetto Castiglione (No. 97)

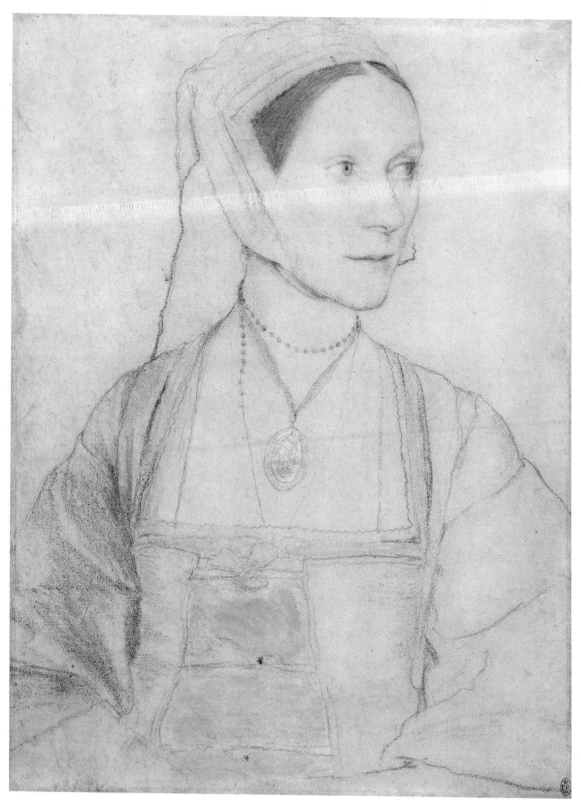

IV Hans Holbein the Younger (No. 47)

V Stefano Della Bella (No. 99)

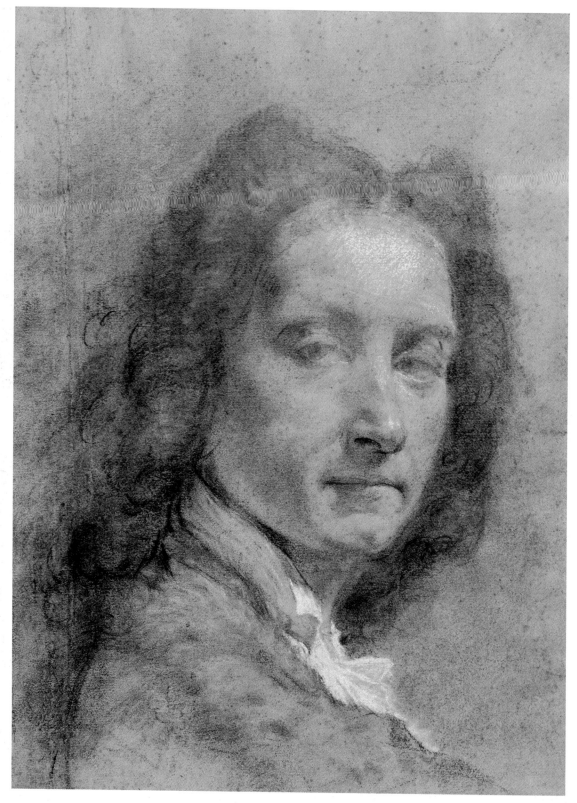

VI GIOVANNI BATTISTA PIAZZETTA (No. 104)

a few blank pages and stumps. The Leonardo drawings were also a seventeenth-century acquisition, although the exact date of entry to the Collection is even less securely documented. There are references to drawings by Leonardo 'in the hands of the King of England' before 1640, but what were presumably the same drawings were later referred to in the collection of Thomas Howard, Earl of Arundel. However, we know that in 1690 Queen Mary II showed the volume of Leonardo (and of Holbein) drawings to her secretary, the Dutch statesman and collector, Constantin Huygens, and the drawings have been in the Collection ever since.

During the reign of King George II (and probably shortly before 1735) the drawings in the Royal Collection, which were at that time chiefly kept in a bureau in Kensington Palace, were listed in an inventory now in the British Library (B.M. Add. 20101, ff. 28 and 29; Fig. F. Described hereafter as the Kensington Inventory). In addition to the drawings by Holbein and Leonardo a number of other works by Italian masters of the sixteenth and seventeenth centuries were mentioned (including four books of drawings by Parmigianino: see No.28), together with prints by Dürer and Hollar, several volumes of drawings 'by defferent hands', and 'Prince Charle's Book with a few Drawings'. The last entry leads us to refer to the few entries in Van der Doort's inventory (dated 1637–9) of Charles I's collection which relate to drawings (see BM, p.2), and in particular to the book 'Conteyning sev'all Accons and postures invented by Michaell Angello Bonorotto', which bore Prince Charles's arms on its front cover and which is probably therefore identifiable with 'Prince Charle's Book' in the Kensington Inventory. The only one of Van der Doort's references to drawings that can positively be identified in the present Collection is the group of French sixteenth-century portraits, to which Nos. 75 and 76 once belonged. These were doubtless preserved due to the fact that they were kept in a relatively inconspicuous album on the shelves or in the cupboards of a library or closet. Other drawings, framed and therefore listed with the paintings, or discovered by the assessors 'in the small trunk', were included in the valuations of King Charles I's property made in 1649–51, and were subsequently disposed of. Among these were a few additional (and sometimes enigmatic) items, such as '1. The drawing of a Candlestick. don by van Melly', and '376. Tobyas & yᵉ Angell in Water Colo.ʳ done by the Kings Neece', valued at 2s and 2s 6d respectively (*W.S.*, XLIII, 1970–2, pp.151, 247). A large number of 'limnings' (including Nos. 44–6)

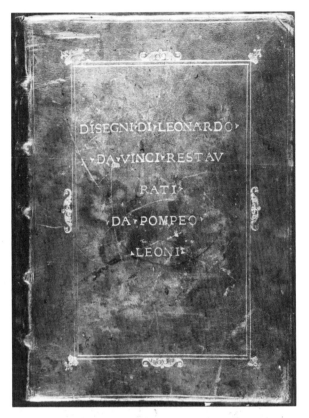

A The Leoni binding which formerly contained all the six hundred drawings by Leonardo in the Royal Collection

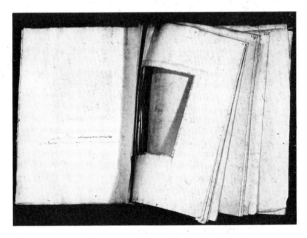

B The Leoni binding, showing the original guard papers

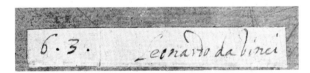

C Inscription in the hand of Richard Gibson on the *verso* of No. 7

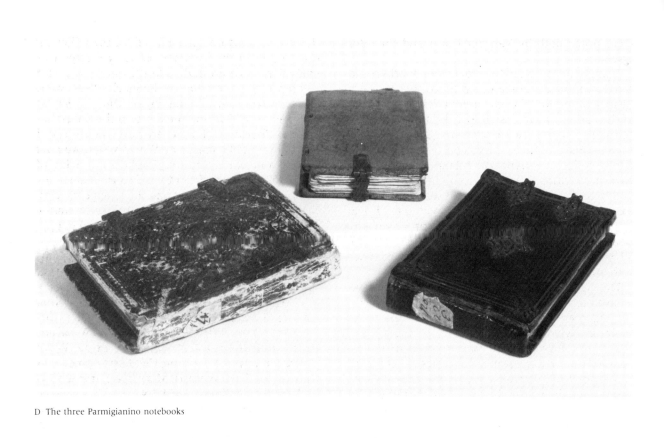

D The three Parmigianino notebooks

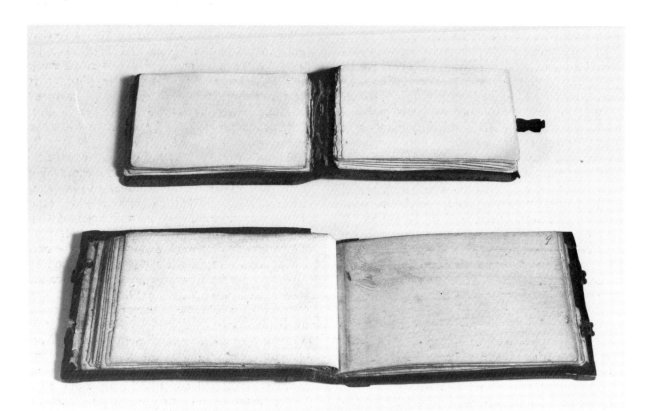

E Two of the Parmigianino notebooks opened to reveal the
sheets of coated paper

were noted both by Van der Doort and the later assessors.

It might be expected that collectors' marks could provide another source of evidence for the early history of the Royal Collection of drawings. Many of the earlier Italian drawings at Windsor bear one of the star marks associated with Nicholas Lanier (1588–1666). Much confusion surrounds the Lanier collector's mark which Lugt cites as having two main forms: a large eight-pointed star (Lugt 2885), and a smaller five-pointed star (Lugt 2886). Examples of both these types exist within the Royal Collection, but are not represented on any of the drawings selected for this exhibition. Instead, No. 37 bears the much rarer six-pointed star, which has hitherto been left unrecognised.

The significance of the different star marks has been a matter of discussion (and controversy) since the eighteenth century. Richardson, Vertue and Walpole were in agreement in assigning a small star to drawings collected by Lanier for the Earl of Arundel, and a large star to drawings collected by Lanier for King Charles I. However, they did not agree when discussing the number of points on the particular stars. Examples of the small five-pointed star mark are to be found in relatively large numbers in the majority of the older drawings collections in England (Christ Church, the Ashmolean, Chatsworth, and the British Museum). The large eight-pointed star also appears in a number of the above collections, but is proportionally less common. If the traditional significance of this mark (as having been applied to those drawings collected by Lanier for King Charles I) is correct, then this wide distribution may be explained by the dispersal of the King's property during the Commonwealth period. However, the lack of any documentation determining what left the Royal Collection at that time and what remained means that it is still impossible to argue conclusively for either one of the two Lanier stars appertaining specifically to the King. The six-pointed star remains an enigma. It should be mentioned here that the two modern royal collector's marks applied to many of the drawings in this exhibition bear no relationship to the date of acquisition of the drawing concerned. They were merely an attempt by the Librarian of the day to mark the more important drawings in the Collection with some sign of ownership. By choosing the monograms of King Edward VII and King George V, during whose reigns no important old master drawings entered the Collection, they have only served to confuse the issue.

To the above miscellaneous and sometimes conflicting pieces of information about the Stuart drawings collection should be added the following one, found in the inventory of King George III's collection made around 1800 (Inventory A), with reference to a drawing by Raphael (P&W 808): 'This drawing was found in an Old Bureau at Kensington which contained part of the Collection of King Charles ye first, where also was preserved the Volume of Leonardo da Vinci.' When we read in the same Inventory that Raphael's drawing of *Poetry* (No. 21) was 'from Kensington', and reconsider all the above information, it appears very likely that an important group of early Italian drawings was already in the Royal Collection during King Charles I's reign.

Other drawings in the Collection, and presumably therefore in the Kensington Inventory, were probably acquired (with the Holbeins and possibly also the Leonardos) during the reign of King Charles II, with the assistance of artist-collectors such as Lely and Gibson, as noted above. A curious insight into the use that was made of the Royal Collection at this time is provided by two notes in the diary of the miniaturist Mary Beale, transcribed by Vertue as follows: 1674. 'Novem. borrowd of W.^m Chiffinch Esq. eleaven of his Majesties Italian drawings –', and 1677 February 'borrowd 6 Italian drawings out of the Kings Collection for my sons to practice by' (*Vertue IV, W.S.,* XXIV, 1935–6, pp.172–3).

The inventory of King James II's collection (published by Bathoe/Vertue in 1758) contains the first reference to the presence of Holbein's *Solomon and the Queen of Sheba* (No.43) in the collection. It includes several further references to drawings, including works by Raphael, Veronese, Callot, Goltzius and Van de Velde, but once again, few can securely be identified today.

Had the drawings at Windsor remained in their original albums, many of our questions concerning their provenance could doubtless have been answered. The rebinding and reorganisation of the albums was apparently begun in the reign of King George III, at which time the chief acquisitions of old master drawings were made. Towards the end of King George's reign the drawings collection was listed, in some detail, in two inventories (hereafter referred to as Inventory A and Inventory B). The King doubtless inherited a love of art (as well as a notable collection) from his father, Frederick Prince of Wales, whose purchases had included an important group of Poussin's works acquired from Dr Richard Mead (e.g. Nos. 69–73). Following Prince Frederick's death in 1751, his eldest son, George, made his own first artistic purchases (of two volumes of flower paintings by Maria Sibylla

F The Kensington Inventory (British Library, Add. MS. 20101, f. 28), listing the drawings in the Royal Collection before 1728

Merian) at Dr Mead's sale in 1755.

However, King George III's main purchases were from abroad. In 1762, through the good services of James Stuart Mackenzie and the Royal Librarian, Richard Dalton, the collection of paintings, drawings, engravings, books, coins and gems, formed by Joseph Smith (one time British Consul in Venice), was purchased for the King for the sum of £20,000. Among the drawings thus acquired was an unrivalled group of works by Venetian artists, including a volume of 143 drawings by Smith's friend Canaletto, and other volumes of works by Piazzetta, Marco and Sebastiano Ricci, and Antonio Visentini. In addition, there was the important group of drawings formerly in the Bonfiglioli collection in Bologna, including Raphael's study for the *Massacre of the Innocents* (No. 19), three volumes by the Carracci, and a series of studies by Guido Reni. The above material had passed from the Bonfiglioli family to the Venetian Procurator Zaccaria Sagredo, from whom Smith also acquired the superb collection of drawings and monotypes by Castiglione (e.g. Nos. 96–8). Unfortunately it is not known from whom Smith obtained the illuminated page by Giulio Clovio with which this exhibition opens (No. 1).

In the same year, 1762 (this time through the agency of the architect James Adam, who was then in Rome), the King purchased for £3,500 the magnificent collection of drawings and engravings belonging to Cardinal Alessandro Albani. This comprised three main portions, which had formerly belonged respectively to the artist Carlo Maratta (as noted above), to the great seventeenth-century Roman scholar Cassiano dal Pozzo, and to the Cardinal's own Albani ancestors. The dal Pozzo collection included the great *museo cartaceo* (paper museum, of drawings relating to antiquity and to natural history), which is mostly still preserved, often in the original bindings, at Windsor. Dal Pozzo was an important patron of Poussin, and a further group of this artist's drawings (including No. 74) which entered the Collection at this time doubtless came from this source. The Albani family collection included the fourteen volumes of drawings by Carlo Fontana containing his designs for projects commissioned by members of that family.

In addition, many miscellaneous purchases were made both in Italy and in England by King George III's Librarian, the antiquarian Richard Dalton, although scarcity of documentation means that it is seldom possible to be sure exactly what these purchases involved. They almost certainly included the group of presentation drawings by Michelangelo referred to above, which had formerly belonged to Cardinal Alessandro Farnese, and which had passed by descent through the Farnese family. The large group of drawings by Guercino in the Collection (including Nos. 92–94) was purchased by Dalton from the Gennari family in 1763 and a series of studies by Sassoferrato (presumably including No. 91) was acquired at around the same time. A number of works by contemporary Italian artists such as Manocchi (see Nos. 116–8) probably entered the Collection during the same period

The foregoing might suggest that (with the notable exception of the drawings by Holbein and Poussin), the Royal Collection was exclusively devoted to works by Italian artists. But in Inventory A a large number of other drawings by Flemish, Dutch, German and French masters are listed, including works by Rubens (e.g. No. 60), Avercamp (e.g. Nos. 65 and 66), and Cornelis Visscher (e.g. No. 61). Holbein's drawing of an unknown lady (No. 49) was reunited with the

other portraits in the 'great booke' before the end of the century.

Because of the number of drawings involved, and the fact that the most important purchases were made by agents in Italy, it is extremely unlikely that the magnificent additions to the Royal Collection in the later eighteenth century can be taken individually to reflect the personal taste of the monarch concerned. King George III was seriously interested in the arts and doubtless considered it a duty as well as a pleasure to acquire fine pieces for his collection. But he was probably more personally concerned with his natural historical drawings (by artists such as Merian and Catesby), and his topographical collection (which is now in the British Museum), than with drawings by old masters. During his reign the Royal Library, in which the drawings have traditionally been and continue to be kept, was situated at Buckingham House (later Palace) in London. The King is known to have been a frequent visitor to the Library, but is not documented as paying particular attention to his volumes of drawings.

King George's son and successor, King George IV, had a more passionate (and extravagant) interest in art, although his chief acquisitions involved objects on a much larger scale than mere drawings. Nevertheless, large numbers of drawings and watercolours with a military or theatrical subject-matter were added to the Collection at this time, including an important group of works by Hogarth (e.g. No. 123). Other drawings by contemporary (or slightly earlier) English artists such as Edridge (Nos. 124 and 125), Rowlandson and Wild were also acquired.

In her Journal entry for 4 September 1838, Queen Victoria noted: 'Lord Melbourne rode out at ½ past 3 with Murray to Cumberland Lodge to see the prints, and came home at ½ past 6. He said it was a *most splendid collection*. There are *37 books* of *Domenichino's Original Drawings*, some of *Raphael's*, some beautiful *Michael Angelos*, Lord M. said, all sketches; some of Albert Durer's; a book of Holbein's drawings . . . I said I had seen in the afternoon a book of beautiful sketches by Guido, and one of Domenichino's. Lord M. said they were

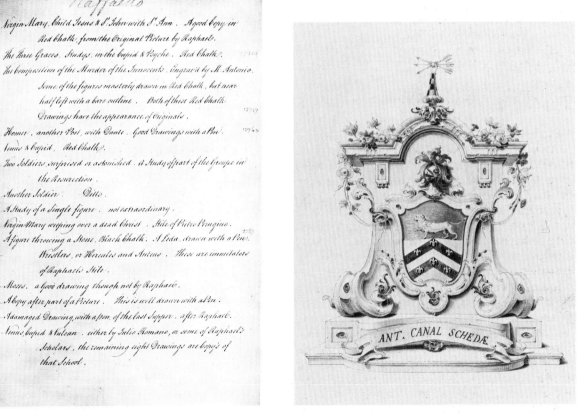

G Extract from Inventory A including (as items 28, 29, 32 and 37) Nos. 18, 19, 20 and 5 of the present exhibition (Inventory A, p. 51)

H Antonio Visentini: the arms of Consul Joseph Smith. This page served as the frontispiece to Smith's volume of drawings by Canaletto (including Nos. 109–14)

I The note of the contents of Smith's Canaletto volume,
now inserted into Inventory A

J The original binding containing Smith's collection of
drawings by Sebastiano Ricci, from which No. 108 has now
been removed

kept in 2 rooms, in cases; that there were every *sort* of print, and most valuable, and that it was impossible to look at them all. We spoke of all this for some time, and of the use Lord M. said these original drawings would be to artists.' Later in the reign, following her marriage and the transfer of the collection of prints and drawings to Windsor Castle, the Queen recorded many happy evenings spent in the Print Room, sorting portrait miniatures, enamels or engravings, arranging the Raphael Collection (for which see, for example, Nos. 116–8), or making up albums of contemporary drawings and prints acquired by the royal couple. On 18 August 1841 'we looked at some beautiful original drawings by the Caraccis which belong to my collection. They are great treasures and there are 5 volumes of them which we had not seen before.' Three years later, on 25 July 1844 'we 2 dined alone together and then looked at some of our enamels, and at the exquisite original drawings by Holbein'. However, in spite of the great and active interest in art shared by Queen Victoria and Prince Albert (Nos. 127 and 128), no important old master drawings were added to the Collection during the early years of the reign. Activity was instead centred on the commissioning and purchasing of works by living masters, recording the features of family, friends, animals, houses, places visited, or recording ceremonies that had taken place (e.g. Nos. 131 and 132). During the years leading up to Prince Albert's death the collection of drawings and engravings was ordered and arranged (with the active participation of the Queen and Prince Albert) in the newly equipped Print Room at Windsor. The system introduced at that time is largely that which survives today.

During the later part of Queen Victoria's reign, while Richard Holmes was Librarian (1870–1906), a number of important and enlightened purchases were made. Several fine old master drawings which otherwise had no obvious association with the Collection were acquired. Nos. 38 and 53, noted above as having belonged previously both to Paul Sandby and to Sir Thomas Lawrence, were purchased at this time. The first was among the drawings bought from the Mayor Collection in 1874. Two years later, when the great series of Sandby drawings and watercolours brought together by Sir Joseph Banks was offered for sale, Holmes was able to acquire many of the finest Windsor views to add to the existing Sandby holdings, acquired during the reign of King George IV. Peter Oliver's copies of paintings in the collection of King Charles I (e.g. Nos. 45 and 46), which had been sold during the Commonwealth period, were

repurchased for the Collection in the 1880s.

During the reign of King Edward VII two series of portrait drawings were commissioned from William Strang (e.g. No. 135), and other drawings were acquired as the result of presentations (e.g. No. 138). Both Queen Alexandra and Her Majesty Queen Elizabeth the Queen Mother have made generous gifts of drawings to the Collection (e.g. Nos. 134 and 139). These, together with the drawings in the Coronation and Jubilee gifts presented to Her Majesty by the Royal Academy (Nos. 140–5), have allowed the range of the Collection to extend to the present day. Her Majesty has continued to acquire drawings and watercolours which are directly relevant to the existing holdings, and in this way additional works by West, Wilkie, Stothard, Nash and in particular Paul Sandby, have entered the Collection in recent years. Almost every item in the Royal Collection is there for some good historical reason. If the artistic quality of some of the more recent additions is sometimes not as great as the more considerable acquisitions of previous centuries, their relevance to the Collection is undiminished.

List of Works Referred to in Abbreviated Form

Note: Catalogues specifically concerned with drawings in the Royal Collection are denoted by a crown alongside the abbreviation

Bartsch A. Bartsch, *Le Peintre Graveur*, Vienna, 1803–21

Bathoe/ Vertue *A catalogue of the . . . Pictures & belonging to King James the Second . . . [and] in the Closet of the late Queen Caroline*, London, 1758

👑 BCS A. Blunt, *The Drawings of G. B. Castiglione and Stefano della Bella in the Collection of Her Majesty The Queen at Windsor Castle*, London, 1954

👑 BF A. Blunt, *The French Drawings in the Collection of His Majesty The King at Windsor Castle*, London, 1945

👑 BM A. Blunt, *Supplements to the Catalogues of Italian and French Drawings in the Collection of Her Majesty The Queen at Windsor Castle* (appended to S, below), London, 1971

BM Michelangelo *Drawings by Michelangelo . . .*, exh. cat. by J. A. Gere and N. Turner, British Museum, London, 1975

BM Raphael *Drawings by Raphael . . .*, exh. cat. by J. A. Gere and N. Turner, British Museum, London, 1983

👑 BR A. Blunt and H. L. Cooke, *The Roman Drawings of the XVII and XVIII Centuries in the Collection of Her Majesty The Queen at Windsor Castle*, London, 1960

Briquet C. M. Briquet, *Les Filigranes*, Paris, 1907

👑 BV A. Blunt and E. Croft-Murray, *Venetian Drawings of the XVII and XVIII Centuries in the Collection of Her Majesty The Queen at Windsor Castle*, London, 1957

Burl. Mag. *The Burlington Magazine*

Byam Shaw J. Byam Shaw, *Drawings by Old Masters at Christ Church, Oxford*, 2 vols., Oxford, 1976

C/L W. G. Constable, *Canaletto*, 2 vols. (2nd ed., revised by J. G. Links), London, 1976

👑 C&P K. Clark and C. Pedretti, *The Drawings of Leonardo da Vinci at Windsor Castle*, London, 1968–9

GBA *Gazette des Beaux-Arts*

Heawood E. Heawood, *Watermarks . . . of the Seventeenth and Eighteenth Centuries*, Hilbersum, 1950

I&V O. Millar, 'The Inventories and Valuations of the King's Goods, 1649–51', *W.S.*, XLIII, 1970–2

👑 JP-H J. Pope-Hennessy, *The Drawings of Domenichino in the Collection of His Majesty The King at Windsor Castle*, London, 1948

JWCI *Journal of the Warburg and Courtauld Institutes*

K Inventory of drawings by Royal artists in the Royal Library, Windsor Castle

👑 KB O. Kurz, *The Bolognese Drawings of the XVII and XVIII Centuries in the Collection of Her Majesty The Queen at Windsor Castle*, London, 1955

Kensington Inventory Catalogue of the Cabinet contents, Kensington Palace, 1735 (B.M. Add. MS. 20101)

Knox G. Knox, *Piazzetta: A Tercentenary Exhibition*, exh. cat., Washington, 1983–4

Levey M. Levey, *The Later Italian Pictures in the Collection of Her Majesty The Queen*, London, 1964

L.S. *Leonardo: Studies for the Last Supper from the Royal Library at Windsor Castle*, exh. cat. by C. Pedretti, Milan etc., 1984–5

Lugt F. Lugt, *Les Marques de Collections de dessins et d'estampes*, Amsterdam, 1921; *Suppléments*, The Hague, 1956

Mahon D. Mahon, *Il Guercino: I Disegni*, exh. cat., Bologna, 1968

👑 M&T D. Mahon and N. Turner, *The Drawings by Guercino in the Collection of Her Majesty The Queen at Windsor Castle*, Cambridge, (forthcoming) 1986

M.D. *Master Drawings*

N.S. *Leonardo da Vinci: Nature Studies from the Royal Library at Windsor Castle*, exh. cat. by C. Pedretti, Malibu and New York etc., 1981

👑 OE A. P. Oppé, *English Drawings – Stuart and Georgian Periods – in the Collection of His Majesty The King at Windsor Castle*, London, 1950

👑 OS A. P. Oppé, *The Drawings of Paul and Thomas Sandby in the Collection of His Majesty The King at Windsor Castle*, London, 1947

Parthey G. Parthey, *Wenzel Parthey*, Berlin, 1853; expanded by R. Pennington, *A descriptive catalogue of the etched work of Wenceslaus Hollar*, Cambridge, 1982

👑 PC K. T. Parker, *The Drawings of Antonio Canaletto in the Collection of His Majesty The King at Windsor Castle*, London, 1948; *reprinted, with an Appendix by Charlotte Miller, New York, 1985

👑 PH K. T. Parker, *The Drawings of Hans Holbein in the Collection of His Majesty The King at Windsor Castle*, London, 1945; reprinted, with an Appendix by Susan Foister, New York, 1983

Popham 1967 A. E. Popham, *Italian Drawings . . . in the British Museum. Artists Working in Parma in the Sixteenth Century*, 2 vols, London, 1967

Popham 1971 A. E. Popham, *Catalogue of the Drawings of Parmigianino*, New Haven and London, 1971

Popham & Pouncey A. E. Popham and P. Pouncey, *Italian Drawings . . . in the British Museum*, London, 1950

👑 P&W A. E. Popham and J. Wilde, *The Italian Drawings of the XV and XVI Centuries in the Collection of His Majesty The King at Windsor Castle*, London, 1949; reprinted, with an Appendix by Rosalind Wood, New York, 1985

Q's G *Canaletto Paintings and Drawings*, exh. cat., The Queen's Gallery, London, 1980–1

RA Royal Archives, Windsor Castle

RL Inventory of the drawings in the Royal Library, Windsor Castle. The nineteenth-century drawings in the Collection are the subject of a catalogue in progress, by Delia Millar

Russell H. D. Russell, *Claude Lorrain*, exh. cat. Washington, 1982–3

👑 S E. Schilling, *The German Drawings . . . in the Collection of Her Majesty The Queen at Windsor Castle* (with BM appended), London, 1971

VdD O. Millar, 'Abraham van der Doort's Catalogue of the Collection of Charles I', *W.S.*, XXXVII, 1958–60

VPD L. van Puyvelde, *The Dutch Drawings in the Collection of His Majesty The King at Windsor Castle*, London, 1943

👑 VPF L. van Puyvelde, *The Flemish Drawings in the Collection of His Majesty The King at Windsor Castle*, London, 1942

W R. Wittkower, *The Drawings of the Carracci in the Collection of Her Majesty The Queen at Windsor Castle*, London, 1952

W.S. *Walpole Society*

VII Frank O. Salisbury (No. 137)

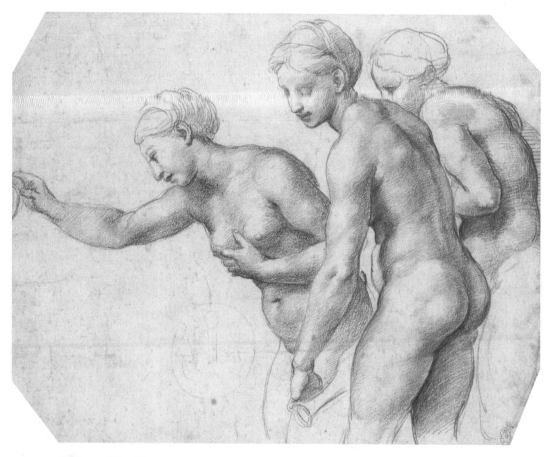

VIII Raphael (No. 18)

THE ITALIAN RENAISSANCE

The favourite drawing instrument of fifteenth-century artists was metalpoint, applied to paper prepared with a chalky coating tinted to various shades which would serve as the artist's middle tone: when a pinky-orange preparation was used (as in No. 2), for instance, there was no need for the flesh tints to be added, and areas of light and shade were introduced with white and black.

The chalky preparation sometimes produced an effect similar to the surface of vellum, which was still preferred to paper for high quality presentation pieces, and particularly for illuminated manuscripts (e.g. No. 1).

There are also many surviving pen and ink drawings from these early years. In the works of virtuoso draughtsmen such as Leonardo (No. 16) and Parmigianino (No. 29, 30, 32 and 33) there is a fineness and control of the pen line that has rarely been surpassed.

By around 1500, black and red chalk (widely available as natural substances) had become a popular drawing medium with leading Italian artists. The highpoint of virtuosity in the use of chalk can be seen in Michelangelo's 'Presentation Drawings' (e.g. Nos. 22 and 24), in which the individual drawn lines have been transformed by rubbing and stumping into a glistening depiction of light and shade. Barocci's polychrome use of coloured chalks (Nos. 26 and 27), though apparently dependant on the (lost) example of Correggio and Leonardo, is now unique in sixteenth-century Italy.

GIULIO CLOVIO
Decorative framework (detail of PW 241; RL 0446)

1 GIULIO CLOVIO (1498–1578)

Composite sheet of illuminations

Tempera and gold paint, with some gold leaf. Vellum, 663 × 421 mm (irregular)

The main illumination signed bottom left: D. IULIO/ CLOUIO F. The subsidiary panel inscribed bottom right: S. TEOD.

VERSO of main illumination: some text and musical notation, pen and brown ink.

This sheet is made up of a number of different fragments, which doubtless once formed part of the same choir-book. Some text and musical notation appears on the *verso*. The size of the original manuscript may be judged from that of the main (signed) fragment, incorporating the decorated initial 'P' and occupying most of the left and central area of the sheet. The lower right area, and fragments top left and top right, appear once to have belonged to another unified page. The subsidiary panel with the standing figure of St Theodore is of a very high quality, but the ornamentation elsewhere (including the outer scrolling border, made up of several fragments) was probably executed by studio hands.

Clovio was Croatian by birth, but moved to Italy early in his life. Vasari stated that he was encouraged to take up painting in miniature by Giulio Romano, one of his earliest masters; indeed, such was Clovio's feeling of obligation that he took his first name (Giulio) in preference to his own (Giorgio) when he entered Holy Orders

after the Sack of Rome. He also, again according to Vasari, learnt some of the elements of illuminating from Girolamo dai Libri while both artists were resident at the monastery of Candiana near Padua (c.1530); Girolamo as a commissioned artist, Clovio as a friar of the house. A marginal note by an unknown eighteenth-century hand in a copy of Vasari's *Lives* states that a large choir-book illuminated by Clovio had been broken up by the Abbots of Candiana and the illuminations dispersed among local connoisseurs (see P&W). The present sheet may have formed a part of this, but it is impossible to be sure, since at least one other major choirbook executed at this time by Clovio is documented. At any rate the Windsor sheet dates from the period before the miniaturist transferred himself permanently to Rome (c.1534). It shows a mixture of obviously Venetian and Mantegnesque elements (the main scene; St Theodore); with central Italian features such as the grimacing faces and supporting *ignudo* of the left-hand border. The latter are reminiscent of Giulio Romano; indeed the grotesque element of the faces is unparalleled in Clovio's other work. Other features of the decoration may be paralleled in the artist's documented work of around 1530: thus the lower right border is particularly reminiscent of the Grimani Evangelistary (Venice, Marciana; 1528).

The owner of the original manuscript is difficult to determine. It may be suggested by the scene within the decorated initial, which shows a cardinal in his study, apparently giving dictation to his clerical secretary. The present sheet has been identified with the following item in the list of Italian paintings acquired by King George III from Consul Joseph Smith: 'No. 345. DON GIULIO CLOVIO. Divers figures cut out of missals and elegantly pasted on cloth and ornamented with gold shading, and in the body of a great P is drawn Cardinal Grimani visiting Don Giulio [Clovio] in his chamber in the Convent. H. 2.3 W. 1.4'. The Cardinal here depicted, however, is not Grimani, who was Clovio's most important patron during the early part of his career: he differs markedly from the figure portrayed in the Soane Museum Commentary on the Epistle of St Paul to the Romans, a secure Grimani commission of 1534–8. The coat of arms, which may not be contemporary, appears to be that of the Bettani family (E. Morando Di Custoza, *Libro d'arme di Venezie,* Verona, 1979). The blazon is Argent (now oxidised to brown), a chevron Gules between three trefoils Or. It is topped by a wild boar.

Provenance: [?Abbey of Candiana;] Consul Joseph Smith; King George III

(P&W 43*; RL 13035)

CAT. 1 *verso* (detail)

Domenico Ghirlandaio, *Birth of the Virgin*
(detail; Florence, Cappella Tornabuoni, S. Maria
Novella)

2 Domenico Ghirlandaio (c.1449–94)

Head of an Old Woman

Metalpoint heightened with white on paper coated with
a salmon pink preparation. 231 × 184 mm

VERSO inscribed in pen and brown ink, lower left: di
Michelanoilo bonaroti

A detailed life study, in which the advantages of a
coloured coating to the paper are used to the full. The
face is first modelled with the slightly diagonal hatching
lines of metalpoint, the shaded areas covered with many
closely spaced parallel lines, and the light areas touched
in along the outlines with flecks of white paint. The
white highlighting is also sometimes cross-hatched, and
in the lower lines of the hood it is applied with unusual
freedom.

Berenson identified this as a preliminary study for a
figure in the left-hand group of the fresco of the *Birth of
the Virgin*, one of the important series of paintings
executed by Ghirlandaio in the chancel (or Cappella
Tornabuoni) of the church of S. Maria Novella, Florence,
between 1485 and 1490. Many of the figures represented
in these frescoes are evidently portrait likenesses, and it
is probable that several represent members of the
Tornabuoni family. The cartoon for another of the heads
in this fresco is at Chatsworth (No. 885r).

At the time of Ghirlandaio's work in the Cappella
Tornabuoni, the young Michelangelo (to whom this
sheet was once optimistically attributed) was working in
the master's studio. However, it is generally considered
that Michelangelo's earliest drawings were in pen and
ink rather than metalpoint.

Provenance: presumably King George III (Inventory A,
pp.16–17: *Diversi Maestri Antichi*, or p.19: *Teste di Diversi
Maestri*: these two categories, the contents of which are
rarely specified, probably contained the bulk of the Early
Italian drawings at Windsor.)

(P&W 9; RL 12804)

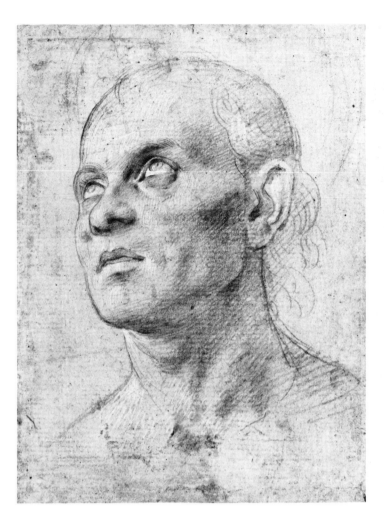

LORENZO DI CREDI, *St Francis receiving the Stigmata*
(Ajaccio, Musée Fesch)

3 LORENZO DI CREDI (c.1458–1537)

Head of St Francis

Metalpoint heightened with white, on paper coated with
a pale pink preparation. 160 × 123 mm

This drawing has been identified as a preparatory study
for the painting of *St Francis receiving the stigmata* in the
Musée Fesch, Ajaccio (see G. Dalli Regoli, *Lorenzo di
Credi*, Pisa, 1966, cat. 99). The early history of the picture
is not known, but it may have been painted as a pendant
to the lost picture of *S. Maria Egiziaca*, for the convent of
S. Chiara, Florence, c.1500.

The technique is typical of the drawings of Lorenzo di
Credi, who was a contemporary of Leonardo da Vinci in
the Florentine workshop of Andrea del Verrocchio.
Leonardo's influence over the younger artist was
considerable.

Provenance: see under No. 2

(P&W 7; RL 12818)

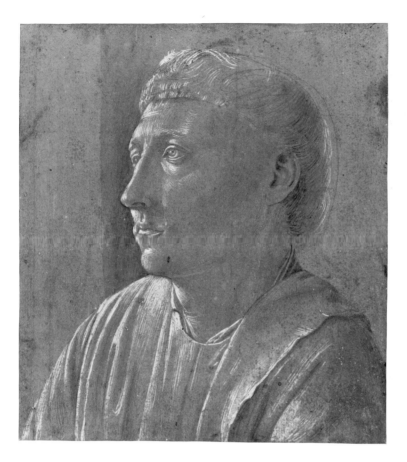

Cat. 4 *verso* (detail)

4 FRA ANGELICO (1387–1455)
 or BENOZZO GOZZOLI (c.1421–1497)

Head of a cleric

Metalpoint and brown wash, heightened with white, on paper coated with an ochre preparation. 189 × 173 mm

VERSO: *Mother and child and St Lawrence, and figure with clasped hands.* Pen and brown ink and wash

The head on the *recto*, which does not seem to be related to any surviving painted work, has all the appearance of a study from life. It incorporates a delicacy combined with a strength of modelling that is usually taken to distinguish the works of Fra Angelico from those of his chief assistant, Benozzo Gozzoli, and was attributed to Fra Angelico by Berenson. In the absence of comparable drawings by the older master, later scholars (including Popham) favoured an attribution to Gozzoli. However, Pope-Hennessy considered that 'Angelico's authorship of the *recto* cannot be ruled out' (J. Pope-Hennessy, *Fra Angelico*, London, 1952, p.189). Another drawing at Windsor (P&W 11 *recto*), also attributed to Gozzoli by

Popham, is in a rather different technique, with bolder application of white highlights and the head set less securely on the neck and shoulders.

The attribution of this drawing has been confused by the figures on the *verso* of this sheet, which are connected to two scenes from the cycle of frescoes representing the lives of Saints Stephen and Lawrence in the chapel of Nicholas V in the Vatican. These frescoes, which were painted between the year of that Pope's accession (1447) and 1449, were commissioned from Fra Angelico but were executed with the help of various assistants (including Gozzoli), to whom independent payments were made. In both the relevant frescoes (*St Lawrence distributing alms* and *St Lawrence before Decius*), Gozzoli's responsibility was considerable. However, as the *verso* drawings must be studies of rather than for the paintings, this argument helps little in the attribution of the present drawing.

Provenance: see under No. 2

(P&W 10*; RL 12812)

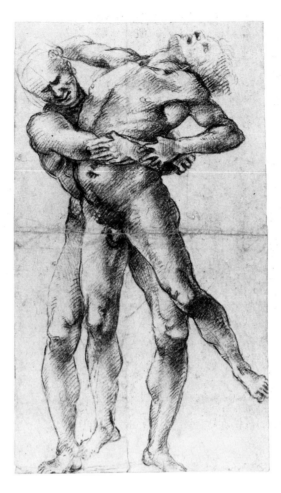

5 LUCA SIGNORELLI (c.1441–1523)

Hercules and Antaeus

Black chalk. The lower quarter of the sheet has several irregular lines of pin pricks, totally unrelated to the present drawing. 282 × 162 mm

Watermark: related to Briquet 3862 (Catania, 1496)

The struggle between the Greek hero Hercules and the giant Antaeus was frequently depicted by Renaissance artists. According to classical myth, Antaeus was strengthened by contact with the earth and therefore arose mightier following a fall. Hercules, perceiving this, lifted him up in the air and crushed him to death. Various sculpted depictions of the scene by ancient Roman artists were known in the Renaissance. Both ancient and modern artists recognised the possibilities it presented for the portrayal of the naked human figure in action. Antonio Pollaiuolo's bronze (in the Bargello) and his painting (in the Uffizi), both dating from the 1470s, were doubtless known to Signorelli when making this drawing. A number of engravings of the subject have survived from the fifteenth century of which one, by an artist from the school of Mantegna (Bartsch XIII, p.302, No. 1), could derive from the present study.

The bold lines of the drawing led early cataloguers (and later Passavant) to attribute it to Raphael. The head on the right is indeed more reminiscent of the work of a master of the High Renaissance (such as Rosso or Pontormo) than of c.1490, when this drawing was probably produced. It dates therefore from Signorelli's middle years, recently described as a time of 'cultivation . . . of a severe monumental style, focussed on the nude figure, which is closely bound up – partly as a cause and partly as a consequence – with the young Michelangelo's espousal of a grand style' (G. Kury, *The Early Works of Luca Signorelli*, New York and London, 1978, p.351).

Provenance: King George III (Inventory A, p.51: *Raffaello d'Urbino e Scuola*, No. 38. 'Wrestlers, or Hercules and Antaeus'

(P&W 29*; RL 12805)

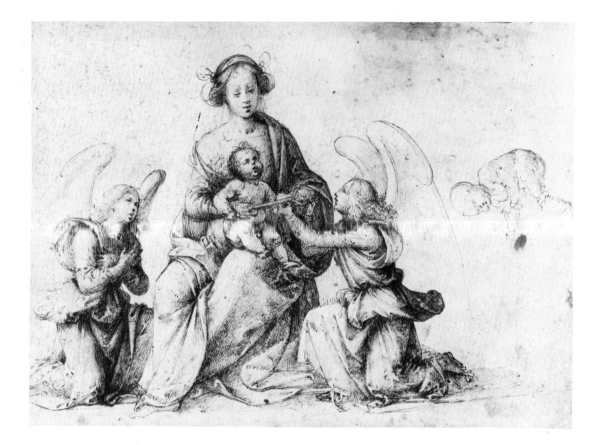

6 FRA BARTOLOMMEO (1472–1517)

Virgin and Child with kneeling angels

Pen and brown ink. 164 × 224 mm

VERSO: *Virgin and Child with the infant St John the Baptist and Angels.* Pen and brown ink, heightened with white.

No painting is known to relate to the compositions on either the *recto* or the *verso* of this sheet, nor to similar drawings by the artist in the Uffizi and the British Museum. Fra Bartolommeo appears to have been working through possible representations of the theme of the Virgin and Child, which were much in demand for altarpieces and devotional paintings. In the present instance one of the kneeling angels supports an open book, which the Virgin is apparently reading to the Christ Child.

The style of drawing is typical of Fra Bartolommeo, with its very fine and dense cross-hatching and the hook-like, almost gothic, terminations of the folds.

Provenance: King George III (Inventory A, p.47: *Michael Angelo, Fra Bartolomeo, And: del Sarto*, p.31. 'Virgin Mary Jesus S:ᵗ John and Angels Adoring. The other side Virgin Mary Jesus & two Angels Adoring, & a sketch of a Child'.)

(P&W 113 *verso*; RL 12782 *verso*)

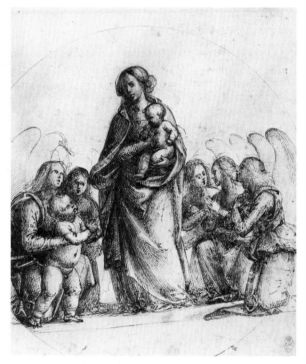

CAT. 6 *verso* (detail)

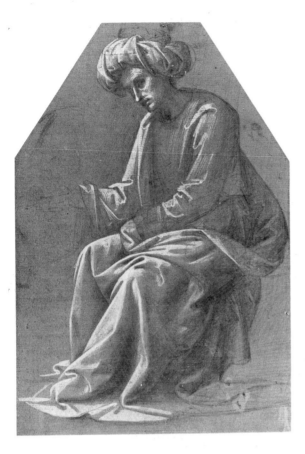

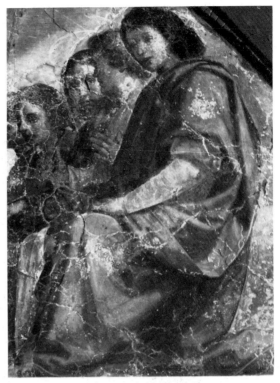

FRA BARTOLOMMEO, *The Last Judgment* (detail; Florence, Museo di S. Marco)

7 FRA BARTOLOMMEO

Seated man in a turban

Metalpoint, heightened with white, on paper coated with a pale blue preparation. 261 × 180 mm (irregular)

VERSO: *A profile* (black chalk); *detailed study of drapery over the legs of a seated figure,* and (inverted) *study of a seated man.* Metalpoint on paper coated with a lilac preparation. Inscribed (by Richard Gibson), lower centre, on two conjoined fragments of white paper together measuring 11 × 79 mm: 6 · 3 · Leonardo da Vinci

The drawings on both the *recto* and the *verso* of this sheet are connected with the figures in the upper (celestial) regions of the fresco of the *Last Judgment* commissioned of Fra Bartolommeo by Gerozzo Dini for the Church of S. Maria Nuova, Florence, in 1498. Following Fra Bartolommeo's retirement from the active world in 1500, by which date the upper part of the fresco had apparently been completed, the painting was continued by his partner, Mariotto Albertinelli (1474–1515). The fresco, much damaged, survives in the Museo di S. Marco.

The figure in the present drawing has been related to that at far right of the fresco. However, the painted figure lacks a turban and is seated at a rather different angle. Similar exotic headgear appears in other preparatory studies for the *Last Judgment* (e.g. a drawing in

CAT. 7 *verso*

Rotterdam), but the artist evidently abandoned the idea when he came to paint the fresco.

The technique of this drawing is unusual in Fra Bartolommeo's oeuvre (cf. No. 6), but occurs in other studies for the same painting in the British and Ashmolean Museums. Recent suggestions that No. 7 should be attributed to Albertinelli are unconvincing.

Provenance: Richard Gibson; then as for No. 2

(P&W 108*; RL 12825)

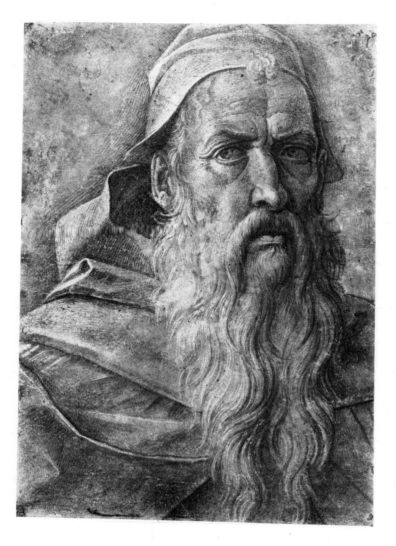

8 GIOVANNI BELLINI (c.1431–1516)

Head of a bearded old man

Drawn in black and white with point of brush, with wash added to both the figure and background. Blue paper (now faded; the original colour is visible along the lower and lower left edges). 257 × 190 mm

Although there appears to be no direct relationship between this drawing and any surviving painting, the head is close in type to the figure of St Anthony Abbot from the St Sebastian triptych, formerly in the Carità (now Venice, Accademia), of the 1460s. The author of the Carità panels is not documented, but it is now considered probable that the commission was given to the elderly Jacopo Bellini, and that his sons Giovanni and Gentile assisted in their execution. Although the individual panels of the altarpieces lack the strength and quality that can be observed in Giovanni Bellini's other

work of this date, the present drawing 'is among the finest . . . ascribed to Giovanni and one of those where the attribution is most convincing' (G. Robertson, *Giovanni Bellini*, Oxford, 1968, p.43). In spite of the numerous abrasions and discolourations this drawing can still be recognised as a work of the first rank, with an unusual degree of finish, and a directness of gaze more typical of a self-portrait than of an objective figure study.

A number of small holes on the left and right sides of the sheet suggest that it may once have been nailed to a backing panel. The surface has been varnished, indicating that the drawing may have been framed and displayed (unglazed) at some stage.

Provenance: presumably King George III (Inventory A, p.59: *Titiano, Paolo Veronese & Scuola Veneziana*, p.1. 'Giovan Bellino'.)

(P&W 2*; RL 12800)

9 ALVISE VIVARINI (c.1445–1503/5)

Design for an altarpiece

Pen with brown ink, wash, and stylus. 345 × 250 mm (irregular)

This drawing is a rare instance of the survival of a design for a fifteenth-century altarpiece. It is likely that it was prepared for the patron's approval. The study is also of interest because it (apparently) shows the intended design for the outer frame, in which the actual architecture would have matched and completed the fictive architectural setting of the painting. Such a concept, in the form of a *sacra conversazione,* was very popular in Venice by the end of the fifteenth century (e.g. Giovanni Bellini's *S. Giobbe Altarpiece*). The architectural content of this drawing is particularly close to that in Alvise Vivarini's *St Ambrose Altarpiece* (Venice, Frari), and also to the earlier of the two Berlin altarpieces (c.1490; see J. Steer, *Alvise Vivarini,* Cambridge, 1982, cat.36, pl.46; cat.8, pl.29; for this drawing see cat.44, pl.47 and pp.170–1). That altarpiece, which has not survived, was described by Cicognara in 1817 as still in 'una magnifica cornice indorata, ed incisa elegantemente da Christoforo da Ferrara uniformandosi nella Architettura alla pittura del quadro' (a magnificent gilt frame, elegantly carved by Cristoforo da Ferrara, which was united with the painted architecture of the altarpiece). The saints in the present drawing cannot all positively be identified. It appears to show St John the Baptist and St Jerome to the left, and St Mark and St Sebastian to the right.

Provenance: see under No. 2

(P&W 31*; RL 069)

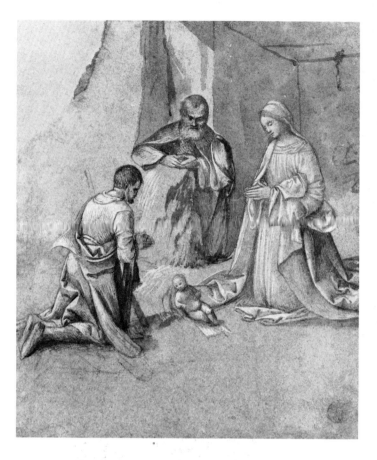

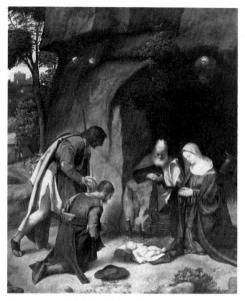

10 GIORGIONE (c.1478–1510)

The Adoration of the Shepherds

Drawn with point of brush in brown, grey and white, with extensive use of wash in the background, over black chalk, on blue paper. 227 × 194 mm. (A large triangular area in the top left corner is a modern insertion.)

The exact nature of the relationship between this drawing and the Allendale *Nativity* (Washington, National Gallery of Art), with which it has obvious connections, has been much discussed. While the individual figures are very close indeed to those in the painting, their spatial relationships are different, as is the position of the Christ Child. In the drawing there is more space between the Virgin and St Joseph, and less between St Joseph and the kneeling shepherd, than there is in the painting; the second (standing) shepherd is omitted from the drawing. In view of these differences it would seem unlikely that this drawing is a copy of the painting. The style of draughtsmanship and the blue paper employed are typical products of a Venetian workshop in the first decade of the sixteenth century. After the previous drawings in this exhibition the present one is notable for its very distinct handling of the paint, and its poverty of draughtsmanship. The placing of the figures in a geometrically created space has hardly been attempted. As in the finished painting, the individual drawn lines are less important than the overall impression created by light and shade and (in the painting) by colour.

In the apparent absence of other drawings indubitably from Giorgione's hand, it is difficult to be certain about the attribution. Most recently, Konrad Oberhuber has described this drawing as a preparatory study for the painting (*Disegni di Tiziano e della sua cerchia*, exh. cat., Fondazione Giorgio Cini, Venice, 1976, No. 1), while Johannes Wilde considered it 'the only drawing which can be attributed with some degree of certainty to Giorgione' (*Drawings by Michelangelo, Raphael and Leonardo*, The Queen's Gallery, London, 1972–3, No. 98).

Provenance: King George III (Inventory A, p.14: *Albert Durer e Maestri Antichi Div.*[si], No. 9. 'Virgin Mary, Joseph & one Shepherd [adoring at the Nativity of Christ]')

(P&W 343*; RL 12803)

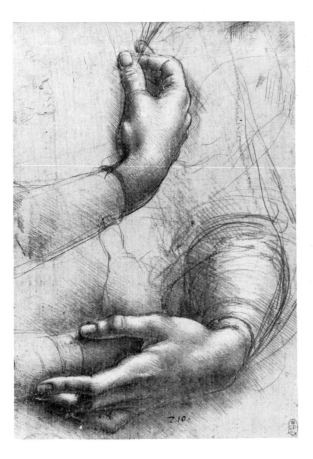

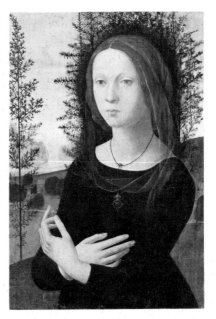

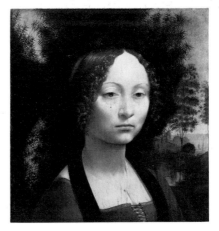

LORENZO DI CREDI, *Unknown Woman* (New York, Metropolitan Museum of Art, Bequest of Richard de Wolfe Brixey, 1943)

LEONARDO DA VINCI, *Ginevra dei Benci* (Washington, National Gallery of Art, Ailsa Mellon Bruce Fund)

11 LEONARDO DA VINCI (1452–1519)

Studies of arms and hands

Metalpoint, heightened with white, over black chalk, on paper coated with a buff-coloured preparation. 214 × 150 mm

These carefully studied drawings of hands can be dated by their technique to between c.1475 and c.1490, at which time Leonardo produced a large number of drawings in metalpoint on paper coated with chalky preparations of various colours. The long, thin hands and fingers are similar to those in the sculptures of Leonardo's master, Andrea Verrocchio, and in Leonardo's Uffizi *Annunciation*.

The present drawing has been related to the portrait of Ginevra dei Benci, painted c.1478 (Washington, National Gallery of Art). The painting has evidently been cut down at the base to above the level originally occupied by the arms and hands. Some indication of the original position of the hands may be found in a portrait of an unknown lady by Leonardo's disciple, Lorenzo di Credi (New York, Metropolitan Museum of Art). The sitter in this portrait, as in the Washington picture, is painted in front of a juniper bush ('ginevra' in Italian), and may therefore be another Ginevra. It has been suggested that she may be identified with Ginevra di Giovanni di Niccolò, a goldsmith's daughter, who married Lorenzo di Credi's elder brother Carlo and is mentioned in the painter's will. In the New York portrait the hands are crossed at waist level. The sitter's left hand is raised to hold a ring, in the same way that the right hand is raised to hold the edge of the bodice in Leonardo's drawing: the gesture is merely reversed.

The small grotesque profile top left is typical of Leonardo's apparently absent-minded additions to his drawings, although the context of the addition is seldom more inappropriate than here.

Provenance: Francesco Melzi; Pompeo Leoni; Thomas Howard, Earl of Arundel; (?) King Charles I; Royal Collection since 1690 at least

(C&P; RL 12558)

12 LEONARDO

Head of St Anne

Black chalk, and some black ink applied with brush (?),
with red chalk off-setting. 187 × 129 mm

A preparatory study for the head of St Anne in
Leonardo's painting, *The Virgin and Child and St Anne*
(Paris, Louvre), of c.1510. A comparison between the
drawing and the painting 'shows how much Leonardo
regularised features in his pictures to attain his ideal of
beauty and perfection, losing thereby something of
freshness and humanity. The drawing has human
mystery, the painting artificial. The head-dress is altered
in the picture being made less horizontal in order to carry
out the rhythm of the pyramidal composition' (C&P, I,
p.96).

Provenance: see under No. 11. King George III (Inventory A, p.23: *Leonardo da Vinci, TOM.I,* No.2. 'A Woman's
Head. Chalk mix'd with crayon')

(C&P; RL 12533)

LEONARDO DA VINCI, *Virgin and Child and St Anne* (detail; Paris, Louvre)

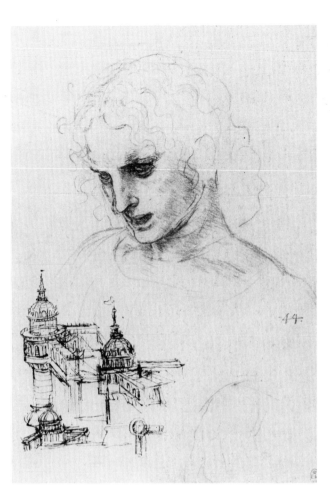

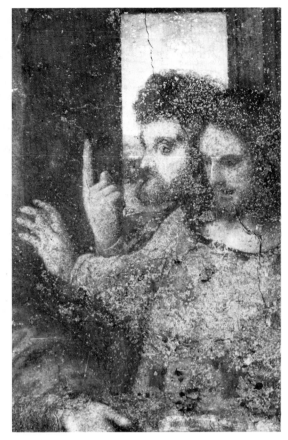

LEONARDO DA VINCI, *Last Supper* (detail; Milan, Convent of S. Maria delle Grazie, Refectory)

3 LEONARDO

St James the Greater

Red chalk and pen and ink. 250 × 170 mm

Watermark: Briquet 6560 (1473)

A preliminary study for the figure seated at Christ's left hand in Leonardo's mural painting of the *Last Supper* in the refectory of the convent of S. Maria delle Grazie, Milan. This work was commissioned from Leonardo by Ludovico Sforza c.1495, and was complete by 1498.

The figure of St James in the painting follows that in the drawing in most essentials. However, the Apostle is shown slightly older in the painting and his left hand, which is raised and with its back turned to the viewer in the drawing, is transformed to an open gesture of shock and wonderment in the painting. The same emotion, following Christ's announcement of the coming betrayal, pervades the facial features, as aptly described by Goethe: 'James the Elder draws back, from terror, spreads his arms, gazes, his head bent down, like one who imagines that he already sees with his eyes those dreadful things which he hears with his ears.'

The architectural study lower left shows (from various angles) the domed corner tower of a high walled structure, presumably a castle. While at work on the *Last Supper* Leonardo was involved in various architectural projects for the Sforza family in and around Milan, to which this study is doubtless related.

Provenance: see under No. 11. King George III (Inventory A, p.23: *Leonardo da Vinci, TOM.I,* No. 10. 'Study of a Mans Head. great expression of horror. Red Chalk. Slight sketch of a Building, on same paper. With a pen.')

(*L.S.*, No. 10; C&P; RL 12552)

14 LEONARDO

Figure in masquerade costume

Black chalk, pen with black and brown ink, and wash.
270 × 181 mm

Drawing of, or design for, a figure in elaborate masquerading costume. Leonardo is known to have designed such costumes in Milan in the 1490s, but the style of draughtsmanship and the coarse paper are typical of the artist's very late work, of c.1513 or even later. This drawing, and a related study of a horseman (RL 12574), have convincingly been connected to a passage in Vasari's life of Pontormo regarding the visit of the Medici Pope Leo X to Florence in 1513, and to Landucci's account of the same Pope's entry to Florence in 1515, when 'Andandogli incontro . . . circa 50 giovani, pure de' piu ricchi e principali, tutti vestiti a una livrea di veste di drappi pagonazze, con vai al collo, a piede, con certe asticciole in mano darientate, molto bella cosa; e poi grandissima cavalleria a cavallo' (Going to meet him [there were] around 50 youths on foot from the most rich and principal [families], all uniformly dressed in purple tunics, with squirrel fur at the neck, holding short staffs. [It was] a very beautiful thing. The youths were followed by a large number of riders).

Provenance: see under No. 11

(C&P; RL 12575)

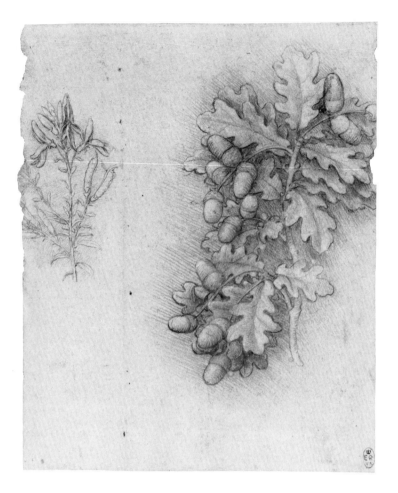

5 LEONARDO

A small oak branch, with a spray of dyer's greenweed

Red chalk with touches of white heightening on paper coated with an orange preparation. 188 × 153 mm

This is one of a group of botanical studies by Leonardo in the Royal Collection, which is now generally dated to the first decade of the sixteenth century and related to the artist's work on the two lost *Leda* compositions. Earlier studies of plants appear in Paris MS. B of c.1487–90.

The technique, red chalk on red paper, is used for three other drawings in this series, of berries (RL 12419–21). It is first seen in Leonardo's studies for the *Last Supper* in the 1490s, and was later used extensively in a series of landscape studies of c.1510 (RL 12410–16). The red coating of the paper acts as a middle ground, on to which highlights are applied with white heightening (some of which must have disappeared with time), and shadow by parallel lines of chalk hatching. It has recently been suggested that the outline of the leaves and acorns was reinforced by Leonardo's pupil and heir, Francesco Melzi.

This sheet was evidently once part of a notebook, and would have been folded down the vertical line to left of centre. Two stitching holes are still visible towards the upper edge, and one towards the lower. These and other botanical studies must have been gathered together by Leonardo for use as incidental details in his paintings. But Leonardo, with his acute powers of observation, would also have been interested to preserve the studies as records of the different types, textures and growth patterns of the plants involved. The spray on the left of the present sheet is set out more in the manner of a botanical specimen than as an inconspicuous detail for a painting.

Provenance: see under No. 11. King George III (Inventory A, p.40; *Leonardo da Vinci*, [the Leoni volume,] pp.206–9. 'various Neat Botanical Studys of Trees, Flowers, & Aquatic Plants. Pen & Red Chalk')

(*N.S.*, No. 15; C&P; RL 12422)

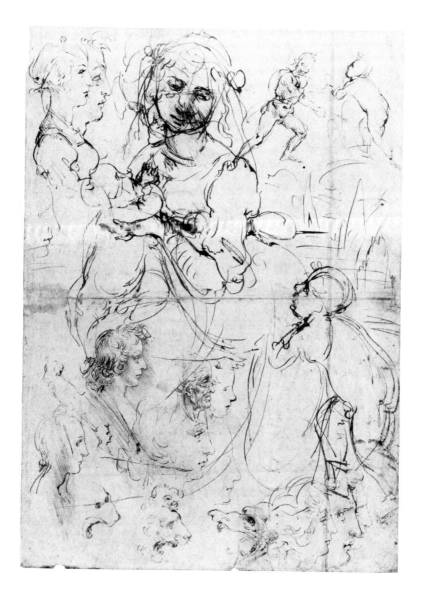

16 LEONARDO

Sheet of studies with the Virgin and Child and St John

Pen and brown ink. 404 × 291 mm
VERSO: *Male and female head studies.* Pen and brown ink
Watermark: close to Briquet 5910 (Florence, 1473–4)

The main subject on this sheet is the half-kneeling figure of the Virgin, with the Christ Child seated on her raised right knee and turning to feed from her breast, while the child Baptist looks on from the right. The Virgin's head is shown in two positions, the first more intimately looking at the Christ Child, the second more assertively gazing towards the Baptist. In the first position the Madonna's

features are close to types depicted by Leonardo's master Verrocchio. The main group on this sheet appears to have been the first statement of the typical triangular (or pyramidal) grouping of the Virgin and Child so much favoured by the High Renaissance artists, including Leonardo himself. There are also analogies between the Virgin and Child in this drawing and in several of Raphael's paintings (in particular the *Belle Jardinière*) dating from the first decade of the sixteenth century. To the right of and behind the main group, Leonardo has drawn the bare essentials of a landscape motif much used by him: flat plains stretching to craggy mountains.

Before discarding the sheet, Leonardo covered it with a number of profiles, both male and female, of all ages. Although they often have the appearance of mere

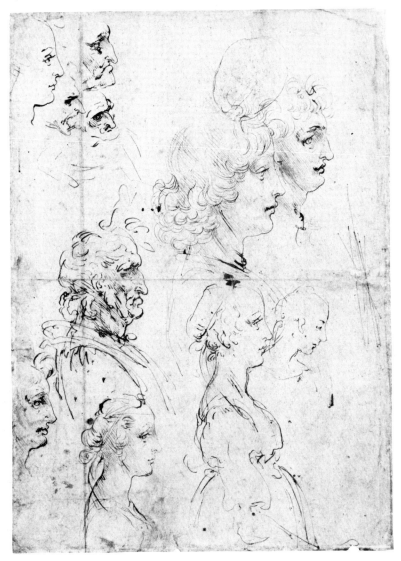

CAT. 16 *verso*

doodles, they have an ideal and sometimes an *all'antica* nature. Similar examples can be found in Leonardo's drawings throughout his life. The studies of animals' heads look forward to those drawn at the time of the Anghiari cartoon.

The pen and ink drawing technique, combining very fine diagonal hatching in the lower profiles with a free sweep of the pen in the main figures, and the style of handwriting on the *verso*, suggest a date c.1480. This sheet is somewhat smaller and probably slightly earlier than the so-called 'Theme Sheet' (RL 12283), which has a similar variety of studies. The repaired vertical cut parallel to the right edge suggests that the sheet may once have narrowly escaped a radical trimming operation. The horizontal line across the centre of the page is an old fold.

Provenance: see under No. 11. King George III (Inventory A, p.24: *Leonardo da Vinci, TOM.I*, No. 26. 'This page is entirely fill'd with an amazing flow of imagination, first a design for a Virgin & Child sucking, a young St John. Two sketches a Man and the Child St John. Thirteen profiles. Two Lyons Heads and a Dragon. On the back of the same are Eleven different characters of Heads. With a Pen.')

(C&P; RL 12276)

CAT. 17 *verso*

17 LEONARDO

A copse of trees

Red chalk. 194 × 153 mm

VERSO: *A single tree with notes.* Red chalk

This page demonstrates the extraordinary control which Leonardo had over the drawn line, whether using metalpoint, pen and ink, or chalk. Red chalk was a favourite medium of the High Renaissance artists, because of its aptitude in describing sculptural curves, and in depicting three-dimensional surfaces without excessive cross-hatching. It was already used by Leonardo in the 1480s but for the first time on a large scale for his studies for the *Last Supper* (e.g. No. 13), painted in Milan in the 1490s. Leonardo's employment of red chalk in this drawing (which appears to date from

c.1500), was unusual, for it is here used with a fineness of line usually found in pen drawings. The chalk point must have been very frequently resharpened to achieve this effect. The successful delineation on such a small scale of a number of different trees, with a variety of forms of foliage, ranging back into space, is quite extraordinary.

The purpose of this study is not known. On the *verso* Leonardo has isolated a single tree and commented below about trees and their foliage in relation to light and shade. This may suggest some connection with the planned Treatise on Painting, and in particular the discussion of Shadow and Light therein, on which Leonardo was working in 1490.

Provenance: see under No. 15

(*N.S.*, No. 7A; C&P; RL 12431r)

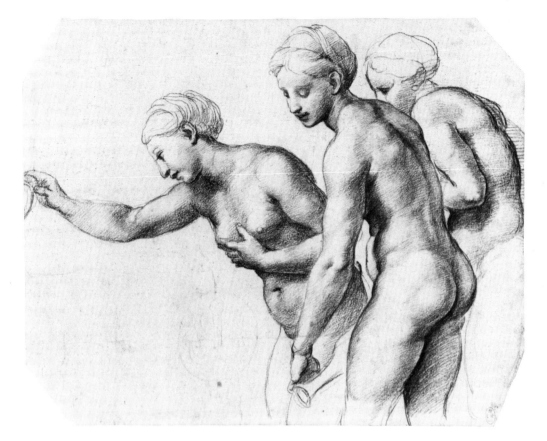

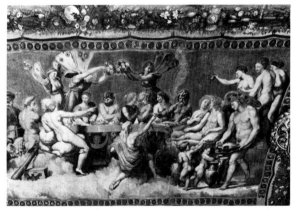

RAPHAEL, *Wedding Feast of Cupid and Psyche* (detail: Rome, Villa Farnesina)

8 RAPHAEL (1483–1520)

The Three Graces (PLATE VIII)

Red chalk with some use of stylus. 204 × 258 mm (irregular)

Watermark: close to Briquet 481 (Arnoldstein, 1510–14)

Study for the group of Three Graces in the right background of the ceiling fresco of the *Wedding Feast of Cupid and Psyche* in the loggia of the Roman villa of Agostino Chigi (now known as the Villa Farnesina). Raphael's decoration of the newly completed loggia was unveiled at the end of 1518. By this stage of his career, his two principal assistants, Giulio Romano and Giovanni Francesco Penni, were active both in the preparatory work and in the execution of their master's numerous commissions. This drawing has from time to time been attributed to Raphael's studio, but recent re-examination has inclined to the view that it is by the master himself. The high quality of the drawing and modelling in areas such as the head of the central figure, together with the use of stylus (particularly noticeable in the back of the right-hand figure), a hallmark of Raphael's drawings, must surely determine the issue.

There is an early offset of this sheet in the Devonshire collection at Chatsworth. This was probably taken and reworked by Raphael himself, and includes rather more of the figures' legs than is shown here suggesting that the present sheet has been trimmed.

One of Michelangelo's drawings in the British Museum for the Sistine ceiling (*BM Michelangelo*, No. 23) is on paper with an identical watermark to the present sheet.

Provenance: King George III (Inventory A, p.51: *Raffaello d'Urbino e Scuola*, p.28. 'The Three Graces. Studys, in the Cupid & Psyche. Red chalk.')

(P&W 804*; *BM Raphael*, No. 162; RL 12754)

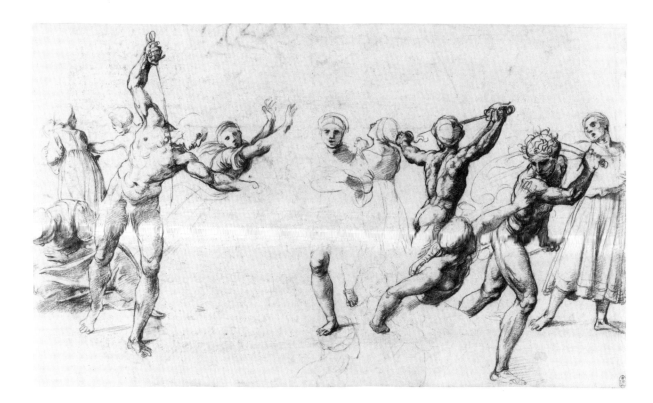

19 RAPHAEL

The Massacre of the Innocents

Red chalk over underdrawing in stylus and black chalk, and pounced dots. 245 × 413 mm

VERSO: *Design for a plate with marine deities.* Pen and brown ink

Watermark: close to Briquet 13884 (Rome, 1501)

CAT. 19 *verso*

The peculiar technique and appearance of this drawing demonstrate one of the many methods employed by Raphael when producing his preparatory designs. The 'father' of the present sheet is a similar (unfinished) one in pen and ink, in the British Museum (*BM Raphael*, No. 122). The outlines of the main figure in that drawing were pricked, and black chalk dust was blown through the pin holes, thus transferring the outlines on to the present sheet. First black chalk and stylus were used to join the dots and briefly reconstruct the composition; then selected areas were worked over in much greater detail, with clothing and some additional figures introduced, in red chalk. The present drawing occupies a transitional stage in the development of the design, prior to what appears to be the completed compositional study (in Budapest), that was passed to the engraver Marcantonio Raimondi for translation into the print (Bartsch XIV, p.19, No. 18). In the entry for this drawing in the Windsor catalogue, Popham observed that it was 'unlikely that a design so elaborately studied was originally intended merely for the engraver'. Recent studies on the fine prints of the Italian Renaissance tend to

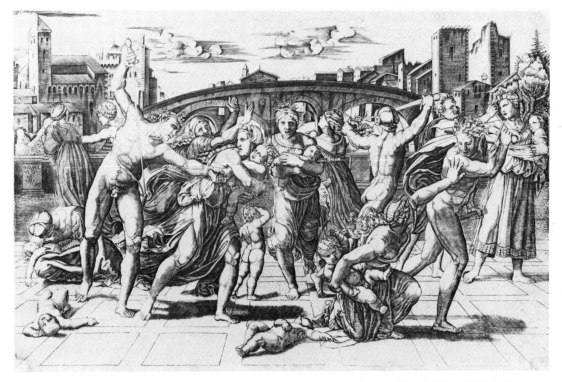

Early copy of MARCANTONIO RAIMONDI's engraving, *The Massacre of the Innocents*, after RAPHAEL (Bartsch XIV, p. 20, No. 18A)

suggest the opposite. No record of any painted version of the *Massacre* by Raphael has survived.

It has been suggested that the drawing on the *verso* may be connected with the two bronze *tondi* commissioned by Agostino Chigi from the goldsmith Cesare Rossetti (Cesarino of Perugia), decorated in relief to a design by Raphael, for which an advance payment was made in November 1510. However, the decoration for that project is specified as being 'cum pluribus floribus' (with many flowers), while the *verso* design here includes marine deities instead.

Nevertheless, a date c.1510/11 for the various drawings connected with the *Massacre* is supported by the appearance of preparatory designs for the Stanza della Segnatura, on which Raphael was working at this time,

on the *verso* of studies for the *Massacre* in the Albertina, Vienna. The fact that a drawing for the ceiling of this Stanza (*Poesia*, see No. 21 below) was carried out on a sheet of paper with the same watermark as a design for the *Massacre* (No. 19), adds support to this argument.

Provenance: Bonfiglioli Collection, Bologna (1719: Richardson); Consul Joseph Smith; King George III (Inventory A, p.51: *Raffaello d'Urbino e Scuola*, p.29. 'The Composition of the Murder of the Innocents. Engrav'd by M:Antonio. Some of the figures masterly drawn in Red Chalk, but near half left with a bare outline. Both of these Red Chalk Drawings have the appearance of Originals.' [the other is No. 18, above].)

(P&W 793 *recto**; *BM Raphael*, No. 123; RL 12737 *recto*)

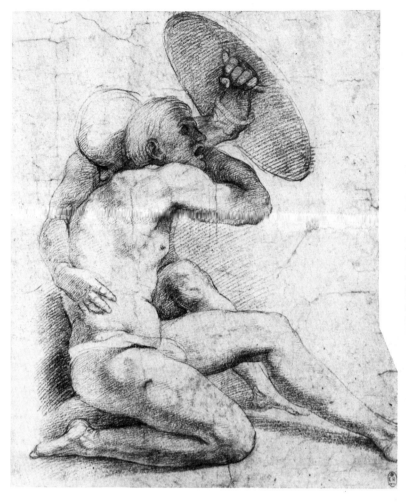

RAPHAEL, *The Resurrection* (Bayonne, Musée Bonnat)

20 RAPHAEL

Warriors protecting themselves with a shield

Black chalk. 267 × 224 mm (irregular)

Watermark: close to Briquet 746 (Lucca, 1469–73)

This is one of a number of studies by Raphael for an altarpiece of the *Resurrection,* for which no documentary evidence whatsoever appears to have survived. However, Michael Hirst has shown convincingly that it was to be the central element of the Chigi Chapel in the church of S. Maria della Pace, Rome, in which Raphael's frescoed Sibyls and Prophets still adorn the entrance wall. (M. Hirst, 'The Chigi Chapel in S. Maria della Pace', *JWCI,* XXIV, 1961, pp.178ff.)

The *Resurrection* drawings appear to date from c.1513–14. However, the painting was evidently unfinished at the time of Raphael's death (and that of his patron five days later), and was eventually re-ordered in 1530 from Sebastiano del Piombo. Although Michelangelo supplied Sebastiano with preparatory studies (see No. 25 below), the commission remained unexecuted.

The figures in the present drawing were presumably intended to occupy the left foreground of the finished composition, holding the shield to hide their eyes from the blinding supernatural light emanating from the Risen Christ. The effect of the light would have been intensified because Raphael apparently intended to paint the *Resurrection* as a nocturnal scene.

There is an important compositional study for the *Resurrection* at Bayonne, and two minor ones exist in the Ashmolean (*BM Raphael,* Nos. 166 and 167). In addition there is a group of six large-scale finished drawings in black chalk of particular figures, to which the present drawing, and another at Windsor (P&W 799; *BM Raphael,* No. 170) belong.

Various elements of the *Resurrection* were re-used by Raphael in his frescoes in the Stanza d'Eliodoro in the Vatican, on which he was working c.1511–14, at around the same time as his studies for the *Resurrection* altarpiece.

Provenance: King George III (Inventory A, p.51: *Raffaello d'Urbino e Scuola,* p.32. 'Two soldiers, surprised or astonished. A study of part of the Groupe in the Resurection.')

(P&W 798*; *BM Raphael,* No. 168; RL 12736)

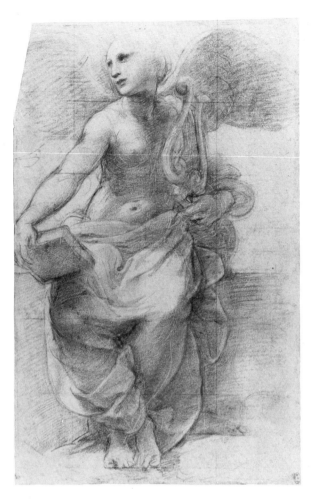

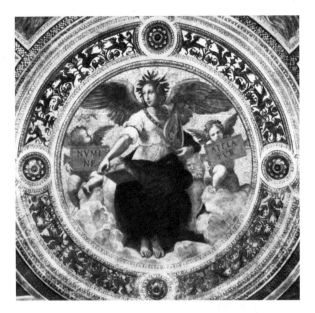

RAPHAEL, *Poetry* (Rome, Vatican Palace, Stanza della Segnatura, ceiling)

21 RAPHAEL

Study for the Figure of Poetry

Black chalk over stylus, squared for transfer.
360 × 226 mm

Watermark: close to Briquet 13884 (Rome, 1501)

A detailed study for the figure symbolising Poetry in the vault of the Stanza della Segnatura in the Vatican. The four roundels in the vault (Theology, Justice, Philosophy and Poetry) continue the subject-matter of the frescoes on the walls below. The vault paintings appear to be stylistically rather later than those of the walls, and may (unusually) have been carried out after the completion of the latter, c.1511.

The technique is typical of Raphael's drawings. The outline of the figure was first drawn, unclothed, in stylus. The drapery was then added in black chalk (through which the stylus lines are clearly visible), and minor adjustments were made to the position of the figure. The finished drawing was then squared for enlargement on to a series of actual-size cartoons, and for transfer to the surface to be painted.

The pose of the painted figure of Poetry is identical to that in the drawing, although more clothing was added for the painting, and the face was slightly altered. The face in the drawing is very similar to that of Eve in the *Temptation* scene elsewhere in the same ceiling, and of St Catherine in the painting in the National Gallery, London.

Provenance: [King Charles I; Kensington Inventory;] King George III (Inventory A, p.49; *Raffaello d'Urbino e scuole*, p.7. 'Emblem of Inspiration, wrote Numine Afflatur; Painted in a Compartment of a Ceiling in the Vatican. This is from Kensington')

(P&W 792*; *BM Raphael*, No. 110; RL 12734)

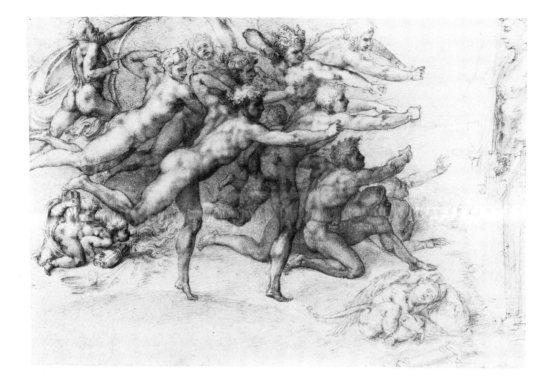

22 MICHELANGELO (1475–1564)

Archers shooting at a herm

Red chalk, with some stumping. 219 × 322 mm

VERSO inscribed in two hands, in pen and ink: (i) D. Giulio Clouio copia di / Michiel Angeli (Don Giulio Clovio copy of Michelangelo); (ii) andrea quaratesi venne · quj adi / 12 · di ap[r]ile · 1530 · edebbe [*α io*] *p* man[d]/are · asno · padre · apisa (Andrea Quaratesi came here on 12 April and had ten ducats to send to our father in Pisa)

Watermark: close to Briquet 748 (Rome, 1505)

A superb example of the type of highly finished drawings in which Michelangelo excelled, and which appear to have been made as presentation pieces and works of art in their own right. It was described as follows by Wilde in the Windsor catalogue: 'The gradations of light and shade are infinite. The figures on the left which are exposed to the full light show the same fineness of surface modelling as the highly polished statues of *Night* and *Dawn* in the Medici Chapel.' The subject and meaning of the present drawing, featuring male and female archers without bows, their arrows aimed at a target term, can still only be guessed at; it was presumably inspired by a classical model, whether literary or artistic. The *Volta Dorata* of the Golden House of Nero in Rome, which was well known to artists during Michelangelo's lifetime, contained a stucco showing (in reverse) a similar scene to that depicted by Michelangelo.

In spite of the first inscription on the *verso*, the drawing is surely an autograph work by Michelangelo rather than a copy by Giulio Clovio, in whose collection it may once

have been (see No. 1 above). Clovio was an admirer, collector and copyist of Michelangelo's drawings. Among his other works at Windsor are a careful red and black chalk copy of Michelangelo's design of *The Flagellation* (P&W 451), and a black chalk copy of the *Tityus* (P&W 459). The Windsor *Rape of Ganymede* (P&W 457) is now also firmly attributed to Clovio (see P&W*). A copy of the present drawing by Bernardino Cesari (brother of the Cavalier d'Arpino) at Windsor (P&W 456), records the appearance of the original composition before the edges were cut; a number of sixteenth-century engravings of the composition also exist.

The inscription on the *verso* of the present drawing is the draft memorandum, made by a member of Michelangelo's household, of a financial transaction involving the transfer of ten ducats from Michelangelo and his brothers in Florence to their aged father, who was resident in Pisa during the siege of Florence by Imperial troops in 1529/30. The transaction was made through the good services of the banker Rinierio Quaratesi, who was also resident in Pisa at the time. Michelangelo's portrait of Riniero's son, Andrea, whom the artist particularly admired, is in the British Museum (*BM Michelangelo*, No. 119).

Provenance: [Giulio Clovio; Cardinal Alessandro Farnese;] King George III (Inventory A, p.45: *Mich:Angelo Buonaroti, TOM.II.*, p.2. 'Men and Women suspended in the Air and Shooting Arrows at a Target fixed on a Term. Cupid a sleep and two Boys burning his Arrows – This Emblematical Subject is painted in a Villa call'd Raphael's near the Walls of Rome. Red Chalk.')

(P&W 424*; *BM Michelangelo*, No. 127; RL 12778)

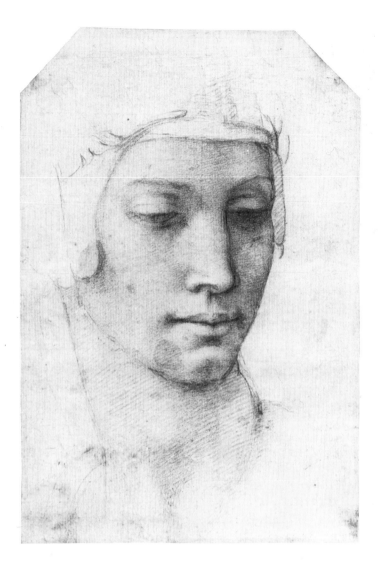

CAT. 23 *verso*

23 MICHELANGELO

Head of a young woman (COVER ILLUSTRATION)

Black chalk, with some stumping. 208 × 142 mm (irregular)

VERSO: *Head of a Young Woman*. Black chalk. Inscribed (by Richard Gibson) in brown ink: MAngolo · 1 · 4

Although unfinished in the headdress and shoulders, and somewhat defaced by stains, the facial features in this drawing are modelled with the same high degree of finish as are the presentation drawings made by Michelangelo as gifts to his particular friends, from c.1530. Vasari mentions that Michelangelo drew a number of *teste divine*, of which this drawing may have been one, as gifts for Tommaso de' Cavalieri.

The female type shown here occurs in Florentine art (typically in paintings by Bronzino) from c.1540. A date in the early 1540s was suggested by Wilde, who finally accepted the drawing on the *verso* (which is a slight version of the drawing on the *recto*) as autograph.

Provenance: Richard Gibson; King George III (Inventory A, p.43: *Mich:Angelo Buonarroti, TOM.I*, p.2. 'Woman's Head. Black chalk.')

(P&W 434*; *BM Michelangelo*, No. 130; RL 12764)

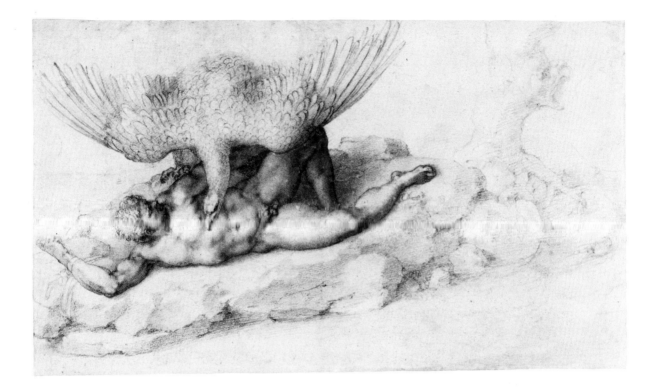

24 MICHELANGELO

Tityus

Black chalk with stumping. 190 × 329 mm

VERSO: *The Risen Christ.* Black chalk

According to Greek mythology the giant Tityus was slain by Apollo and Artemis for offering violence to their mother Leto. Odysseus saw him bound in Hades, while vultures tore at his liver.

Vasari records that Michelangelo made a drawing of *Tityus* for his friend, Tommaso de' Cavalieri. Other surviving drawings destined for the same recipient are the *Fall of Phaethon* (P&W 430), the *Children's Bacchanal* (P&W 431), and what may be one of the *teste divine* (P&W 434, No. 23 above). Each of these incorporates draughtsmanship of a very highly finished nature, quite unknown in drawing before this date. These subjects were frequently engraved during Michelangelo's lifetime.

The *Tityus* was apparently made as a pendant to the lost drawing of *Ganymede* (cf. P&W 457): both compositions incorporate a male nude and a large bird, in the case of

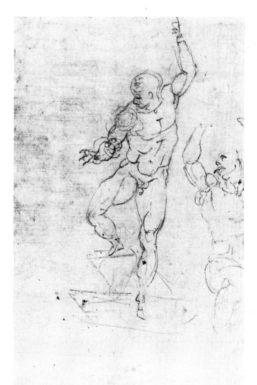

CAT. 24 *verso*

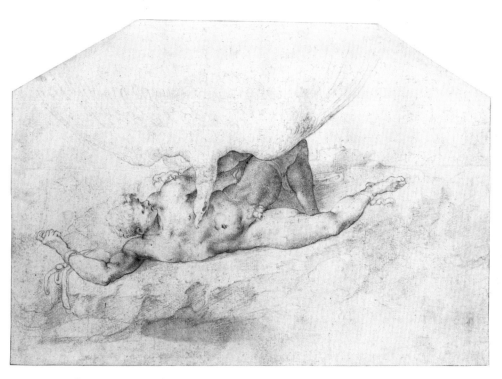

Tityus a vulture, of *Ganymede* an eagle. A further somewhat surprising connection is suggested by the drawing of the Risen Christ on the *verso* of the present sheet, which by turning the page through 90° exactly translates the outlines of the recumbent figure of *Tityus* into the standing figure of the resurrected Christ. The *verso* is thus one of a group of drawings connected with Michelangelo's studies for Sebastiano's commission (received in 1530) to paint an altarpiece of the *Resurrection* for the Chigi Chapel in S. Maria della Pace, Rome. Raphael was still working on this project c.1513–14, but it remained unfinished at the time of his death in 1530 (see No. 20 above).

Michelangelo first met Cavalieri in the autumn or winter of 1532. Shortly before the end of the year the artist wrote for the first time to his young friend, who was ill at the time, enclosing two drawings with his letter. In his reply, dated New Year's Day 1533, Cavalieri wrote that the more he studied the two drawings (which he did for two hours daily), the more they pleased him. It is very likely that the two drawings were *Ganymede* and *Tityus*. Panofsky has explained the additional allegorical interpretations of the subject which were doubtless self-evident to both artist and recipient. 'The Ganymede, ascending to heaven on the wings of an eagle, symbolizes the ecstasy of Platonic love, powerful to the point of annihilation, but freeing the soul from its physical bondages and carrying it to a sphere of Olympian bliss. Tityus, tortured in Hades by a vulture, symbolizes the agonies of sensual passion, enslaving the soul and debasing it even beneath its normal terrestrial state. Taken together the two drawings might be called the Michelangelesque version of the theme ''Amor sacro e profano'' ' (E. Panofsky, *Studies in Iconology*, New York, 1939, p.218). Both compositions were much copied in engravings, in cameos, and in drawings. There are two sixteenth-century copies of *Tityus* at Windsor (P&W 458 and 459), of which the latter is by Giulio Clovio.

Provenance: given by Michelangelo to Tommaso de' Cavalieri; Cardinal Alessandro Farnese: King George III (Inventory A, p.45: *Mich: Angelo Buonaroti, TOM. II.*, p.6. 'Prometheus. [Black chalk]')

(P&W 429*; *BM Michelangelo*, No. 123; RL 12771 *recto*)

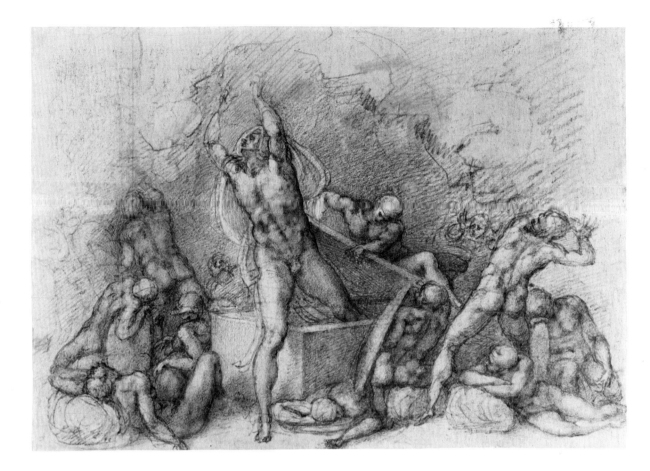

25 MICHELANGELO

The Resurrection

Black chalk with red chalk off-setting. 239 × 344 mm

VERSO: *Studies of a shoulder.* Black chalk. Inscribed in pen and brown ink: D. Giulio Clouio –

One of a large number of studies for a *Resurrection* composition by Michelangelo. The pose of the principal figures is here reversed from that on the *verso* of *Tityus* (see No. 24 above); the position of the legs of the resurrected Christ thus now exactly copies that of the recumbent Tityus. Michael Hirst has convincingly connected both Michelangelo's and Raphael's *Resurrection* studies to an (unexecuted) altarpiece of the *Resurrection,* which Sebastiano del Piombo was contracted to paint in the Chigi Chapel of S. Maria della Pace, Rome, in a document dated 1st August 1530 (see above No. 20). It is known that Michelangelo supplied Sebastiano with drawings for other commissions in the early 1530s, and it is very probable that he provided the *Resurrection* drawing to help him with this commission. Whether Sebastiano owned the sheet or not, it appears to have passed into the collection of Giulio Clovio at an early date (see *verso* inscription).

Provenance: [Giulio Clovio; Cardinal Alessandro Farnese;] King George III (Inventory A, p.45: *Mich:Angelo Buonaroti. TOM.II,* p.4. 'Resurrection of Christ. Black chalk.')

(P&W 427*; *BM Michelangelo,* No. 46; RL 12767 *recto*)

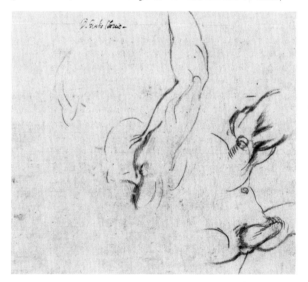

CAT. 25 *verso* (detail)

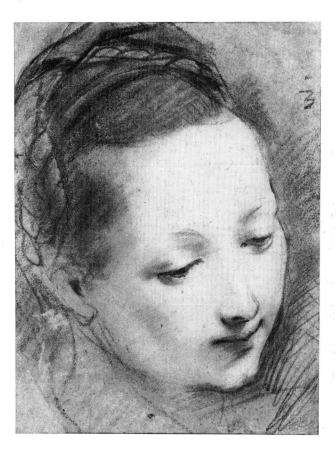

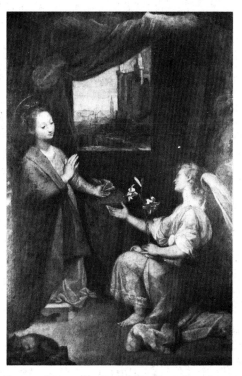

FEDERICO BAROCCI, *The Annunciation* (Rome, Pinacoteca Vaticana)

6 FEDERICO BAROCCI (1526–1612)

Head of the Virgin (PLATE II)

Black, white and coloured chalks on blue-grey paper. 299 × 230 mm (the four corners made up with triangular insertions)

This drawing is a study for the figure of the Virgin in the Vatican *Annunciation* (Rome, Pinacoteca Vaticana), painted between 1582 and 1584 for the Chapel of Francesco Maria II, Duke of Urbino, in the Basilica at Loreto. The stance and angle of the head accord exactly with those in the painting, although the hair style appears to have been somewhat adapted in the finished picture and associated etching. The head, with high forehead, delicate eyebrows and finely chiselled chin, is very typical of Barocci, and is already seen in works such as the *Madonna del Gatto* (London, National Gallery), datable to the mid-1570s.

Other preliminary studies for the painting are preserved in the Uffizi. These include posed male and female nude figures in the position of the Virgin, in black and white chalk. The present drawing (and No. 27) is in a technique much favoured by Barocci for highly-finished head studies. It was described in Lomazzo's *Trattato* of 1585 as 'a pastello', and looks forward to drawings in a similar technique produced in the mid-eighteenth century, in particular by French artists.

Provenance: King George III (Inventory A, p.124: *Frederico Barocci,* among thirteen drawings 'Of Studys of Heads')

(P&W 96*; RL 5231)

AGOSTINO CARRACCI after BAROCCI, *Aeneas and Anchises*

27 BAROCCI

Head of Anchises

Black, white and coloured chalks on blue paper.
375 × 260 mm

This drawing is usually described as a study for the head of Anchises in the second of Barocci's two paintings of *Aeneas and Anchises*, painted for Monsignor Giuliano della Rovere and dated 1598 (Rome, Galleria Borghese). The first version was commissioned by the Emperor Rudolph II and was painted between 1586 and 1589. It was last recorded, in a very poor state of repair, in London in 1800 and may have been destroyed soon after. The appearance of the earlier version, which differed only slightly from the Borghese picture, is known from Agostino Carracci's engraving published in 1595 (Bartsch XVIII, p.99, No. 100), and the preparatory drawing for this now at Windsor (W. 99). In the lost painting, Anchises seems to have been clean-shaven, with a rather lower hair-line. In the Borghese version he is bearded. It has therefore been suggested that this drawing is a finished study for the latter. However, as in both compositions part of the old man's head is masked by the helmet of his son, Aeneas, the matter cannot be easily resolved. It would be surprising if Barocci had returned to the drawing board before painting what was almost an exact replica of an earlier composition. Barocci's study for the head of Ascanius (the boy crouching at Aeneas' feet), in the same technique as the present study, was recently sold at Christie's, London (15 April 1980, lot 20).

Provenance: King George III (Inventory A, p.124: see under No. 26 above)

(P&W 98*; RL 5233)

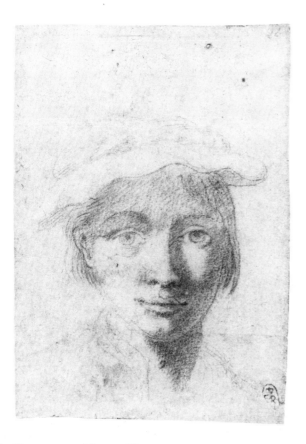

8 FRANCESCO MARIA MAZZOLA
called PARMIGIANINO (1503–40)

Self-portrait

Red chalk. 106 × 75 mm (illustrated actual size)

This tiny drawing is evidently connected with Parmigianino's painted self-portrait, in the Kunsthistorisches Museum, Vienna. Both date from the artist's youth, and the painted portrait is described in some detail by Vasari: 'One day he began to paint himself with the help of a concave barber's mirror ... He set to work to copy everything he saw there, including his own likeness, in the most natural manner imaginable ... Being a handsome man, with the face of an angel rather than a man, his reflection in this ball appeared divine.' Towards the end of Parmigianino's *Vita*, Vasari noted how 'As Francesco still doted on his alchemy, over-powered by its infatuation, he allowed his beard to grow long and disordered, which made him look like a savage instead of a gentleman. He neglected himself and grew melancholy and eccentric, and died aged only 37.' A late (bearded) self-portrait appears on a small sheet of designs for the Steccata, at Chatsworth (Popham 1971, No. 719, pl.343).

The date of this drawing may be calculated by the sitter's age (around 17?), and on the basis of Vasari's assertion that the painted self-portrait was taken to Rome in 1524. The drawing should probably therefore be dated c.1520, and clearly shows the influence of Correggio in the strongly contrasting areas of light and shade.

The provenance of the forty-two Parmigianino drawings at Windsor is uncertain (but see Popham 1971, pp.35–6). Four pocket-books containing drawings (supposedly) by Parmigianino are listed in the 1735 Kensington Inventory. It is very likely that most, if not all, of the Cabinet contents had previously belonged to King Charles I. Popham has shown that the fourth volume, which is the only one of the four of which the binding has not survived at Windsor, and was described in Inventory A as containing '30 drawings in various manners', may have held the majority of the smaller autograph Parmigianino drawings in the Royal Collection. He has also suggested that this volume could have been the one acquired by Duke Ferdinand Gonzaga from Signor Moselli in Verona, and that it could have passed, via Nys, from the Mantuan collection to King Charles I, who is said to have owned drawings by Parmigianino. However, reversed etchings of some of the drawings, including Nos. 30 and 33 (in those cases attributed respectively to Lucas Vorsterman and Hendrik van der Borcht II) survive in the British Museum. These were presumably made when the originals were in the collection of the Earl of Arundel, who is known to have employed these artists (and Wenceslaus Hollar) to produce etched reproductions of his drawings. From internal evidence the other three Windsor pocket-books (illustrated on p. 11 above) are unlikely to have entered the Royal Collection until the early eighteenth century. Other Parmigianino drawings (e.g. P&W 598) are known to have entered the Royal Collection during the reign of King George III. The matter is therefore no less confused than is the case with the drawings by Leonardo at Windsor.

Provenance: [? King Charles I; Kensington Inventory (part of Nos. 20–3);] King George III (Inventory A, p.132: *Four small Pocket Books of Drawings by Parmegiano*.)

(P&W 556; RL 0529)

PARMIGIANINO, *Self-portrait* (Vienna, Kunsthistorisches Museum)

PARMIGIANINO, *Design for the Steccata*
(detail; London, British Museum)

29 PARMIGIANINO

Nude supporting a decorative frame

Pen and brown ink, and wash, heightened with white.
93 × 69 mm (illustrated actual size)

This drawing is related to the decorative scheme in the church of S. Maria della Steccata, Parma, which occupied Parmigianino from 1531 to 1539, the year before his death. According to the contract of May 1531, Parmigianino was to undertake the decoration not only of the eastern apse, but also of the barrel vault, *sottarchi* and other related portions of the eastern area of the church. It was in the latter that Parmigianino's inventive powers were to be encouraged to the full. Around a hundred drawings related to this scheme are known, few of which correspond very closely to the surviving decoration in the Steccata. The figure in this drawing, with his very distinctive twisted pose, appears on an important sheet of studies for the Steccata in the British Museum (Popham 1967, I, No. 125). But whereas in the Windsor drawing he supports (and is supported by) octagonal frames, in the London drawing the frames have become elongated ovals. In the finished scheme this figure appears on a greatly reduced scale, as part of a decorative band framing the two lateral edges of the eastern barrel vault.

This drawing was among a number engraved and published by Conrad Martin Metz in London in 1789 and 1790.

Provenance: see under No. 28

(P&W 590; RL 0549)

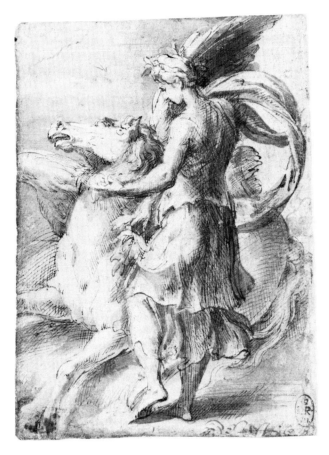

PARMIGIANINO

Philyra and Saturn in the form of a horse

Pen and brown ink, and wash, heightened with white.
111 × 82 mm (illustrated actual size)

VERSO: *Figure of Philyra*, traced through from the *recto*.
Pen and brown ink

In spite of his initial hesitations about identifying this
drawing with the above title (rather than 'Pegasus and a
Muse'), Popham eventually decided in its favour. The
subject was a popular one with Parmigianino, by whom
seven other variants of the theme are known; one of
these is at Windsor (P&W 587). A late dating for the
Philyra drawings is suggested by the fact that studies for
the Steccata appear on the same sheet as a Philyra study
at Chatsworth. It does not appear to have been connec-
ted with any painting, although No. 30 (or the British
Museum drawing) has been reproduced in engravings
and etchings several times. One of these (an etching by
Lucas Vorsterman) was presumably made in the first half
of the seventeenth century while this drawing was in the
collection of Thomas Howard, Earl of Arundel.

Vasari described Parmigianino as having been born
'con i pennelli in mano' (literally 'with brushes in his
hand'). He attributed a number of drawings to the
following incident in Rome, after the troubles of 1527.
'The sum of his [Parmigianino's] discomfort at that time
was that he had to make a quantity of designs in water-
colours and with the pen, which constituted his ransom,
one of the soldiers being very fond of painting.' Over
eight hundred drawings by Parmigianino are known
today.

Provenance: Thomas Howard, Earl of Arundel; see
under No. 28

(P&W 586*; RL 0563)

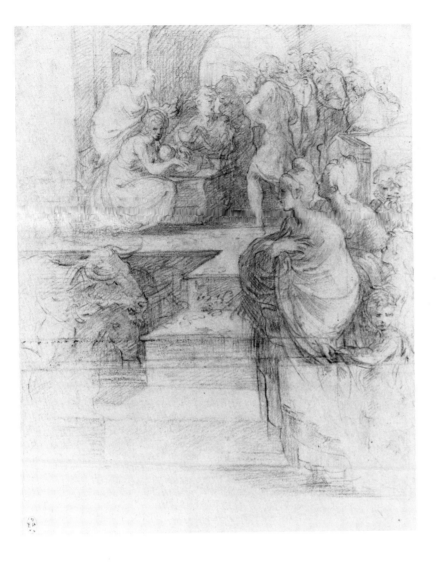

Parmigianino, *Adoration of the Shepherds* (etching; Bartsch XVI, p. 8, No. 3; London, British Museum)

31 Parmigianino

Adoration of the Shepherds

Black chalk. 247 × 198 mm

This drawing is one of a number of preparatory studies for Parmigianino's etching of the *Adoration* (Bartsch XVI, p.8, No. 3). It differs from the others, and from the etching, in showing the foreground figures at full length, and including the ox and the ass in the left foreground. The essential difference, however, is the concentration in the print on the main subject, which is there shown in an enclosed space, with only four shepherds looking on in addition to Mary and Joseph and the unidentified female figure in the right foreground. The proposed trimming lines can still be seen in the drawing, running vertically to the left of the shoulder of the foreground figure, and horizontally at various levels across that figure's body. The lowest of these horizontal lines is a fold in the paper, above which the drawing is worked in considerably more detail, which would suggest that the cut-off point for the

etching was originally to have been rather lower than that finally selected.

Another drawing for the *Adoration* (which has been dated by Popham to Parmigianino's Roman years, 1524–7), is mentioned in the following entry in the inventory of the collection of Alfonso d'Este: 'La nativita di N.S. del *Parmegiano* di lapis nero'. That drawing is likely to have been a more finished piece than the present one.

Provenance: King George III (Inventory A, p.123: *Coreggio Parmegiano &c.*, p.21. 'Birth of Christ & Adoration of the Shepherds. Black Chalk')

(P&W 576; RL 0535)

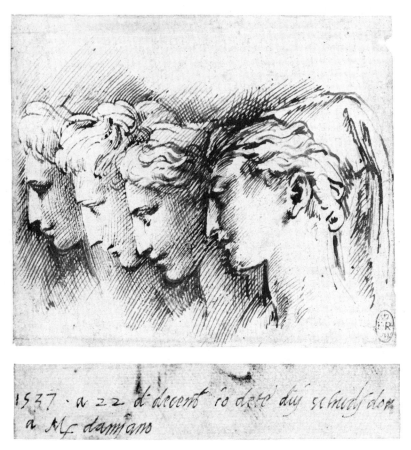

CAT. 32 *verso* (detail)

2 PARMIGIANINO

Four female profiles

Pen and dark brown ink. 88 × 105 mm (illustrated actual size)

VERSO inscribed in pen and brown ink (in the artist's hand): 1537. a 22 di decenb io dete duj schudj dor / a Mf damjano (On 22 December 1537 I gave two gold *scudi* to Messer Damiano)

Both the *verso* inscription and the content of the *recto* associate this sheet with Parmigianino's work at the Steccata in Parma (see No. 29 above). Popham identified the Messer Damiano of the inscription with the architect Damiano de Pleta (born in 1498), who stood surety for Parmigianino's completion of work at Steccata at the time of the new contract of 27 September 1535. Popham likewise suggested that 'The head on the right, to which the others seem to have been added as an afterthought, might well be a study for that of one of the virgins on the right of the vaulting of the Steccata, or a reminiscence of one of these' (P&W). The same scholar later concluded: 'The sheet is probably an example of Parmigianino "doodling" ' (Popham 1971, p.200).

Provenance: see under No. 28

(P&W 601*; RL 0526)

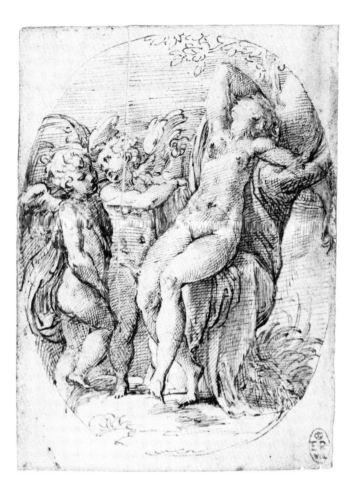

33 PARMIGIANINO

Sleeping Venus with two Amorini

Pen and brown ink and wash. 118 × 78 mm (illustrated
actual size)

Although the style of draughtsmanship appears to be
rather later, it is possible that this sheet is related to
Parmigianino's frescoes in the Rocca Sanvitale at Fon-
tanellato (1523/4) – with the principal theme of Diana
and Actaeon – or to a sheet of studies by Parmigianino in
the Uffizi, entitled *Bathing nymphs with Venus and Cupid*,
and dated by Mr Popham to c.1524–7 (Popham 1971,
No. 74). It may be the design for an (apparently unex-
ecuted) woodcut. The drawing was engraved in reverse
by Hendrik van der Borcht II, presumably while in the
Arundel collection.

Provenance: Thomas Howard, Earl of Arundel; see
under No. 28

(P&W 583; RL 0546)

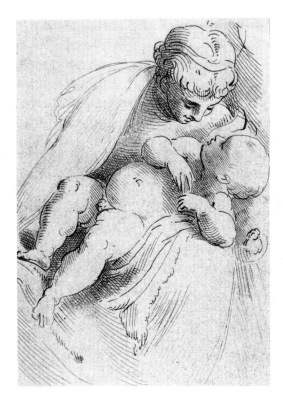

C. M. METZ after PARMIGIANINO, *Virgin and Child* (engraving)

34 PARMIGIANINO

Virgin and Child

Pen and dark brown ink, with faint wash. 108 × 78 mm
(illustrated actual size)

Among Parmigianino's many surviving drawings are a
large number showing the Virgin with the Christ Child,
posed intimately and often drawn (as here) on a very
small scale. Occasionally these compositions, which
were evidently very popular, were translated into print
during the artist's lifetime. Popham has demonstrated
that 'the feeling is very near to that of the midwife
bending over the Infant Christ in Caraglio's engraving of
the *Adoration of the Shepherds* after Parmigianino, dated
1526 (Bartsch XV, p.68, No. 4) and the drawing probably
dates from about that time' (Popham 1971, p.637).
However, the first accurate printed reproduction of the
present drawing appears to have been the late
eighteenth-century engraving by Conrad Martin Metz.

Provenance: see under No. 28

(P&W 569; RL 0568)

35 JACOPO ROBUSTI,
called TINTORETTO (1518–94)

Standing man seen from behind

Black and white chalk on blue paper. 369 × 187 mm

With two drawings in the Uffizi and one (in a very similar technique) in the Princes Gate Collection, this is a study for Tintoretto's great canvas of the *Crucifixion*, now in the Accademia, Venice. It was originally painted for the church of S. Severo, Venice, and has been dated variously from the 1540s to the 1560s. Rossi inclines to a dating of c.1554/5 (P. Rossi, *I Disegni di Tintoretto*, Florence, 1975, p.58).

The figure in this drawing reappears supporting the ladder below Christ's Cross in the centre of the painting.

The vertical lines to left and right of the figure's torso indicate the position of the ladder. While the drawing appears to show the figure well lit, with several highlighted areas, in the painting he is in darkness except for his (now turbaned) head, the dark outline of the figure being silhouetted to dramatic effect against the strongly lit area behind the Cross. A similarly posed (and equally dramatically lit) figure had been very successfully included by Tintoretto as the central protagonist in his painting of *The Miracle of St Mark*, painted for the Scuola Grande di S. Marco in 1548 (now also Venice, Accademia).

Provenance: King George III (Inventory A, p.59: *Scuola Veneziano*, pp.38–43. 'Tintoretto')

(P&W 952*; RL 4823)

PELLEGRINO TIBALDI *Trompe l'oeil* doorway
(Rome, Castel S. Angelo, Sala Paolina)

Left: CAT. 36 *verso*

36 PELLEGRINO TIBALDI (1527–96)

Figures on a staircase

Pen and dark brown ink and wash, over blue chalk, heightened with white, on blue paper. 309 × 142 mm

VERSO: *Staircase with decorated walls.* Pen and brown ink and wash over black chalk, heightened with white

As Oskar Fischel was the first to observe, this is a study for the *trompe l'oeil* doorway on the right of the end wall of the Sala Paolina of the Castel Sant'Angelo in Rome. In 1544 Perino del Vaga was commissioned by Pope Paul III to decorate the state apartments on the top floor of the Castle, but he died in October 1547 leaving unfinished the Sala Paolina, the largest and most important room; its decoration was completed by his assistant, Tibaldi, then aged only 20, who followed his master's general intentions but interpreted them in his own characteristic style (see J. A. Gere, *Burl. Mag.*, CII, 1960, pp.14 ff.; M. Hirst,

Burl. Mag. CVII, 1965, pp.569 ff.; E. Gaudioso, *Gli affreschi di Paolo III at Castel Sant' Angelo,* exh. cat., Rome, 1981–2, particularly No. 106). Popham rightly observed that the present drawing is certainly by Tibaldi, whose violent Michelangelesque style is in contrast to Perino's decorative suavity.

The drawing on the *verso* has only recently been revealed. It is a view of the actual doorway on the left-hand side of the same wall, through which is visible a flight of steps leading to a corridor, and walls covered with Pompeian-style decoration *all'antica*. Tibaldi traced the outlines in reverse on to the *recto*, in order to achieve an exactly symmetrical background for the two figures in his *trompe l'oeil* doorway. The illusionistic effect has been somewhat impaired by the recent mounting of the doorway fresco on to a hinged panel in order to facilitate access to an area of Roman brickwork.

Provenance: presumably King George III

(P&W 943*; RL 5488)

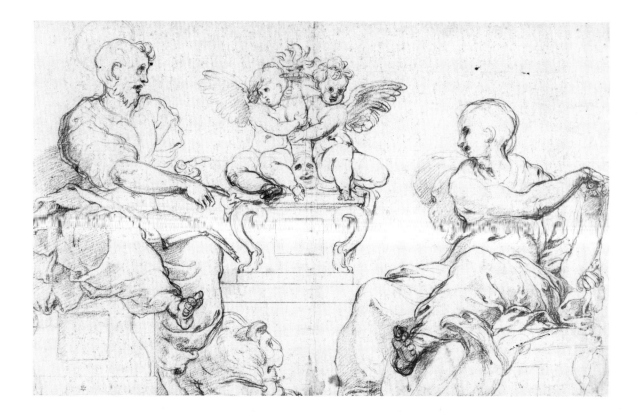

37 PIETRO BUONACCORSI,
called PERINO DEL VAGA (1501-47)

St Mark and St John the Evangelist with child angels
Red chalk, squared for transfer with a stylus. Lower right
corner made up. 318 × 504 mm

Oskar Fischel was the first to point out that this drawing
is a study for the fresco on the vault of the Cappella del
Crocefisso in S. Marcello al Corso, Rome, which Perino
was commissioned to paint in February 1525. According
to Vasari, the work was unfinished when Perino left
Rome at the time of the Sack in 1527, but after his return
in 1539 it was completed, under his supervision, by
Daniele da Volterra, who was entirely responsible for the
execution of the pair of Evangelists on the other side of
the vault (Saints Luke and Matthew) and for the head of
St John. On the basis of an old photograph of the
unrestored fresco, and the variation between the heads
in the drawing and in the painting, Popham concluded
that the head of St Mark was also due to Daniele da
Volterra (*Burl. Mag.*, LXXXVI, 1945, p.66).

The present drawing corresponds very closely with the
fresco. Its style suggests that it must belong to the first
period of work in S. Marcello (1525–7). A finished design
for the whole vault includes the two Evangelists almost
exactly as shown here, but the subject of the picture
space above their heads was at this stage to be God the
Father rather than the Creation of Eve, the subject finally
chosen (Berlin, Kupferstichkabinett; K. Oberhuber,

'Observations on Perino del Vaga as a Draughtsman',
M.D., IV, No. 2, 1966, pp.170–82, particularly p.178,
Pl.45a). The figure of St Mark is depicted in a drawing in
the Albertina (Oberhuber, *ibid.*, Pl.46). The larger-scale
drawings in black chalk for the figures of Saints Luke and
Matthew in the Louvre (Nos. 2814 and 1825) must from
their style and technique belong to the second phase of
work.

Provenance: possibly Nicholas Lanier (small six-pointed
star, cf. Lugt 2885 and 2886; see p.11 above); King
George III (Inventory A, p.52: *Giulio Romano, Polidoro, e
Perino del Vaga, Tom.2*, p.11. 'St. Mark & St. John. [Perin.
del Vaga]')

(P&W 974; RL 01218)

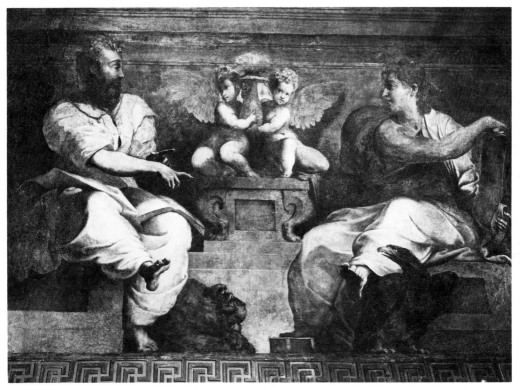

PERINO DEL VAGA, *Saints Mark and John the Evangelist* (Rome, S. Marcello al Corso, Cappella del Crocefisso)

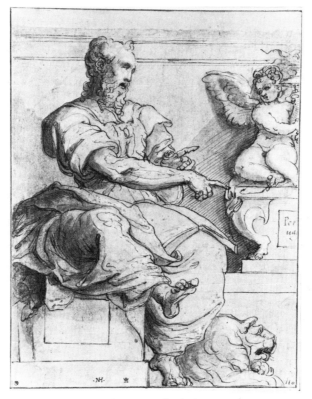

PERINO DEL VAGA, *St Mark* (Vienna, Albertina)

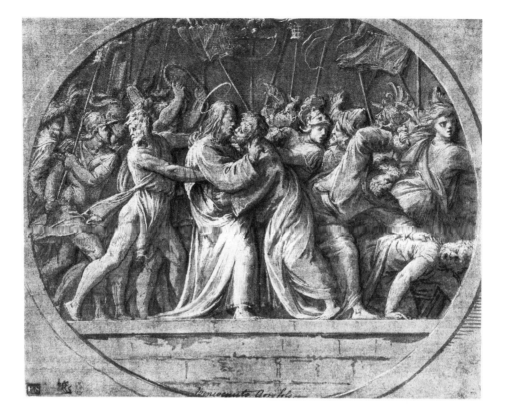

38 POLIDORO DA CARAVAGGIO (1496–1543)

The Betrayal of Christ

Black and grey applied with point of brush, heightened with white, on paper coated with a dark blue wash.
210 × 262 mm

Inscribed lower centre, by a later hand: Benevenuto Garofolo

The drawing corresponds closely with, and is evidently the design for, an oval crystal plaque engraved in intaglio by Valerio Belli now in the Vatican Library together with two companion plaques representing *Christ carrying the Cross* and *The Entombment*. It has been suggested that they were made to decorate the cross 'di cristallo divino' which, according to Vasari, Belli executed for Pope Clement VII, and for which a payment of 1111 gold ducats is recorded in 1525. An earlier cross by Belli, datable c.1510–15, is now in the Victoria and Albert Museum. The placing of the similar plaques in the base of the London cross may indicate how the three in the Vatican would have been set.

Vasari felt unable to praise Belli whole heartedly because he always based the design of his engraved crystals on 'drawings by other artists or on Antique gems'. The traditional attribution of the present drawing was to Garofalo, and recently the name of Biagio Pupini has been put forward (L. Ravelli, *Polidoro Caldara da Caravaggio*, Bergamo, 1978, No. 975). Popham, however, followed Frederick Antal's suggestion of Polidoro da Caravaggio, and this does indeed seem to be the most convincing solution. Polidoro was a prominent and

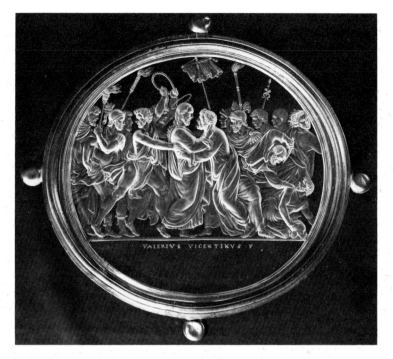

VALERIO BELLI, *The Betrayal* (crystal engraved intaglio; Rome, Vatican Library)

active figure in Rome in the years before the Sack in 1527, whereas it is highly improbable that either Garofalo or Pupini would have been involved in a Papal commission of such importance. In any case, the style of the drawing and its high quality are enough to exclude either attribution. The drawing is unusually controlled and explicit for Polidoro, but this would be explained by the purpose for which it was made. The system of hatching with white bodycolour in fine parallel strokes can be matched in other drawings attributed to him and apparently datable in this relatively early phase of his career (e.g. the *Holy Family* in the Ashmolean Museum; Ravelli, *op.cit.*, No. 8). In style the Windsor drawing is close to Polidoro's frescoes in the Cappella della Passione in S. Maria in Camposanta, Vatican City. Although these are undocumented, they have been dated 1522/23.

Pope-Hennessy has pointed out *à propos* of a bronze version of the crystal, that Belli has subtly altered the viewpoint: in the drawing the figures are seen from below, whereas in the crystal the spectator's eye is slightly above the level of the floor on which the action is taking place (J. Pope-Hennessy, *The Study and Criticism of Italian Sculpture*, New York, 1980, p.216). Polidoro's main activity in Rome in the 1520s was the imitation of Antique reliefs – an illusion that would have required a similar *di sotto in sù* viewpoint, to which Polidoro would have been accustomed.

Provenance: Paul Sandby (Lugt 2112); Sir Thomas Lawrence (Lugt 2445); W. Mayor (Lugt 2799; catalogue 1875, published by Hogarth, No. 43); purchased at 30 gs.

(P&W 692*; RL 050)

39 GIOVANNI ANTONIO DE' SACCHIS
called PORDENONE (c.1484–1539)

St Augustine surrounded by child angels

Black and grey applied with brush, and wash, heightened with white, on faded blue/grey paper. Squared for transfer with a stylus. 245 × 194 mm

This finished study has been described as 'one of Pordenone's finest, fully pictorial, chiaroscuro type drawings' (C. E. Cohen, *The Drawings of Giovanni Antonio da Pordenone*, Florence, 1980, p.126). The painting for which it served as a *modello* has not apparently survived. On the basis of the influence of this figure found in Titian's altarpiece for S. Giovanni Elemosinario, Venice, W. Friedlaender has argued convincingly that Pordenone's drawing was preparatory for his series of mural paintings of the Church Fathers in that church described by Boschini in 1664. Pordenone's painting of St Augustine in the church of the Madonna di

Campagna, Piacenza, in 1529, also has various elements in common with this composition.

A preliminary black chalk study for the Saint and attendant angels, and a second more detailed study of two of the angels, are preserved in the Ashmolean Museum, Oxford (*Il Pordenone*, exh. cat., Pordenone, 1984, pp.204–5).

Provenance: King George III (presumably Inventory A, p.59: *Titiano Paolo Veronese, e Scuola Veneziana*, pp.2–6 and 12. 'Pordenone'.)

(P&W 741*; RL 5458)

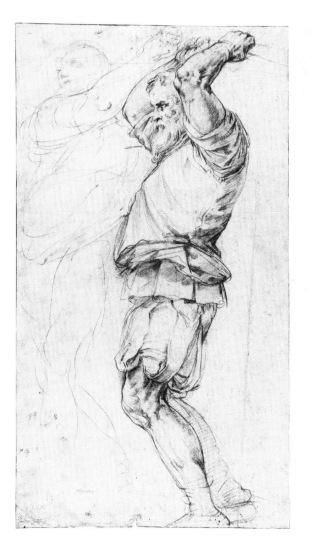

The appearance of Titian's hypothetical painting of the *Flagellation* is known from these two engravings alone. It has not been recorded since the sixteenth century and may be identifiable with the picture of 'Christo, poco minore del vivo, battuto da Giudei alla Colonna, che è bellissimo' (Christ at the column, beaten by the Jews, a little smaller than life-size; which is very lovely) that Vasari describes as having been painted by Titian for the Queen of Portugal (see H.E. Wethey, *The Paintings of Titian. I The Religious Paintings*, London, 1969, pp.93–4, under cat. 41 'lost Works').

The intermediary status of this drawing between the lost painting and Franco's etched copy is somewhat surprising in view of the very exuberant handling of the red chalk medium. In the absence of evidence to the contrary it is just possible that the original painting was by Franco rather than Titian, and that the engraved copies were made by Franco after his own work, and by Rota after Franco's. Bartsch's reasons for introducing Titian into the equation are not known, although both Franco and Rota studied and copied Titian's works. Franco's own painting of the *Flagellation*, which incorporates a central figure of Christ tied to a column but is otherwise dissimilar to the engraved composition, is in the Cathedral Sacristy at Urbino (see *Mostra di opere d'arte restaurate*, exh. cat., Urbino, Palazzo Ducale, 1970). That painting has been dated to the decade before Franco's return from Rome to Venice, where he is documented from November 1554. Vasari states that Franco's print-making activity was confined to the years following his return to Venice, by which time he had achieved a subtle blend of Michelangelesque elements (picked up in Rome) with the art of his native town.

Franco's drawing for the figure of Christ in the *Flagellation* etching is in New York. In medium, style and size it is strictly comparable to No. 40. And like No. 40, it is reproduced in the same sense in the derivative engraving illustrated here, but in reverse in Franco's etching. (J. Bean, *15th and 16th Italian Drawings in the Metropolitan Museum of Art*, New York, 1982, p. 95, No. 84.)

Provenance: presumably King George III

(P&W 329; RL 048)

0 BATTISTA FRANCO (1510–61)

Standing bearded man

Red chalk. 401 × 224 mm

Inscribed in faint black chalk: Battista Franco

This fine drawing is directly related to one of the figures in Franco's etching of the *Flagellation* (Bartsch XVI, p.122, No. 10), signed *Battista franco fecit*. The Royal Library has an uninscribed and undescribed copy of this print (illustrated here), which faithfully copies Franco's original, but in reverse. Franco's etching was described by Bartsch as 'gravée d'après le *Titien*'. The same description is given by Bartsch when discussing Martin Rota's much smaller engraving of an almost identical *Flagellation*, which is signed and dated 1568 (Bartsch XVI. p. 250, No. 7). The two artists appear to have copied Titian's painting independently of one another. The figure shown in this drawing, for instance, is followed closely in Franco's etching but is depicted by Rota with legs slightly apart and britches gathered, not slashed.

BATTISTA FRANCO, *The Flagellation* (engraving, reverse of Bartsch XVI, p. 122, No. 10)

THE NORTHERN RENAISSANCE

The use of vellum and of paper with a coloured preparation (e.g. Nos. 52 and 54) continued in Northern Europe well into the sixteenth century in the drawings of artists such as Hans Holbein the Younger (Nos. 48–51). The great advances made in printing during these years depended on the discovery of new recipes for ink, which are hinted at in the inscriptions in Stradanus' drawing of a printing shop (No. 57): 'The smoke, as it prints little black figures on the page, produces a book up to a thousand thousand columns long.' During the hand-press period printing ink consisted of a varnish of boiled oil and (for black ink) purified and powdered lampblack. The latter was produced by collecting the smoke of burning resin. The importance of ink in northern drawings of the fifteenth and sixteenth centuries is suggested by the fact that only one of the eleven drawings in this section does not involve its use (No. 47). Ink (made from a variety of recipes) was applied with a quill (Nos. 48, 54, 57 and 58), or reed (Nos. 55 and 56) pen, or with a brush (No. 53)

Holbein's employment of coloured chalks, either with (No. 50) or without (No. 47) a coloured preparation to the paper, appears to derive from contemporary French use. That tradition is still very apparent in the works of François Quesnel and his studio (e.g. Nos. 75 and 76), of nearly a century later.

JAN VAN DER STRAET *called* STRADANUS Border design for tapestry of September (detail of VPF 175; RL 6858)

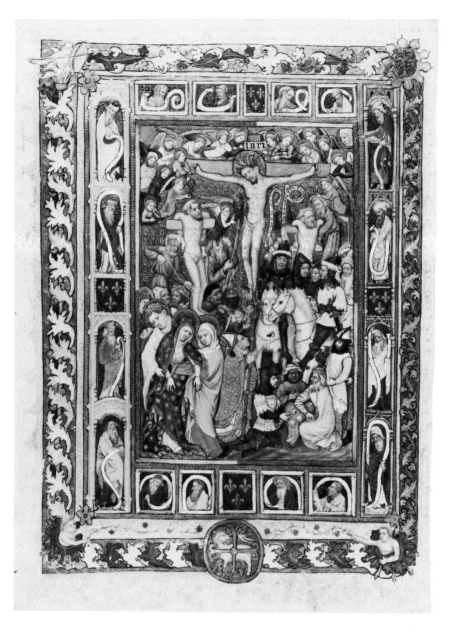

TWO LEAVES FROM A MISSAL: FRANCE, c.1400

41 *The Crucifixion*

42 *God in Majesty with the Evangelists*
Illumination on vellum. 373 × 270 mm; 374 × 275 mm

In many illuminated missals, two full-page paintings, the
Crucifixion and God in Majesty, precede the canon of the
mass. These leaves were just such a bifolium: the wider
borders at the outer margins and the traces of sewing
holes at the inner margins confirm the original arrange-
ment. The Crucifixion, set against a heavily tooled gold
ground, is of the general type found in manuscripts from

the fourteenth century and is derived from the 'crowded
Crucifixion' of Italian trecento painting. The Agnus Dei
medallion in the lower margin of the Crucifixion would
have received the ritual kiss of the priest during the
celebration of mass: the red gesso appearing from under
the gold is a sign of wear. In the painting of the Majesty,
the unusual iconography of the four evangelists writing
on the backs of their symbols derives from Ottonian and
ultimately from Carolingian models.

Because of their subjects, the Windsor leaves have
long been thought to come from an unknown missal,
sometimes nicknamed the 'Fly Missal' in allusion to the
fly perched on the horse of the soldier nearest to the
Crucifixion. Insects often occur in the margins of manu-
scripts, as does the fly in the upper margin of the Majesty

miniature, but in this unusual and prominent position, the fly may be an emblem of mortality as well as an illusionistic device. Recently, and following the publication of an illuminated missal now in the Casanatense Library in Rome (MS. 1909; see bibliography below: Curmer), Monsieur François Avril of the Bibliothèque Nationale, Paris, has recognised these leaves as the missing canon miniatures from the Casanatense manuscript. They were removed between about 1864 and 1878 (see bibliography below: Curmer and Adorisio).

The Casanatense manuscript is a missal with music of the use of Rome, and is decorated with twelve calendar initials, sixty-five other historiated initials and many full-page borders. It was made in the years around 1400 for the ecclesiastic who kneels in prayer at the foot of the

cross in No. 41 and in other initials in the missal. At this date, the cross he holds probably implies that he is an archbishop, rather than simply a bishop. He was once identified by the arms on his right shoulder, now obliterated, and by the arms in the borders of these and many other pages, now repainted. On a few pages the original arms are still imperfectly visible. They were quartered, and although at present insufficient detail has been recovered to permit certain identification, there is nothing inconsistent with the arms of Jean d'Armagnac, Bishop of Mende and Archbishop of Auch, who died in 1408, and who has been proposed as the original patron on other grounds (J. Hamburger, forthcoming monograph). The repainted arms (Azure, three fleurs de lys Or, debruised by a bendlet Gules) are those of Pierre

de Beaujeu, afterwards duc de Bourbon, who acquired the missal before 1488, probably from Jacques d'Armagnac, duc de Nemours, who was executed in 1477, and whose name and cipher were identified by Adorisio on the upper and lower edges of the missal.

The origin of the Casanatense missal remains uncertain. In the main body of the manuscript, the full-page 'armorial' borders at the main liturgical divisions of the text, and other unhistoriated initials and borders, closely resemble similar decoration in French (i.e. 'Parisian') style in the missal of the antipope, Clement VII, which was made in Avignon about 1390 (B.N. MS. lat. 848). However, neither the soft figure style, combined with extensive use of black outline, of the main artist of the Casanatense missal (who worked on the canon pages and on other initials in the manuscript), nor the borders of the canon pages in their present inventive combination, nor the unusual juxtaposition of heavily tooled gold grounds and pen ornament, can be paralleled in the known Avignon or Paris books.

In the years around 1400, artists of very different origins often collaborated to produce one manuscript. It is thus unusually difficult to localise books of this period in terms of their style. The artistic repertory of the present pages seems to include many northern as well as some Italian features. This would not in itself exclude an Avignon origin for the manuscript.

Provenance: until between 1864 and 1878, part of the Casanatense missal (MS.1909): before 1477, Jacques d'Armagnac, duc de Nemours; before 1488, Pierre de Beaujeu, afterwards duc de Bourbon; given, 1728, by Pope Benedict XIII, to the Casanatense Library, Rome (inscription f.1). The two leaves removed at an unknown date, and transferred to the Royal Library in the late nineteenth century (year unknown) [No foundation for the ownership of Jean de Berry (cf. Adorisio, Meiss)]

(RL 25009 and 25010; L. Curmer, *Les Evangiles des Dimanches et Fêtes de l'Année*, Paris, 1864, I, pp.40, 116, 120 and III, pp.61, 87–90, 97; A. Adorisio, 'Un messale miniato donato a Jean de Berry ed oggi nella Bibliotheca Casanatense di Roma', *Miscellanea in Memoria di Giorgio Cencetti*, Turin, 1973, pp.293–315; M. Meiss, *French Painting in the Time of Jean de Berry: the Limbourgs and their Contemporaries*, New York, 1974, p.420)

WENCESLAUS HOLLAR *Allegory of the Death of the Earl of Arundel* and detail; (etching, Parthey 466)

3 HANS HOLBEIN THE YOUNGER (1497/8–1543)

Solomon and the Queen of Sheba

Miniature painting, with pen and brush, including some use of gold paint. Vellum, 228 × 181 mm

Inscribed, in the foreground: REGINA SABA (the Queen of Sheba); on either side of the throne: BEATI VIRI TVI . . . ET BEATI SERVI HI TVI / QVI ASSISTVNT CORAM TE . . . OMNITP̃E ET AVDIVNT / SAPIENTIAM . . . TVAM; on the curtain behind Solomon: SIT DOMINVS DEVS BENEDICTVS, / CVI COMPLACIT IN TE, VT PONERET TE / SVPER THRONVM, VT ESSES REX / (CONSTITVTVS) DOMINO DEO TVO (Happy are thy men and happy are these thy servants, who stand in thy presence, and hear thy wisdom. Blessed be the Lord thy God, who delighted in thee, to set thee upon his throne, to be King [elected] by the Lord thy God); and on the steps of the throne: VICISTI FAMAM / VIRTVTIBVS TVIS (By your virtues you have exceeded your reputation)

This exquisite miniature painting incorporates the only original likeness of King Henry VIII by Holbein that has survived in the Royal Collection. The King is seen in the guise of Solomon, and the words inscribed around him, based on those in II Chronicles 9 (verses 7–8), implying that he, like Solomon, is answerable only to God, must be connected to the events leading up to Henry VIII's assumption of the role of Supreme Head of the Church in 1534. The Queen of Sheba was traditionally represented as a type of the Church; by receiving her homage, the King thus receives the homage of (and implicit acceptance by) the Church of England.

This miniature is first recorded in the Royal Collection in 1688 when it was hanging at Hampton Court. It had previously belonged to Thomas Howard, Earl of Arundel, in whose possession it was twice etched by Hollar. Once (Parthey 74) without framework in 1642 and secondly, following Arundel's death in 1646, in an elaborate circular frame (Parthey 466). It is quite possible that, in this form, it had been presented to the King as an (albeit undocumented) New Year's gift, early in Holbein's second stay in England, c.1535.

Provenance: (King Henry VIII;) Thomas Howard, Earl of Arundel (1642); in Royal Collection by 1688 (when at Hampton Court; Bathoe/Vertue, p.87); by 1743 at Kensington (*ibid*. Kensington, p.5, No. 37)

(PH*; RL 12188)

HOLBEIN, *The Duke* (woodcut, from the *Dance of Death*)

44 PETER OLIVER (c.1589–1647)
after HOLBEIN

'The Duke' from the Dance of Death

Miniature painting with pen and brush, including some use of gold paint, within a narrow gold border in imitation of a bevelled frame. 63 × 53 mm (illustrated actual size)

This limning is an actual size copy of Holbein's woodcut from the so-called 'Dance of Death' series, cut to the artist's designs by Lutzelberger in 1523–5, but first published (with no mention of the artist's name) in *Les simulacres et historiées faces de la mort* (Lyon, 1538). The series had an immediate and widespread popularity, and was frequently re-issued.

The forty-one separate 'Pictures of Death' each show Death, in the form of a skeleton, claiming a living representative of the different ranks of society as his prey. Associated with each picture is an appropriate biblical sentence. In this case, the following passage, taken from the Vulgate (Ezekiel, chapter 7, verses 27 and 24), was given: 'Princeps induetur moerore, et quiescere faciam superbiam potentium'. The relevant clauses are given in the Authorized version of the Bible as follows: 'The prince shall be clothed with desolation', and 'I will also make the pomp of the strong to cease'.

Oliver's copy is mounted on a small wooden panel, bearing King Charles I's cipher brand 'CR'. It can be identified with the following entry in Van der Doort's inventory: 'Don by ould Isack Olliver after Holben. Item a little peece where death with a greene Garland about his head streatching both his Armes to apprehend a Pilate in the habbitt of one of the spirituall Prince Ellecto^{rs} of Germany', and is noted as measuring 2½ × 2 inches (*VdD*, p.121). During the Commonwealth it was valued at 10*s* and was presumably sold. The date of its return to the Royal Collection is not recorded; its whereabouts was apparently unknown in 1858, when it was referred to in F. Douce, *Holbein's Dance of Death* (London, 1858, p.196).

The old attribution to Isaac Oliver has recently been challenged (J. Finsten, *Isaac Oliver*, New York and London, 1981, vol. 2, p.146–7, cat. 111: 'almost certainly by Peter Oliver . . . although it is very much "after Holbein in the manner of Isaac Oliver"'. Although it is not known when, or for whom, Oliver made this miniature copy, it could have belonged to the series of copies commissioned from Peter Oliver by King Charles I (see Nos. 45 and 46). The 'Dance of Death' series was evidently greatly admired in artistic circles during the century after Holbein's death. Joachim von Sandrart records the following episode in his life of Holbein: 'I remember that when the famous Paul Rubens came to Utrecht in 1627, and the virtuosi paid a special visit to Honthorst there and accompanied [Rubens] from there to Amsterdam, and speculated about the drawings of the Dance of Death in Holbein's booklet, Rubens praised the same very highly, saying that it should commend itself to me as a young man, as in his youth he himself had copied it . . . and as a result of this he delivered a laudatory and fine discourse on Holbein, Albert Dürer and other old German masters for almost the entire journey.' Forty-seven of Rubens' copies (in pen and ink) have survived, in the collection of Dr Pfann, and have recently been published in facsimile (*Peter Paul Rubens tekeningen naar Hans Holbeins Dodendans*, with commentary by I. Q. van Regteren Altena, Amsterdam, 1977). There they are described as 'the very earliest work by Rubens known to us' (p.56), dating from before his departure for Italy in 1600.

Provenance: King Charles I (*VdD*, p.121; *I&V*, p.247, No. 368, valued at 10*s*); presumably returned to the Royal Collection after 1858

(OE 458)

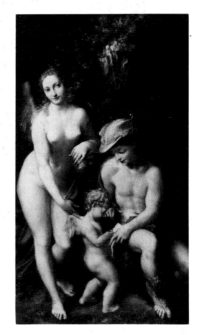

CORREGGIO, *Venus, Mercury and Cupid*
(London, National Gallery)

45 PETER OLIVER
after CORREGGIO

Venus, Mercury and Cupid ('The School of Love')
Miniature painting, within a gold border. Vellum.
207 × 137 mm

Inscribed in gold paint, top right: Anton: Coregium
Inuenit:/Imitatus Est Petrus Oliuarus: − /1634

One of a group of seven miniature copies by Peter Oliver
of Italian paintings in the collection of King Charles I,
recorded by Van der Doort (see also No. 46). Correggio's
original painting, now in the National Gallery, London,
was purchased on behalf of the King from the Gonzaga
collection at Mantua in 1628. The picture was recorded
at Whitehall in Van der Doort's inventory of *c.* 1639, and
was sold for £800 in 1651. It was purchased for the
National Gallery in 1834. Oliver dated his copy 1634; his
other miniature copies, of which four (with five addi-
tional ones) are in the Royal Collection, are (or were)
inscribed with dates between 1628 and 1639. In the
Exchequer accounts for 1635 it is recorded that the artist
was paid £100 for work ordered or completed for the
King: this payment presumably relates at least in part to
these copies. King Charles I's brand, with the number '8'
noted by Van der Doort, still appears on the back of the
frame. Oliver's copy when noted by Van der Doort was

said to bear the date 1636; it was sold for £50 in 1650
during the Commonwealth Sales. Although in Vertue's
catalogue of the contents of Queen Caroline's closet at
Kensington in 1743, this copy is listed, in 'A black ebony
frame, with folding doors', it evidently left the Collection
thereafter. It was repurchased for the Royal Collection by
Queen Victoria's Librarian, Richard Holmes, in 1885. A
second copy of Correggio's painting is noted in King
Charles I's collection, described as a 'Blacke and White
Limbning'.

This and other copies of Correggio's somewhat dama-
ged original show a quiver and arrows emerging behind
Venus' leg, which is absent in the painting in its present
state. The precise theme of the original painting was
apparently a more sublimated form of love contrasted to
the sensual love shown in the pendant painting of
Antiope, now in the Louvre, but also formerly in the
collection of King Charles I. Peter Oliver's miniature
copy of *Antiope* is also in the Royal Collection (OE 463).

Provenance: King Charles I (*VdD*, p.104); sold 21 May
1650 to John Embry for £50 (*Ie²V*, p.256); in the Royal
Collection (at Kensington) in 1743 (Bathoe/Vertue,
p.23, No. 149); Bohn sale, Christie's, London, 26 March
1885, lot 1177; purchased by Richard Holmes for the
Royal Collection (£21)

(OE 462)

46 PETER OLIVER
after RAPHAEL

St George and the Dragon
Miniature painting on vellum. 223 × 166 mm

A copy of the painting of *St George and the Dragon* now in the National Gallery of Art, Washington. When it was reacquired for the Royal Collection in the nineteenth century, Oliver's copy was described as bearing King Charles I's brand, which is no longer present. Van der Doort mentioned that it was dated 1628, and gave measurements that are rather larger than the present size of the copy. No inscriptions are visible today, but the date is important for the year of the arrival of Raphael's original in the Royal Collection. Although it is traditionally stated to have been presented to King Henry VII by

Duke Guidobaldo of Urbino, in return for the gift of the Order of the Garter (witness the garter worn by St George in the oil painting), no trace of the painting in sixteenth-century royal inventories has yet been found. Indeed in 1627, the year before Oliver's copy, Lucas Vorsterman engraved the painting in the collection of the Earl of Pembroke. Vertue, writing between 1717 and 1721, claimed to have been told by Lord Pembroke that an ancestor had received the painting from Castiglione, who had commissioned it from Raphael. Van der Doort specifies that King Charles I received the oil painting 'in exchange of my lord Chamberlaine for the booke of Holbins drawings' (containing Nos. 47–51 below).

Oliver's copy was apparently made for King Charles I, in whose possession Raphael's original was noted from 1639 (*VdD*, p.79). Following the Commonwealth Sales, the original was in France, then travelled to Russia in the

RAPHAEL, *St George and the Dragon* (Washington, National Gallery of Art, Andrew W. Mellon Collection)

eighteenth century before being acquired for America from the Hermitage in 1937. Although there is no record of the fact, Oliver's copy was also presumably sold during the Commonwealth and did not return to the Royal Collection until 1882, when it appeared in the Hamilton Palace sale. On 31 July 1882 Queen Victoria informed her eldest daughter, the Empress Frederick, that: 'Mr Robinson [Sir J. C. Robinson] has been continually looking out for pictures and things at the sale . . . I have also got another small drawing, after Raphael, of a St George and the Dragon, which had Charles I's mark on it' (RA, Add. U 32).

As is the case with No. 45, a number of minor variations exist between the panel in its present state and Oliver's copy, the most notable of which is the smoke from the Dragon's mouth, which is now absent from the original.

Provenance: King Charles I (*VdD*, p.103); presumably sold during the Commonwealth; Hamilton Palace sale, 15 July 1882, lot 1667; purchased by Richard Holmes for the Royal Collection

(OE 464)

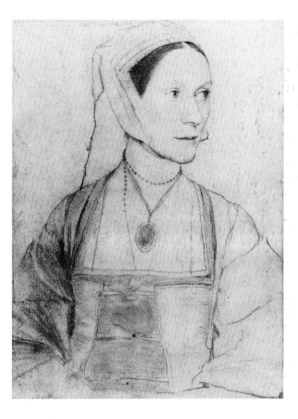

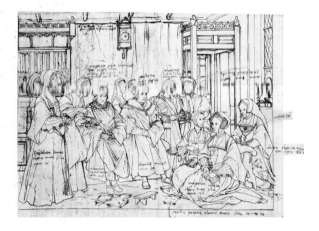

HOLBEIN, *Sir Thomas More and his family* (Basel, Kupferstichkabinett, Oeffentliche Kunstsammlung)

47 HANS HOLBEIN THE YOUNGER (1497/8–1543)

Cecily Heron (PLATE IV)

Black, white and coloured chalks. 380 × 281 mm

This drawing belongs to the series of eight portrait studies in the Royal Collection made in preparation for Holbein's group painting of the family of Thomas More, the humanist scholar and future Lord Chancellor. This work, which perished during the eighteenth century, occupied the artist for much of his first period of residence in England (1526–8). Its appearance is known from Holbein's line drawing of the composition in Basel, inscribed with the sitters' names and sent by the artist to his friend Erasmus, who had first introduced Holbein to More. In the group portrait Cecily Heron (born 1507), More's third daughter by his first marriage, is shown seated, third figure from the right, surrounded by the rest of the More family and household in their home in Chelsea. In 1525 Cecily had married her father's ward, Giles Heron, and by the time of Holbein's paintings she was evidently expecting a child (witness the ingenious expanding bodice she wears). In 1540 she was widowed by the execution of her husband, implicated by Thomas Cromwell in More's downfall. Her pose is strongly reminiscent of that of her namesake, Cecilia Gallerani, as portrayed by Leonardo da Vinci in the painting in Cracow.

Parker considered that the drawing had been over-worked, particularly in the left eye and outline of the veil falling on the left shoulder. However, it is now generally considered that relatively little retouching has been carried out on the Holbein drawings, and that the coloured chalk work is original. This drawing was successfully engraved in soft-ground etching by Frederick Lewis at the end of the eighteenth century, but it is thought that his plate was soon destroyed by the Royal Librarian, John Chamberlaine, in order to protect his own edition of Bartolozzi's engravings after the Holbein drawings at Windsor (published between 1774 and 1800; see PH, p.22).

Provenance: from the 'great booke' of Holbein's drawings, owned successively by King Edward VI (d.1553); Henry Fitzalan, Earl of Arundel (d.1580); Lord Lumley (d.1609); Henry, Prince of Wales (d.1612); Charles, Prince of Wales (later King Charles I); between 1627 and 1639 (or in 1628 if the date noted by Van der Doort on No. 46 is to be believed) exchanged with the Earl of Pembroke and given by him to Thomas Howard, Earl of Arundel (d.1646); in the Royal Collection by 1675; noted in the Kensington Inventory, 1727; 1727/8 the 'great booke' broken up, and the contents framed and glazed; the Holbein drawings hung first at Richmond Lodge, then at Kensington Palace, where listed and located in Bathoe/Vertue; King George III (Inventory A, the Holbein drawings listed in two volumes; the present drawing is presumably among the fifteen anonymous portraits noted on p. 58).

(PH 5*; RL 12269)

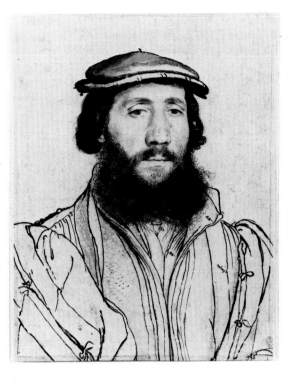

8 HOLBEIN

An unidentified gentleman

Black and coloured chalks, with black ink and wash, applied with pen and brush, on paper coated with a pink preparation. 274 × 211 mm

Inscribed in pen and ink: atlass (silk); and (twice): at[lass]; and: s (satin?)

Watermark: Briquet 12863/4 (The Hague/Utrecht, 1524/5)

A closely worked preparatory study, evidently intended for translation into paint (witness the notes of material), but to which no surviving oil painting is known to relate. The same watermark (or a close variant) is found on several of the sheets related to the More family group (1526–8), and to other highly worked drawings presumably carried out early in the artist's second period of residence in England from 1532 (e.g. Ormond PH 23, Southampton PH 66, and the unknown lady, No. 49 below).

This drawing, or the painting for which it was preparatory, was etched in reverse by Hollar, in a circular format, in 1647 (Parthey 1547). It is also among the subjects traced by George Vertue in the mid-eighteenth century, preparatory to his (abortive) scheme to produce a series of engravings after the Holbein drawings at Windsor. These tracings are now at Sudeley Castle, Gloucestershire.

Provenance: see under No. 47

(PH 32*; RL 12258)

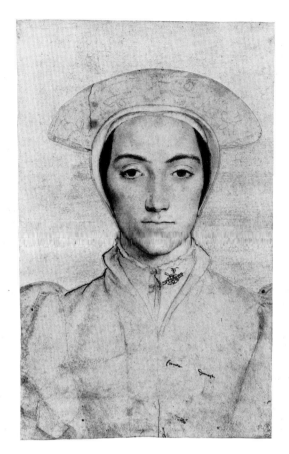

49 HOLBEIN

An unidentified lady

Black and coloured chalks with white bodycolour and pen and black ink on paper coated with a pink preparation. The drawing has been cut around the edges and mounted on to a fresh sheet of paper. 268 × 166 mm

Inscribed in pen and black ink: samat (velvet); damast (damask)

VERSO: inscribed in ink, and again in chalk: hans holbein

Watermark (of drawing): variant of Briquet 12863 (The Hague, 1524)

As is the case with No. 48, no painted portrait is known which corresponds with this drawing. The sitter was formerly thought to be Anne of Cleves, but her features differ very markedly from those in Holbein's painting in the Louvre.

The paper of this portrait drawing is similar to that employed in other drawings at Windsor, including No. 48. The quality of the penwork is very fine, particularly in the eyes and eyebrows. Typically, the repeating pattern on the high collar of the shirt is sketched in only once, and the materials of the bodice are noted. The subtly modelled left side of the face, bordered by the stark black hairline, has something in common with Cardinal Fisher's haunting image (No. 51).

This drawing was separated from the others in Holbein's 'great booke' and like two other Holbein drawings (in the Louvre and the British Museum) the figure was cut around in silhouette. Like Visscher's portrait below (No. 61), it belonged to Jonathan Richardson the Elder (1665–1745). Later, with the Poussin Marino drawings, it belonged to Dr Richard Mead. It was acquired at Mead's sale in 1755 by Walter Chetwynd, whose heir (Benjamin Way, of Denham) presented it to the Royal Collection at an unrecorded date shortly before Chamberlaine's publication of the Holbein drawings (1792–1800). Of this generous gift Chamberlaine wrote that Mr Way 'lately had the honour of receiving his Majesty's permission to add it to the Royal Collection' (J. Chamberlaine, *Imitations of Original Drawings by Hans Holbein . . .*, London, 1792–1800, vol. I, No. 3).

Provenance: removed from the 'great booke' at an unrecorded date (see provenance of No. 47); Jonathan Richardson the Elder (Lugt 2184); Dr Richard Mead; purchased at his sale, 1755, by Walter Chetwynd; bequeathed to Mr Benjamin Way, who presented it to the Royal Collection before 1792; King George III (Inventory A, p.56: *Holbein Tom:1.*, p.5. 'Queen Anne of Cleve')

(PH 47*; RL 12190)

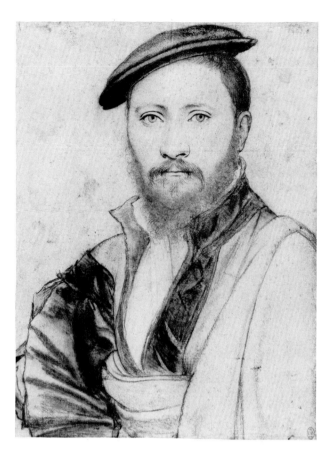

0 HOLBEIN

An unidentified gentleman

Black, white and coloured chalks, partly stumped, with grey-blue bodycolour and pen and black ink, on paper coated with a pink preparation. 297 × 222 mm

Although the identity of the sitter is still unknown, this drawing is clearly a preparatory study for the circular oil painting in the Metropolitan Museum, New York, dated 1535, and inscribed with the sitter's age 'ETATIS SVAE 28'. Comparison between the two, particularly on the basis of infra-red photography of the oil painting, reveals how closely Holbein adhered to the black ink outlines in his underdrawing for the painting. The drawing of the nostrils and eyes is very precisely reproduced in the painting. The drawing must at one time have extended further to the right, as is the case in the painting.

Provenance: see under No. 47

(PH 33*; RL 12259)

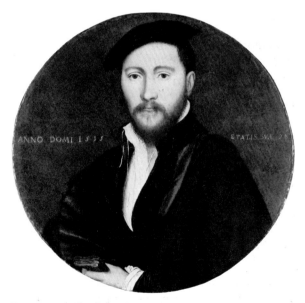

HOLBEIN, *An unidentified gentleman* (New York, Metropolitan Museum of Art, The Jules Bache Collection, 1949)

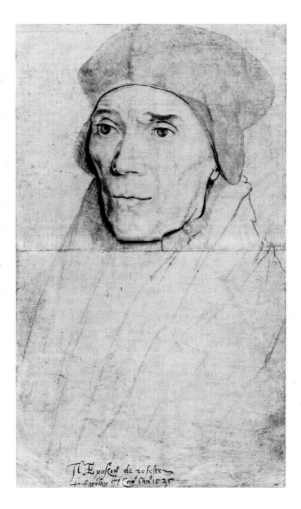

51 HOLBEIN

John Fisher, Bishop of Rochester

Black, white and coloured chalks, brown-grey water-colour wash and black ink applied with point of brush, on paper coated with a pink preparation. 382 × 232 mm

Inscribed in pen and black ink: Il Epyscop° de resester / fo ta. . .ato Il Cap° lan° 1535

Watermark: close to Briquet 11341 (Lisieux, 1526)

John Fisher (1469–1535) belonged to the group of churchmen and statesmen for whom Holbein worked during his first visit to England (1526/28). He had been appointed Bishop of Rochester in 1504, and with Thomas More and Archbishop Warham he strongly opposed the proposed church reform and royal divorce. In consequence he was fined, imprisoned, attainted, and finally beheaded, on 22 June 1535, shortly after being raised to the cardinalate. The inscription on the drawing presumably refers to this event. No satisfactory explanation has yet been given as to why this note, on a portrait of an Englishman made in London by a Swiss artist, is in Italian. It is generally believed that the Holbein portraits

at Windsor remained in the artist's studio at the time of his death, thereafter passing through a number of solely English collections.

It is inherently unlikely that this very penetrating likeness would have been taken following Holbein's return to England in 1532, because Fisher was out of favour by this time. Although no drawings on pink-coated paper can be securely dated to Holbein's first English period, several drawings from before that visit employ this preparation. Indeed the uncoated paper (as in No. 47) was the innovation, rather than the coated paper. It may be relevant that the application of the pink priming is quite distinct in No. 51 from that, for instance, in Nos. 48–50. The large format of the present drawing would seem to support an early dating. No original oil painting depending on this drawing is known, although several drawn copies are recorded.

Provenance: see under No. 47; King George III (Inventory A, p.56. *Holbein.Tom:I.*, p.32. 'Fisher, Bishop of Rochester')

(PH 13*; RL 12205)

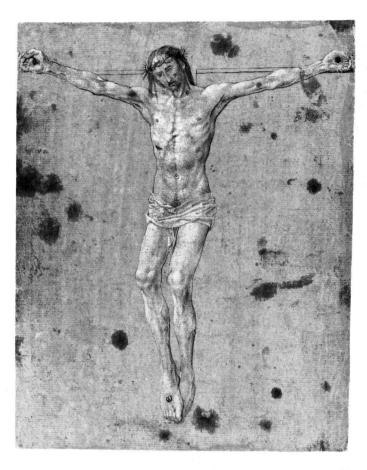

2 ANONYMOUS FLEMISH FIFTEENTH CENTURY

Christ on the Cross

Black ink applied with pen and point of brush,
heightened with white on paper coated with a grey
preparation. 260 × 210 mm

Watermark: close to Briquet 8531 (Cologne, 1481)

This drawing is apparently a preparatory study for the
central figure in the small panel painting of the *Calvary* in
Museo Civico Correr, Venice. Both drawing and painting
have been attributed to Hugo van der Goes (d.1482),
although current opinion suggests they are by an
anonomous Flemish fifteenth-century artist.

Provenance: possibly King George III (Inventory A, p.16:
Diversi Maestri Antichi.TOM.III., 'pages 52 containing the
old Italian Masters, and many old Flemish ones.')

(VPF 1; RL 12951)

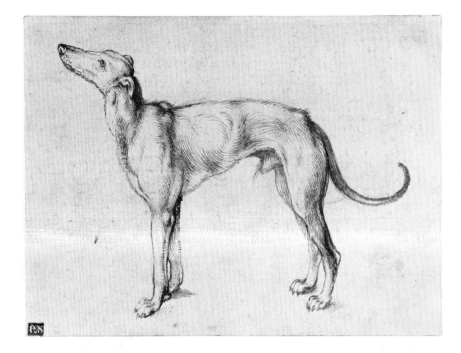

53 ALBRECHT DÜRER (1471–1528)

A Greyhound

Grey applied with point of brush. 147 × 198 mm

VERSO: almost entirely coated with black chalk

Watermark: Briquet 15375 (Vicenza, 1492)

This sensitive drawing of a greyhound is the only surviving preparatory study for Dürer's engraving of *The Vision of St Eustace* (Bartsch XIV, p. 12, No. 57), in which the dog appears in reverse. The engraving is normally dated c.1500, which must also be the approximate date of this drawing. It is similar in technique to drawings of the *Soldier on Horseback* (Vienna, Albertina) and the *Three Helmets* (Paris, Louvre), both of c.1495. The same watermark recurs in 27 drawings listed by Strauss from the two decades either side of 1500, including the *Three Helmets*. It is also used for the woodcuts of the *Large Passion* (c.1497–1500; see W. Strauss, *The Complete Drawings of Albrecht Dürer*, New York, 1974, vol. 2, p.504 and vol. 6, pp.326–7).

Another drawing at Windsor related to the *St Eustace* is described in Inventory A: 'A most elaborate drawing of Albert Durer's. The Saint Eustace: great part of the Dogs with the foreground left unfinished. This Drawing is larger than his Engraving' (Inventory A, p.20). This is evidently a copy of the engraving by a sixteenth-century northern draughtsman (S 24; RL 12178).

Provenance: Paul Sandby (Lugt 2112); Sir Thomas Lawrence (Lugt 2445)

(S 20; RL 12177)

DÜRER, *The Vision of St Eustace* (engraving; Bartsch XIV, p. 12, No. 47)

54 ERHARD ALTDORFER (c.1480–c.1561)

St George and the Dragon

Pen and black ink, heightened with white, on paper coated with an ochre preparation. The sheet edged with a black framing line. 178 × 132 mm

VERSO inscribed in black lead, in a nineteenth-century hand: von d[en] Gebru[d]ern [Rein]hold / Je 846 // [mit] nicht (?) [andern] / F.W. Franck

In his study of the drawings of Albrecht Altdorfer (1952), F. Winzinger ascribed a group of drawings (including No. 54) to the master's brother, Erhard. It has been dated c.1510 and does not appear to be related to any painting.

Provenance: presumably entered the Royal Collection during the nineteenth century (see *verso* inscription)

(S 1; RL 12184)

55 JAN MÜLLER (1571–1628)

Vulcan in his forge

Reed pen with dark brown ink and wash, over traces
of black chalk, heightened with white on cream paper.
412 × 275 mm

This drawing, with No. 56, belongs to a uniform group of
four studies in the Royal Collection of the gods *Mars,
Vulcan, Pluton* and *Jupiter* (VPF 133–134). The exag-
gerated depiction of the musculature, and the elongated
forms, with small heads and feet, is typical of northern
mannerism. Van Puyvelde's attribution to Spranger and
Welcker's to Goltzius was questioned by Reznicek in
favour of Jan Harmensz Müller, an engraver working
under the influence of Cornelis van Haarlem and
Spranger (E. Reznicek, 'Jan Harmensz. Müller as

Draughtsman', *M.D.*, XVIII, 1980, p.119). Other draw-
ings which may formerly have belonged to the same
series represent *Hercules* (Leiden, PrentenKabinet), *Tityus*
(Brussels, Musées Royaux des Beaux-Arts) and *Neptune*
(New Haven, Yale University Art Gallery). The latter
drawing bears old ascriptions to both Müller and
Goltzius. The fact that several of the gods, including
Vulcan in the present drawing, hold their attributes in
their left hand, suggests that this series may have been
planned in preparation for engravings.

Provenance: unknown, but possibly as for No. 52 above

(VPF 134; RL 12968)

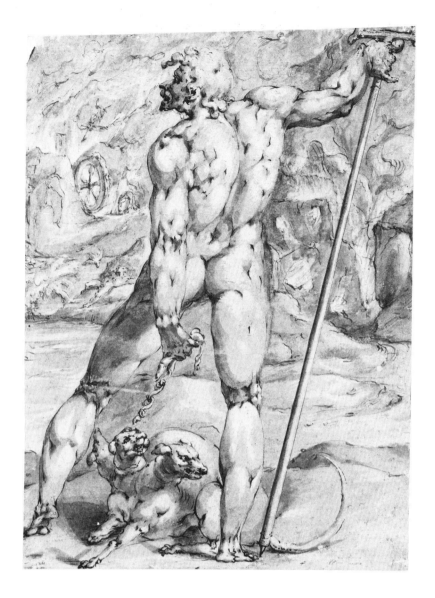

56 MÜLLER

Pluton and Cerberus

Reed pen with brown ink and wash, heightened with
white, on buff-coloured paper. 400 × 295 mm

See note to No. 55

Provenance: see under No. 55

(VPF 134a; RL 12967)

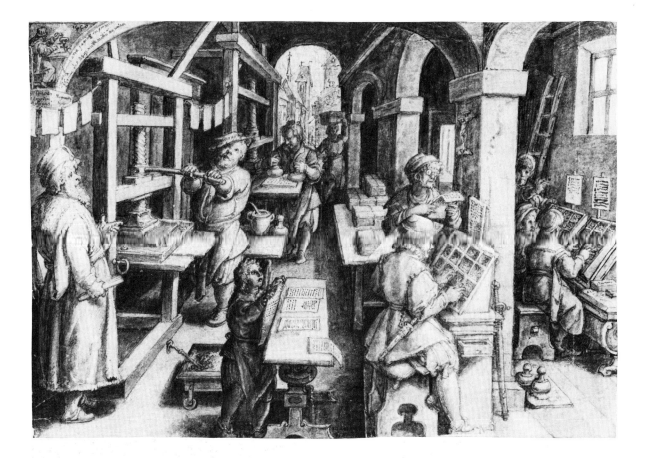

57 Jan van der Straet,
called Stradanus (1523–1605)

Printers at work

Pen and brown ink and wash over black chalk,
heightened with white. 185 × 269 mm (The seated
figure in the foreground to right of centre is drawn on an
irregularly shaped insertion with maximum dimensions
100 × 60 mm)

Signed in pen and brown ink, lower centre: Ioan /
Stradan; inscribed in latin (twice), top left, with date
1440

VERSO: inscriptions revealed during restoration, 1980.

 (i) centre right: Io: Guttembergius. Argentinensis./
Moguntie 1440 (Johannes Gutenberg of Strasburg.
Mainz 1440)

 (ii) centre (as on *recto*, upper left): Sigilla fumus atra
paginae imprimens / Librum dat usque mille mil-
lium agmina (The smoke, as it prints little black
figures on the page, produces a book up to a
thousand thousand columns long)

 (iii) left: Lodovico guisardino nella [d]escrinz*one* /
van de nederlanden scrift in mennetz herstmael de
druckene ghevonden heft / [ma?]erde heste was
van Arlem (*waer die*) maer im noemt hem niet./
[G?]hi sal de naeme*n* setten alzoet v ghoet dunken

sal alzoe heft S^or Allemari ghezeit (Ludovico Guic-
ciardini writes in his description of the Low
Countries that printing was first invented in Mainz,
but that the first was in Haarlem but he does not
give a name. You will provide the name as you will
think best; this is as S^or Allemari told me)

This and the following drawing (No. 58) are preparatory
studies for plates in the *Nova Reperta*, an undated series of
nineteen prints by Adriaen Collaert and Theodore Galle.
The series, published in Antwerp by Philips Galle to
designs by Stradanus, was concerned with a number of
new inventions and in its comprehensive scope it is
typical of the practical and speculative curiosity of
Renaissance man. No. 57 was used (in reverse) for plate 4
of the *Nova Reperta* entitled 'Impressio Librorum' (Book
printing). The following caption appeared below the
title: Potest vt vna vox capi aure plurima: Linunt ita vna
Scripta mille paginas. The engraving faithfully reprodu-
ced the drawing, but omitted the text relating to
Gutenberg.

 In No. 57 compositors are shown setting the type of the
printer's copy above their typecases. To the left, the
master printer looks on while (at the back) the forme is
inked, and (in the left foreground) the press is pulled. An
under-age apprentice lays out some newly printed proofs
in the centre foreground while stacks of paper are

CAT. 57 *verso*

Below: STRADANUS, *Impressio Librorum* (engraving: London, British Museum)

brought in from behind and piled on the central table. The damp printed paper dries on the lines to the left. In the corner of the arch top left, Johannes Gutenberg is shown at work on the invention of printing with the date 1440 on the inner keystone below.

This date has been misread for 1550, and used as an argument to date these drawings, and the related prints, to very early in the artist's career, which is not necessarily the case. Indeed Baldinucci states that Stradanus did not turn to providing designs for engravings until after his return from Naples in 1575. The plates of the *Nova Reperta* are very similar in both size and style to those of Stradanus' *Vermis Sericus* (on the cultivation of silk), which is also undated.

Various pieces of evidence point to a date c.1590 for the *Nova Reperta* series. Theodore Galle, who engraved nine drawings and the title page, was born in 1571. It is unlikely that he could have worked on the series before c.1590, when he would have been 19. The inscription on the *verso* shows that Stradanus had read Ludovico Guicciardini, *Descrizzione di tutti i paesi bassi* (first published Antwerp, 1567); he had probably also consulted André Thevet, *Pourtraits et vies des hommes illustres* (Paris, 1584), which includes a comparable portrait of Gutenberg and a very full account of the operation of a printing house.

The statement that printing was invented in Mainz in 1440 is derived from contemporary or later sources such as the *Cologne Chronicle*. By the 1560s, with the rise of the Dutch merchant communities, both the place and the

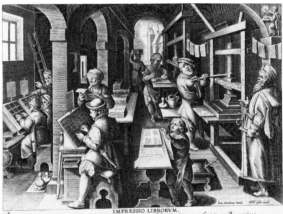

date of the invention were much discussed, and the town of Haarlem was introduced to the equation (for instance, by Guicciardini, who is quoted on the *verso*). This may be the reason for the omission of the date and place in the engraving. (See C. W. Gerhardt, 'Die Zeichnung 4761 von Windsor, Ein neuer Gutenberg-Beleg', *Gutenberg-Jahrbuch*, 1972, pp.44–9.)

Provenance: King George III (Inventory A, p.18: *Strada and Old Masters*, containing 73 drawings on 55 pages)

(VPF 158; RL 4761)

58 STRADANUS

Engravers at work

Pen and brown ink and wash over black chalk heightened with white. 187 × 287 mm

Watermark: small anchor within circle (unrecorded)

See note to No. 57. This drawing was presumably also intended for publication in the *Nova Reperta* although the scene finally published as No. 19 under the title 'Sculptura in Aes' (Metal Engraving) is very different. Here the engravers are at work on a number of metal plates, presumably copying the designs on the vertical stands in front of them. The printing methods used appear to be very similar to those in No. 57, concerned with letterpress printing. They involve screw (rather than roller) presses. In the final print more sophisticated roller presses are shown, and the printing shop has been substantially modernised.

The engraving 'Sculptura in Aes' could be the first representation of roller presses, which were introduced towards the end of the sixteenth century, and may first have evolved in the Netherlands (see H. Meier, 'The

origin of the printing and roller press. Part IV: The roller press', *The Print Collector's Quarterly*, vol. 28, 1941, pp.497–627).

Provenance: as for No. 57

(VPF 157; RL 4760)

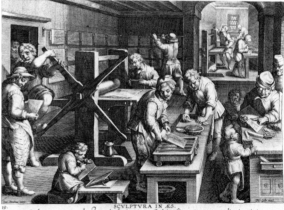

STRADANUS, *Sculptura in Aes* (engraving; London, British Museum)

THE SEVENTEENTH CENTURY

The fact that two of the drawings in this section (Nos. 61 and 77) were executed on vellum serves as a reminder that paper could still not replace this time-honoured material for fineness and smoothness of surface. The relative expense of paper is suggested by the frugal use of both sides of the sheet either for drawing (Nos. 60, 79, 83, 86, 87 and 91) or for manuscript additions (Nos. 71, 80 and 93). The use of tinted paper was now widespread throughout Europe, having originated in Venice c. 1500 (see Nos. 10 and 35).

Chalk was a very popular medium, although a polychrome effect was now sometimes also achieved by the addition of watercolour washes (Nos. 65, 66 and 96). Monochrome washes were added to both ink and chalk drawings, with increasingly dramatic effects (Nos. 71, 72, 74, 78–81 and 94). Castiglione's *oeuvre* (e.g. Nos. 96–8) includes experiments in a variety of different techniques.

AGOSTINO CARRACCI
Decorative framework (W 179; RL 1859)

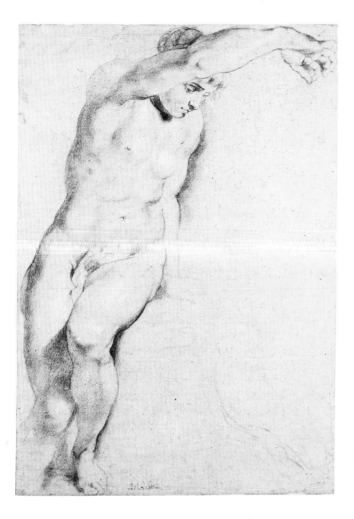

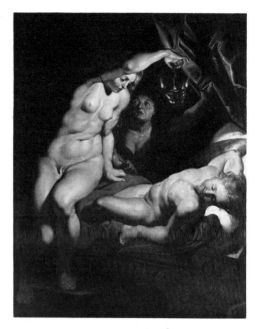

RUBENS, *Cupid and Psyche* (Hamburg, collection of Professor Dr Rolph Stödter)

59 PETER PAUL RUBENS (1577–1640)

A nude female figure

Black with white chalk, with some red chalk offsetting, on buff-coloured paper. 581 × 404 mm

Inscribed in pen and brown ink: Del Rubens

VERSO: inscribed in faint black chalk: 80 00

Watermark: continuous line MB with a 4 (reversed) above (unrecorded)

This is one of a group of chalk drawings produced during the decade following Rubens' return to Antwerp from Italy in 1608. In its sculptural form, and the style of the chalk drawing, it is reminiscent of studies by Raphael and Michelangelo, whose works Rubens saw during his travels. The muscular and thick-set form of this figure suggests that, in common with Italian practice, a male model must have sat for this drawing.

Rubens' painting of *Cupid and Psyche* in the Stödter collection, Hamburg, depends on this drawing. A date in the period 1612–15 has been suggested. Similar figures appear in other related paintings by Rubens, as cited by van Puyvelde. In this drawing, the figure of Psyche holds out an oil lamp. Over twenty years later the same figure reappears in the oil sketch of *Cupid and Psyche* for the decorations in the Torre de la Parada (now Bayonne, Musée Bonnat).

Provenance: presumably Italian (see inscription; not apparently included in King George III, Inventory A)

(VPF 279; RL 6412)

CAT. 60 *verso*

0 RUBENS

Silenus with Aegle and other figures

Pen and brown ink and grey wash. 280 × 507 mm

Inscribed top centre, by the artist, in pen and brown ink: Vetula gaud (an amused old woman); and along the lower edge, inverted, by an (?) eighteenth-century hand, in darker brown ink: Nº jjj . teekeningen (No. 3 of the drawings)

VERSO: *Figure studies* in black ink, applied with pen and point of brush, and wash. Inscribed top right, in brown ink: 80; lower left, in brown ink: 150; and top right, inverted, in black lead: 2510.12.

Watermark: large elephant (unrecorded)

The numerous studies on both *recto* and *verso* of this sheet are connected with several different compositions which occupied Rubens during the decade following his return from Italy in 1608. The principle figures on the *recto* show the drunken and fettered Silenus being crowned by the Naiad, Aegle, as recounted by Virgil. No related painting appears to have survived, although the pose of Silenus at far left recalls that of the sleeping satyr in the *Bacchanal* in Vienna.

The newly-revealed *verso* contains three studies for a dead Christ similar to that figure in the signed and dated *Pietà* of 1614 in the Kunsthistorisches Museum, Vienna. The figures on horseback are related to the painting of the *Wolf and Foxhunt* in the Metropolitan Museum, New York (c.1614/15), while the nude figures lower centre may be related to the Berlin *St Sebastian* of c.1612. The female martyrdom scene top left does not appear to have been worked up into a painting.

Provenance: King George III (Inventory A, p.105: *Rubens, Vandyke, Visscher &c*, 'Silenus and Bacchanalian Women')

(VPF 280; RL 6417)

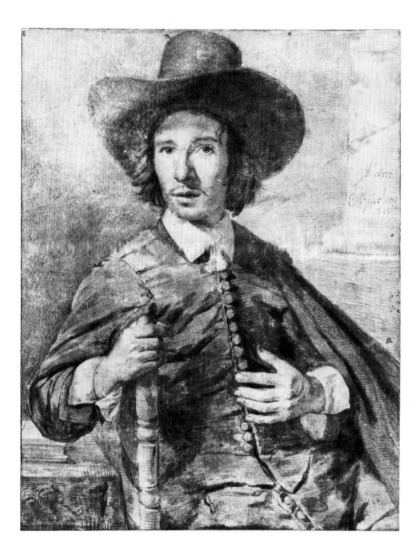

61 Cornelis Visscher II (c.1629–62)

Portrait of a young man
Black chalk, on vellum. 290 × 226 mm
Inscribed upper right: A° 1655. / C. Visscher / fecit.

As well as producing a large number of technically highly accomplished portrait drawings (most of which are on vellum and are dated between 1652 and 1658) Visscher was a prolific engraver. However, no engraving related to the present drawing has been found, and no identification has been proposed. What is probably a copy of the present study is in the Museum of Fine Arts, Boston (15.1266). Five drawings by Visscher are noted in Inventory A (p.105), of which only four can now be traced in the Royal Collection (VPD 729–32).

Provenance: Jonathan Richardson the Elder (Lugt 2184); King George III (Inventory A, p.105: *Rubens, Vandyke, Visscher &c.,* 'Portrait of a Gentleman half-length')

(VPD 732; RL 6425)

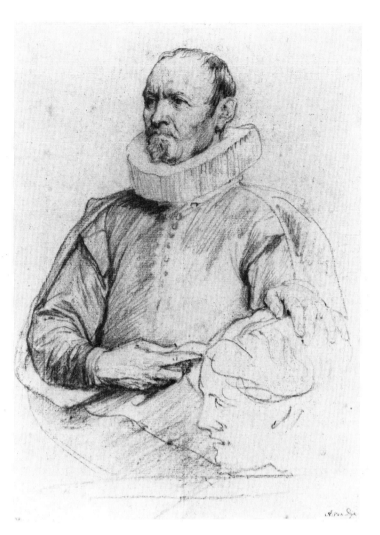

2 ANTHONY VAN DYCK (1599–1641)

Nicholas Rockox

Black chalk. 300 × 217 mm

Inscribed in brown ink, lower right: A: Van Dyck.; and lower left: 630

VERSO: inscribed along lower edge, in black chalk: Nicholaus Rockox; and in brown ink (much faded): . . . kox Bor. . . tot Antwerp.

Nicholas Rockox (1560–1640), Burgomaster of Antwerp on nine occasions, is here shown with his left hand resting on a marble head, doubtless intended to symbolise the sitter's famed art collection. The bust may be that of Athena, which can be seen with four male classical busts in the picture of the *Dining Room in the House of Nicholaas Rockox* by Frans Francken the Younger (Münich, Alte Pinakothek). Rockox was also a close friend of Rubens, who portrayed him on several occasions (M. Jaffé, 'Rubens' portraits of Nicolaas Rockox and others', *Apollo*, April 1984, CXIX, No. 266, pp.274–81).

Van Dyck's oil portrait of Rockox is in the Hermitage, while a related drawing is in the British Museum. These appear to date from 1621 or slightly before. It has been suggested that the present drawing was made in preparation for van Dyck's *Iconography*. There are two other portraits of Rockox in the *Iconography*: Nos. 115 (engraved by P. Pontius) and No. 165 (engraved by Vorsterman in 1625; see M. Maquoy-Hendrickx, *L'Iconographie d'Antoine van Dyck*, Brussels, 1956). The present drawing depicts a rather older man than No. 165, but there too items relating to Rockox's antiquarian interests are shown at his side. Various seventeenth-century references to drawn portraits of Rockox by Van Dyck (including No. 62) are known (J. G. von Gelder, 'Lambert ten Kate als Kunstverzamdaar', *Nederlands Kunsthistorisch Jaarboek*, 1970, p.177).

Provenance: Lambert ten Kate Hermansz. sale, Amsterdam, 16 June 1732, pf.I., 15; King George III (Inventory A, p.105: *Rubens, Vandyke, Vischer &c.*, one of 'Two Portraits')

(VPF 221; RL 6421)

63 Attributed to JAN ASSELYN (1610–52)

An Italian courtyard

Black chalk and grey wash. The sheet edged with a black framing line. 201 × 312 mm

Watermark: similar to Heawood 2843 (Holland, Schieland, 1648)

Van Puyvelde's attribution of this fine drawing to Asselyn is by no means certain, although it is possibly an unusual example of his work.

Provenance: possibly King George III (Inventory A, p.115: *Paesi di Claudio Loranese e Altri,* among pp.19–33, 'One of Eilshamer and two of Assalyn Crabacci, and twelve of various. . . .')

(VPD 13; RL 12852)

64 JACOB VAN RUISDAEL (1628–82)

Fishing scene with a windmill

Black chalk and grey wash, with a small amount of red chalk off-setting top left. 195 × 290 mm

Signed with monogram, lower right

The same location is depicted from a slightly altered viewpoint in a drawing (of a similar size and technique) in the Amsterdam Historisch Museum (A 10305; S. Slive, *Jacob van Ruisdael,* exh. cat., The Hague and Cambridge, Mass., 1982, No. 74). It is there identified (on the *verso*) as 'bij Alkmar' (near Alkmaar), and elsewhere as 'de hoge voetbrug by Amersfoort' (near Amersfoort). However, it has not proved possible to check the actual location.

Both drawings are very typical works by this popular master. Slive argued that because of the 'less concentrated emphasis on the bridge' and the 'gain in airiness and light' in the Windsor drawing, then it should be dated to the years after 1655, while the Amsterdam sheet is slightly earlier. Although four drawings by van Ruisdael are noted in Inventory A (p.120), only three can be traced in the Collection today (VPD 667–9).

Provenance: presumably King George III (Inventory A: *Italian, Flemish & Dutch Landscapes.TOM.I.,* p.120, among 'Four by Ruysdael')

(VPD 669; Slive, *supra,* No. 75; RL 6607)

65 HENDRIK AVERCAMP (1585–1634)

Three figures with horse-drawn sleigh

Pen and brown ink and watercolour, over faint black lead underdrawing. The sheet edged with a black framing line. 139 × 195 mm

The forty-eight drawings by Avercamp in the Royal Collection constitute one third of the artist's known drawn *oeuvre*, and represent the largest holding in one collection. Earlier scholars have suggested that the main figures in the sleigh in No. 65 are the King and Queen of Bohemia, who visited Kampen in 1626. However, the evidence to support such an identification is lacking.

Provenance: King George III (Inventory A, p.118: *Dutch Masters*, among 42 'Drawings of some Master in the Stile of Breughel, representing the Diversions of the Dutch and Flemish on the ice &c. . .')

(VPD 18; RL 6469)

66 AVERCAMP

Skating scene

Pen and brown ink with watercolour over faint black lead underdrawing. The sheet edged with a black framing line. 175 × 294 mm

Like many of Avercamp's drawings at Windsor, this study has the appearance of being a finished work by the artist, in spite of the humorous shorthand figure style.

Provenance: see under No. 65.

(VPD 16; RL 6466)

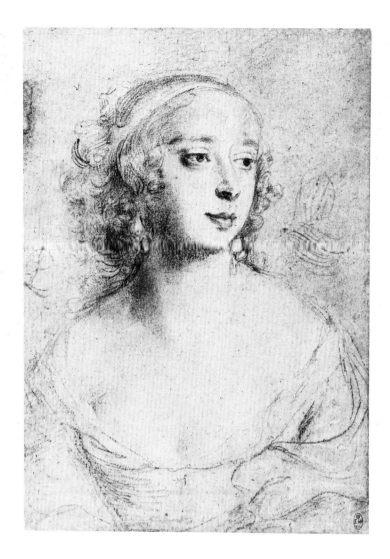

67 PETER LELY (1618–80)

Unidentified Lady
Black, white and coloured chalks on lightly primed surface. 263 × 190 mm
Inscribed in black chalk, to left and right of the sitter's head, with the monogram PL.
Watermark: illegible

Oliver Millar has recently suggested that this drawing may be identifiable with the portrait in 'Craions' of 'the late Lady *Chesterfield'*, included in Lely's sale; there is a certain resemblance of facial features between No. 67 and Lely's oil portrait of Elizabeth Butler, Countess of Chesterfield (d.1665) at Chevening (O. Millar, *Sir Peter Lely*, exh. cat., National Portrait Gallery, London, 1978, Nos. 34 and 79).

Provenance: unknown (but see above)

(VPD 610; RL 13255)

8 ISAAC OLIVER (c.1560–1617)

Nymphs and Satyrs

Black ink with white heightening over black chalk, on discoloured brown paper. The edges outlined, twice, in black; the left and right edges originally framed (in black chalk) inside the present borders. 205 × 357 mm

Inscribed in brown ink, lower right: Ollivier

This curious drawing is unique in Isaac Oliver's *oeuvre*, and in English art of around the turn of the century. The style and content are related to the work of the Northern Mannerists, and in particular of Wtewael, Spranger and Cornelis van Haarlem. Sir Roy Strong has suggested that Oliver spent some time in the Low Countries following his early training in France and before finally settling in England. In her recent biography of Isaac Oliver, Jill Finsten has commented on this sheet as follows: 'For all its complications, drama and crowded composition, it is in many ways an almost scholarly virtuoso display . . . Like the preceding [i.e. OE 459], this drawing is a high point of Oliver's most sophisticated maniera period, *c.*1600–1610' (J. Finsten, *Isaac Oliver*, New York and London, 1981, vol.2, p.217–8, cat. 182).

This was evidently executed as a work of art in its own right. Oliver's patron, Queen Anne of Denmark, may have owned his large limning of Venus, Cupid and Satyrs. This is now untraced, but appears in several seventeenth-century royal inventories and was described as a 'Somerset House piece' (*Vvd*, p.310; Finsten, *op. cit.*, cat. 96).

It is interesting to compare this drawing with the thematically rather similar sheet of studies of Rubens (No. 60), if only to demonstrate the great advances made by the younger artist following his crucial visit to Italy.

Provenance: King Charles I (*Vertue IV, W.S.* XXIV, 1935–6, p.91); King Charles II and King James II (Bathoe/Vertue, p. 56: No. 638. 'By Isaac Oliver. A drawing in black and white of satyrs and women sporting'). Not traced in Inventory A.

(OE 460; RL 13528)

69 NICOLAS POUSSIN (1594–1665)

Diana hunting

Pen and dark brown ink, with black chalk, on blue paper.
151 × 232 mm

The technique of this drawing is unusual, because of the
total exclusion of wash and the use of blue paper. Other
works of the same date (late 1620s) such as Nos. 70 and
72 have a markedly different appearance, although the
thick pen outlines are also to be found in those drawings.

This is clearly a fragment of a larger sheet, the purpose
of which is not known. It has recently been suggested by
Konrad Oberhuber (in a letter to the author) that this
drawing, with Nos. 70 and 72 below, are early copies of
lost originals by Poussin, made in the 1640s.

Provenance: from the first volume of Poussin's drawings
at Windsor, owned by [Cassiano dal Pozzo (d.1657);]
Cardinal Massimi (d.1677); Dr Richard Mead; Frederick
Prince of Wales, by c.1750; King George III (Inventory A,
p.98: *N. Poussin. The Smaller Volume*, p.16. 'Diana shoot-
ing a Stag.')

(BF 178; RL 11985)

70 POUSSIN

The Birth of Adonis

Pen and brown ink with grey wash. 183 × 325 mm

Poussin's earliest known works are the series of fifteen drawings illustrating Ovid's *Metamorphoses,* which were commissioned by the Italian poet Giovanni Battista Marino in 1623. Poussin may have met Marino at the court of Marie de' Medici, and the drawings are likely to have been intended as illustrations for a new edition of Ovid. The present drawing, which is part of the series, shows the Naiads receiving Adonis, who was born from the trunk of the tree into which his mother Myrrha had been transformed (*Metamorphoses,* X, 503). It is described in detail by Bellori, as follows: 'Tra questi scorgesi il natale di Adone, che esce dal ventre di Mirra, gia in arbore convertita, con le chiome e le braccia disciolte in frondi e con le gambe indurate in tronco; evvi una Ninfa che aiuta a trar fuori il bambino, e l'altre vi accorrono con vasi ed arredi, riguardando la sua nuova bellezza con maraviglia' (Among these we noticed the birth of Adonis, who emerges from the belly of Myrrha, who has already been transformed into a tree, with her hair and arms dissolved into foliage, and her legs hardened into a tree trunk; and there was a Nymph who helped to pull out the baby, and the others assisted with vases and cloths, regarding her new beauty with wonderment; Bellori, p.410).

The Ovidian drawings, which are all at Windsor, are characterised by the rapid line of a thick quill or reed pen, with bistre ink and a grey or grey-brown wash; the latter is a peculiar characteristic of this early period. 'They show Poussin in his pre-Roman days as a typical member of the Second School of Fontainebleau' (BF, p. 7). See also note to No. 69 above.

Provenance: G.B. Marino (d.1625); Cardinal Massimi; thereafter as for No. 69 (Inventory A, p. 99: *N. Poussin. The Smaller Volume,* p.29. 'The Metamorphoses of Myrra and birth of Adonis.')

(BF 154; BM, pp.214–15; RL 11933)

POUSSIN, *The Holy Family* or *Roccatagliata Madonna* (Detroit, Institute of Arts, Gift of Mr and Mrs A. D. Wilkinson)

Below: CAT. 71 *verso* (detail)

71 POUSSIN

The Holy Family

Pen and brown ink and wash. 139 × 106 mm

VERSO: *Fragmentary draft of a letter*, in Poussin's hand. Pen and brown ink

The content of both the *recto* and *verso* of the present sheet suggests that it was worked on by Poussin c.1639, shortly before his return to Paris. The draft on the *verso* (fully discussed by R. Salomon in *JWCI*, I, p.79–82), requests the assistance of an unknown recipient with the gaining of assurances concerning Poussin's pay and conditions of work. It is very likely that this was prompted by one of Poussin's many invitations from Cardinal Richelieu and King Louis XIII, suggesting that he should return home to France from his preferred domicile in Rome. When Poussin did return, in 1640, one of the works he painted was the *Roccatagliata Madonna* now in Detroit. That picture has various affinities with the present drawing,

particularly the setting in a domestic interior with an open window in the far wall. However, the spatial relationships and positions of the figures are quite different, and it is therefore unlikely that there is a direct interdependence from one to the other.

Provenance: see under No. 69 (Inventory A, p.100: *N. Poussin. The Smaller Volume*, p.53. 'Virgin, Child & Joseph.')

(BF 208; RL 11917)

2 POUSSIN

Dance in honour of Pan

Pen and brown ink and wash, over traces of black lead and stylus. 205 × 325 mm

VERSO: *Figure studies* (scarcely legible; possibly for a Holy Family). Red chalk

Watermark: Briquet 7628 (Fabriano, 1602)

On stylistic grounds this drawing is usually dated to the 1620s, following Poussin's arrival in Rome in 1624. It appears to show the direct influence of Titian's *Bacchanals,* and in particular of the *Bacchanal of the Andrians* (Madrid, Prado), which at the time hung in the Villa Ludovisi, Rome.

Poussin's painting of the *Bacchanal before a Herm* (London, National Gallery), datable to the late 1630s, has several elements in common with the drawing, which is perhaps surprising in view of the ten years which appear to separate them. However, this and other bacchanalian drawings have more of the baroque in them than the related paintings. During the 1620s Poussin was experimenting with many different styles. Contact with the great Italian masters may have been responsible for the unusually dynamic content, with dramatic shading, found in this and related drawings from the time. In contrast, in the bacchanalian paintings the energy was

POUSSIN, *Bacchanal before a Herm* (London, National Gallery)

tamed, and the design became more ordered and classical, and thus so typical of this most intellectual of artists. See also note to No. 69 above.

Provenance: see under No. 69 (presumably Inventory A, p.98: *N. Poussin. The Smaller Volume,* among pp.18–22. 'All Triumphs of Bacchus and Sacrifices to Priapus.')

(BF 174; RL 11979)

73 POUSSIN

St Mary of Egypt and St Zosimus

Pen and brown ink and brown wash. 226 × 310 mm

This drawing was described by Anthony Blunt as 'of great importance historically, since it is probably the earliest surviving example of Poussin's experiments in the field of landscape', and dated c.1635 or later (BF, *sub numero*). Sandrart mentioned that Claude and Poussin used to go into the Roman Campagna to sketch (see No. 79), but we know that Poussin also relied on a study of northern artists (such as Breenbergh and Poelenburg) for his depiction of the landscape. In this drawing for the first time the figures are shown as an intrinsic part of the landscape, rather than ranged in front of a landscape back-drop as in No. 70.

The subject of the drawing is St Mary of Egypt receiving the Sacrament from St Zosimus by the River Jordan, having spent forty-seven years in the desert. It has been connected with a (lost) painting of the *Magdalen in the desert* mentioned by Sandrart (see BM, p.215), and with the series of six Anchoritic subjects painted by various artists for King Philip IV at the Buen Retiro during the late 1630s. One of these (now lost) is recorded as representing a landscape 'con Santa Maria Egipciaca y el

Abad Socimas, quande la vio subir al cielo'. The subject, an unusual one, was evidently current at the time (A. Blunt, 'Poussin Studies VIII', *Burl. Mag.*, CI, 1959, pp.389–90).

Provenance: see under No. 69 (Inventory A, p.100: *N. Poussin. The Smaller Volume*, p.66. 'S:¹ Mary of Egypt receiving the Sacrament in the desert.')

(BF 195; RL 11925)

74 POUSSIN

The Confirmation

Pen and brown ink and brown wash. 182 × 258 mm

VERSO: ink study of a *female head* clearly visible from the *recto*

Watermark: similar to Heawood 796 (Rome, 1646)

The subject of this drawing is the Sacrament of Confirmation, shown as the laying-on of hands in a classical interior. Poussin executed two series of paintings of the *Sacraments*, the first (1636–42) for Cassiano dal Pozzo, and the second (1644–8) for the Sieur de Chantelou. The later series incorporates several new features, and is characterised by an increased gravity and concentration on essentials. BF 205 is a preparatory study for *Confirmation* in the first series. No. 74 is an early study for *Confirmation* in the second series (Edinburgh, National Gallery of Scotland, on loan from the Sutherland Collection), but still retaining features in common with the same subject in the first series. A second drawing (perhaps a studio work) for the same picture is in the Royal Collection (BF 261), while two others are in the Louvre.

POUSSIN, *The Sacrament of Confirmation* (detail; Edinburgh, Duke of Sutherland Collection. On loan to the National Gallery of Scotland)

Provenance: See under No. 69 (Inventory A, p.100: *N. Poussin. The Smaller Volume*, p.63. 'The Sacrament of Confirmation'); alternatively from the second volume of Poussin's drawings at Windsor, owned by [Cassiano dal Pozzo; Cosimo Antonio dal Pozzo;] Pope Clement XI; Cardinal Albani; purchased for King George III by James Adam in 1762 (Inventory A, p.101: *N. Poussin. The Larger Volume*, p.8. 'Another sketch of a Confirmation')

(BF 215; RL 11897)

75 Attributed to FRANÇOIS QUESNEL (1543–1619)

An unidentified gentleman
Black and coloured chalks, with watercolour.
301 × 222 mm

Watermark: close to Heawood 2088 (1572)

See note to No. 76. A very similar watermark appears on
the portrait of a lady in the Woodner collection, also
attributed to François Quesnel (G. Goldner, *Master Draw-
ings from the Woodner Collection,* exh. cat., Malibu, Fort
Worth and Washington, 1983/4, No. 55)

Provenance: see under No. 76

(BF 19; RL 13058)

76 QUESNEL

An unidentified lady

Black and coloured chalk, with watercolour.
307 × 229 mm

This drawing and the previous one belong to a group of eleven similar portrait studies at Windsor (BF 9–19), which appear to have been in the Royal Collection since the early seventeenth century. Inspite of their uniformly poor condition (resulting from exposure to light, possibly without glazing, and abrasion by silver-fish), it is possible to relate them to very similar studies in the Bibliothèque Nationale, Paris, which are now generally accepted as the work of François Quesnel. No. 75 is specifically related to the portrait of the Sieur de Fourcy (E, Moreau-Nélaton, *Les Clouets et leur Emules,* Paris, 1924, II, fig. 238), and more remotely to those of the Baron de Contenant and the Sieur de Clusseos (*ibid.,* II, figs. 236 and 237). Blunt suggested that, on the basis of costume, No. 76 should be dated c.1586–95, and No. 75 c.1590–1600. (For similar portraits see also J. Adhémar, 'Les Portraits dessinés du XVIe siécle au Cabinet des Estampes, Part I', *GBA,* vol. 82, 1973, p.121–98).

The two sons of the artist Pierre Quesnel (François and Nicholas) were born in Edinburgh, where their father was employed at the court of King James V of Scotland. They moved to France in 1572, and found employment at the courts of Henri III and later Henri IV.

Provenance: probably (with BF 2, by Clouet) the remaining portion of the volume of 49 portraits 'in dry Cullors of the Cheifest Nobility and famous men at that tyme in ffraunce', listed by Van der Doort in the Collection of King Charles I (*VdD,* p.125); the volume had been presented to the King by the Duc de Liancourt (French Envoy to the Court of St James). The drawings cannot be traced in Inventory A.
(BF 12; RL 13059)

APOLLON. LE ROY.

HENRI DE GISSEY (c.1621–73)

Louis XIV as Apollo

Black lead, with bodycolour, watercolour, gold paint and oxidised silver. Vellum, 295 × 214 mm

Inscribed in brown ink along lower edge: APOLLON . LE ROY

The identification of the dancer in this study as 'The Sun King', Louis XIV, is suggested by the inscription and confirmed by comparison with the drawing of the young King's dress in the *Description particulière du grand ballet* et *comédie des Nopces de Pelée et de Thétis* (by Benserade), performed under the direction of G. Torelli, and to the music of Carlo Caproli, at the Salle du Petit-Bourbon on 14 April 1654 (Paris, Institut de France, MS 1005; illustrated in M.-F. Christout, *Le Ballet de Cour de Louis XV*, Paris, 1967, Pl. XIX, No. 33). It has plausibly been suggested that Gissey, described in the same year as 'dessinateur ordinaire du Cabinet du Roi', was responsible for the costume designs (numbering 73 in all) for the 'ballet de cour' in this production (which was performed on five subsequent occasions). Five similar drawings also related to the *Noces* are in the Musée Carnavalet, Paris. (L. Guilmard-Geddes, 'Les Noces de Pelée et de Thétis', *Bulletin du Musée Carnavalet*, 1977, pp.5–9; 'La Guerre' and the Fury were included in *The Sun King*, exh. cat., Louisiana and Washington, 1984–5, Nos. 156 and 157.) The technique is identical, with a similar use of gold paint. Unfortunately in the Windsor drawing (unlike the Paris ones) the original colours have faded badly, following exposure to light. It shows a richly decorated costume, encrusted with gold and precious stones. The headdress consists of feathers supported by a diadem of rubies and pearls.

These drawings are evidently depictions of, rather than designs for, costumes in the ballet sequences. Three of them (No. 77 and two of the Musée Carnavalet drawings) are related to the King's own costume. Louis XIV himself appeared as Apollo in the Prologue, a Fury in Act I, a Dryade in Act II, both an Indian and a Courtier in Act III, and finally as War. The performance of the *Noces* on 14 April 1654 was attended by several members of the exiled Stuart court. King Charles II and his mother, Henrietta Maria, were in the audience, while Princess Henrietta Anne ('Minette') participated in the ballet of the Prologue as the muse Erato, in attendance on Louis XIV's Apollo (see M.-F. Christout, *op.cit.*, especially p.260; C. Oman, *Henrietta Maria*, London, 1936, p. 232).

Louis XIV's enthusiasm for the ballet was first made public in his appearance in *Le Ballet des Fêtes de Bacchus* in May 1651. Among the audience was John Evelyn, who commented: 'the glory of the Masque was the greate persons performing in it, the French King, his brother the Duke of Anjou, with all the Grandees of the Court, the King performing to the admiration of all . . .' (Evelyn, *Diary*, 11 May 1651). In *Le Ballet de la Nuit* (February 1653), again to verses by Benserade, Louis XIV appeared as the Sun, leading twenty-two aristocratic dancers (representing the genii of Humour, Grace, Love, Valour, Victory, Favour, Fame and Peace) in the *grand ballet*. The King's costume in that Ballet was probably also designed by Gissey and his studio. It is known from a watercolour in the Bibliothèque Nationale, Paris (a photograph of which was included in *Spotlight*, exh. cat., Victoria and Albert Museum, London, 1981, No. 27).

Gissey's work as theatrical designer was noted by both Mariette and the Abbé de Marolles. The latter wrote in verse: 'Jesse [sic] fut admirable. A former des dessins pour des jeux de ballets. / Ses crayons achevés ne portoient rien de laid / D'une manière fine et d'un air agréable . . .'. His style was directly dependant on that of Stefano della Bella who had worked for the French Court during his period of residence in France from 1639 to 1649 (see No. 99). Gissey's costume designs for *Psyche*, performed in the Tuileries in January 1671, are in the Nationalmuseum, Stockholm (J. de la Gorce, 'Les Costumes d'Henry Gissey pour les représentations de Psyche', *GBA*, No. 66, 1984, pp.39–52). In the Victoria and Albert Museum there are six drawings attributed to Gissey, including one which may be a design for Louis XIV's costume, c.1660 (B. Reade, *Victoria & Albert Museum: Ballet Designs and Illustrations 1581–1940*, London, 1967, No. 24–9). The survival of a large number of costume designs attributed to Gissey demonstrates that he maintained an active studio in which his original ideas were duplicated and developed.

Provenance: unknown

(BF 72; RL 13071)

78 CLAUDE GELLÉE,
 called LE LORRAIN (1600–82)

The Landing of Aeneas in Italy

Pen and brown ink, with brown and grey washes and
black chalk, and some white heightening. 257 × 335 mm

Inscribed in ink, lower left: CLAVDIO . I . V . F. / Roma .
1677

This finished piece belongs to a large group of drawings
connected with Claude's picture of *The Landing of Aeneas
in Italy*, painted for Prince Gasparo Altieri and now at
Anglesey Abbey (National Trust). The painting was com-
missioned as a pendant to an earlier picture by Claude of
an unrelated subject (*Landscape with the Father of Psyche
sacrificing to Apollo*, 1662). The Altieri family considered
themselves descendants of Aeneas, the legendary
founder of Rome, and on the *verso* of one of the
preparatory studies (in Stockholm) for the *Aeneas* paint-
ing Claude explained his source: 'Claudio Gile inventor
. . . Ill.° principe don Gaspare mi a detto che desidera il
sugiette / de Aenea che mostra il ramo di uliva a palante
per / signo di pace – libro 8 di Virgilio' (Invented by
Claude Gelée. Prince Gasparo told me he desired the
subject of Aeneas showing the olive-branch to Pallas as a
sign of peace – Book VIII of Virgil). According to Virgil,
Pallas was the son of King Evander, ruler of Pallanteum,
the future site of Rome.

The earliest preparatory drawing for the picture is
dated 1671. The painting was completed in 1675, and
thereafter the composition was copied at least three
times on paper: once in the *Liber Veritatis*, once in a
drawing in the Uffizi, and in the present piece (see
Russell D67). Diane Russell has suggested that the initials
following Claude's name in the signature may signify

CLAUDE, *The Landing of Aeneas in Italy* (Anglesey Abbey, National
Trust)

'Invenit et fecit'. Claude thus indicated (as he did on his
etchings) that he was responsible not only for the orig-
inal concept but also for the execution of this copy. There
are a number of small variations from the picture, which
led Blunt to suggest that it was 'a preparation for a new
painting'. The penwork in this drawing, carried out by
Claude in his late seventies, is remarkably fine. The
subtle gradations in the tone of the different areas of
wash are typical of his late work.

Provenance: [? Cardinal Massimi;] King George III
(Inventory A, p.115: *Paesi di Claudio Loranese e altri*,
among pp.1–18: 'Eight Landscapes mostly large Draw-
ings of Claudio Loranese, Seventeen small studies – ten
pages.')

(BF 48; RL 13081)

Cat. 79 verso

9 Claude

The wall of a villa near Rome
Pen and brown ink and brown wash. 128 × 93 mm
VERSO: *Figure studies,* in pen and ink
Watermark (fragmentary): similar to Heawood 921

One of a group of 38 small drawings, of which 12 are in
the Royal Collection while others are at the British
Museum and elsewhere. These may once have con-
stituted a single notebook. Several incorporate views of
buildings in or around Rome, which was Claude's home
from 1625 until his death in 1682. Joachim von San-
drart, who was in Rome from 1628 to 1635, records
many drawing and painting expeditions to the Roman
Campagna with Claude. It is very likely that these small
sketches were made during these early years. The dia-
gonal viewpoint and parallel vertical hatching of this
drawing set it somewhat apart from the other sketches of
the group.

Provenance: see under No. 78

(BF 50; RL 13084)

80 CLAUDE

Landscape with river and bridge

Pen and brown ink and brown wash. 96 × 153 mm
(illustrated actual size)

VERSO: *Fragment of a letter*, in pen and ink

The influence of northern artists such as Breenbergh and
Callot would suggest that this drawing is an early
(experimental) work of c.1640. It does not appear to be
related to any known painting, and on the evidence of
the *verso* has been trimmed.

If the writer or recipient of the letter on the *verso*
(neither of whom seems to have been Claude) could be
identified, a precise date might be easier to ascertain.

Provenance: see under No. 78

(BF 49; RL 13095)

1 CLAUDE

Landscape with a dance

Pen and brown ink, brown and grey wash, black chalk and white heightening on buff paper. 342 × 442 mm

Inscribed lower left, in pen and ink: CLAV 1663 / Roma (the last word partly cut off)

VERSO signed in pen and brown ink, lower centre: CLAVDIO I · V · fecit; inscribed (by a later hand) in pen and brown ink: Claudio Lorenese vero

CLAUDE, *Marriage of Isaac and Rebecca* (London, National Gallery)

Like No. 78 this is a finished work by Claude, but unlike that drawing it is not directly connected to any oil painting. There is an obvious relationship with the painting of the *Marriage of Isaac and Rebecca* (London, National Gallery), dated 1639, but during the intervening twenty-four years Claude's art had developed considerably. By the time of this drawing the subject is more predominantly the landscape, and in particular the two groups of majestic trees occupying the central area. These are strongly modelled in light and shade, and the figures below are thus less significant.

Provenance: see under No. 78

(BF 41; Russell 56; RL 13076)

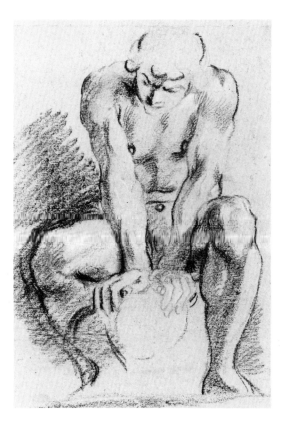

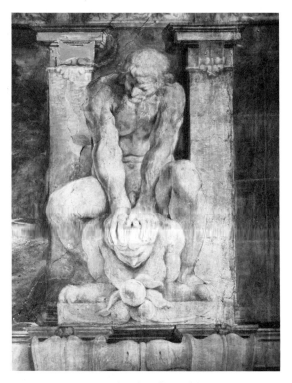

LUDOVICO CARRACCI, *Seated Nude* (Bologna, Palazzo Fava)

82 LUDOVICO CARRACCI (1555–1619)

Seated nude figure

Black chalk (two shades) and white chalk on blue paper.
341 × 237 mm

This drawing is apparently a life study made in prepara-
tion for the figure of a male nude crushing a harpy,
painted in grisaille between two scenes of the Aeneid in
the Palazzo Fava, Bologna. The drawing of the sitter's
right leg shows a significant adjustment from prelimi-
nary to final position. In the finished painting the group
becomes yet more compact, with the feet tucked in
behind the front legs of the harpy, and the thumbs
crossed. According to Malvasia, the Carracci studio won
the contract to carry out painted decorations in the
Palazzo Fava partly through the fact that Antonio Car-
racci (Annibale and Agostino's father) was tailor to
Count Filippo Fava, and partly because they offered to
carry out the work at a very low price. It was their first
major commission, and initially involved two large
frescoed friezes, with narrative pictures (on the subject of
Jason and the Argonauts, and the story of Europa), plus
decorative panels and monochrome terms. Work began
c.1583 with Ludovico in charge, and personally respon-
sible for the major elements of the scheme. His younger
cousins Annibale and Agostino worked on the subsidiary
room, concerning the story of Europa, and then assisted
Ludovico in the larger room. After completing work on
the Europa and Jason cycles, in c.1586 the Carracci

painted a third frieze in the Palazzo Fava, illustrating
scenes from the Aeneid. The twelve narrative panels
were separated by monochrome figure groups, com-
posed of a warrior struggling with a harpy. The majority
of work on this series was by Ludovico, although
Annibale contributed three panels and one warrior and
harpy group (see D. Posner, *Annibale Carracci*, London,
1971, Vol. I., pp.53–7, and Vol. 2, pp.15–16, No. 30).

The two main repositories of drawings by the brothers
Agostino and Annibale Carracci, and their cousin
Ludovico, are the Louvre and Windsor. The series of over
six hundred studies at Windsor came from three distinct
sources. The first group includes those drawings already
listed in the Collection in the early eighteenth century
(Kensington Inventory). The second group was acquired
in 1762 with the Albani collection, having previously
belonged to Domenichino (who spent his formative
years in the Carracci workshop), to Raspantino and to
Maratta. The third group was also acquired in 1762, with
Consul Smith's collection, having belonged to the Bon-
figlioli family in Bologna in the seventeenth century, and
thereafter to the Sagredo family in Venice. The drawings
are listed in Inventory A, but had evidently been re-
arranged into one unified *corpus* by that time, thus losing
all indication of their provenance.

Provenance: see above. King George III (Inventory A,
p.76: *Caracci. TOM.6*, 'A figure in the Fava Gallery at

(W 3; RL 2082)

3 ANNIBALE CARRACCI (1560–1609)

Study for the Conversion of St Paul

Pen and brown ink on cream paper. 345 × 255 mm

VERSO: additional studies for the same composition, in pen and ink

The economy of line and the vigorous pen and ink drawing of this study would suggest a date in the late 1590s, following Annibale's transfer to Rome. No painting of the *Conversion of St Paul* by Annibale is known, but this sheet (and two others at Windsor, W 401 and 402) were identified by Wittkower as preparatory for a composition of this subject. The drawings on the *verso*, which were revealed during restoration in March 1985, are clearly for the same composition. St Paul's horse is held by the same youth as on the *recto*, but now standing on the far side. The legs of the fallen figure of St Paul are visible at lower left, but in a quite different position to those on the W 399.

The horse plus taming youth on both *recto* and *verso* of this sheet are likely to have been at least partly inspired by the classical figures of Horse Tamers which Annibale would have seen on arrival in Rome.

Provenance: see under No. 82 (Inventory A, p.75: *Caracci.TOM.4.*, one of '3 studies for the Picture of the Conversion of St. Paul. [An: Caracci]')

(W 400; RL 1989)

84 ANNIBALE CARRACCI

Self-portrait

Black and white chalk over traces of black lead on blue
paper. 381 × 249 mm

The directness of gaze, the generic similarity of the sitter
to that in Agostino's self-portrait (W 164), and the
technical affinities between this drawing and other
studies of the later 1570s (while Annibale was in his
teens) have combined to suggest that this is an early self-
portrait. If the drawing is much later than 1580 (as has
been suggested by Mahon), such an identification
becomes untenable. There is also a certain resemblance
to the painted self-portrait published by Posner (*op.cit.*
under No. 83, vol.2., No. 1, pl.1), and dated c.1580 by
which time the face had become slightly plumper, and a
thin moustache had grown.

Provenance: see under No. 82 (Inventory A, p.77: *Car-*
acci.TOM.9, one of '46 studies of Heads . . . by Anib:
Caracci')

(W 360; RL 2254)

85 GIANLORENZO BERNINI (1598–1680)

Self-portrait
Black chalk heightened with white on buff paper.
415 × 270 mm
Watermark: close to Heawood 5 (Rome,
seventeenth century)

Although chiefly known as a sculptor (and architect),
Bernini also executed a number of drawn and painted
self-portraits, which may include a youthful study in the
Royal Collection (BR 53) and two portraits in the Ash-
molean from the artist's middle years. This drawing
probably dates from around the time of Bernini's visit to
Paris in 1665. It has an intensity and a degree of finish
that are quite distinct from Bernini's designs for sculp-
ture (e.g. No. 86).

Provenance: [probably Albani collection; purchased
1762 by] King George III (Inventory A, p.114: *Giovan
Lorenzo Bernino, TOM .I,* among '7 portraits')

(BF 54; RL 5539)

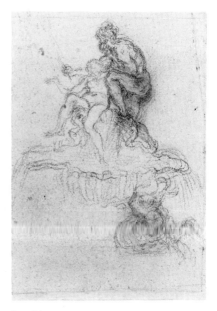

CAT. 86 *verso*

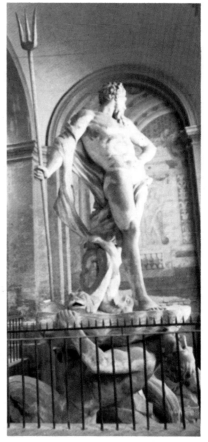

86 BERNINI

Design for a Fountain of Neptune

Black lead and black chalk on coarse buff-coloured paper. 345 × 236 mm

VERSO: *Variant design for a Neptune fountain* (inverted). Black lead and black chalk.

With a drawing of a river god and dolphin in the Talleyrand collection, Paris (H. Brauer and R. Wittkower, *Die Zeichnungen des Gianlorenzo Bernini*, Berlin, 1931, pl.34), and BR 45, these drawings (on both *recto* and *verso*) are related to the two stucco fountains in the courtyard of the Palazzo degli Estensi, Sassuolo (Modena), commissioned by Francesco I d'Este from Bernini in 1652, but executed under the direction of Antonio Raggi. The fountain of Neptune at Sassuolo was one of a number of projects for Neptune fountains undertaken by Bernini. The best known of these is now at the Victoria and Albert Museum, London, having been transferred there from the Villa Montalto.

Provenance: see under No. 85 (Inventory A, p.114: *Giovan Lorenzo Bernino.TOM.II*, among seven 'Designs of Fountains in different parts near and at Rome')

(BR 44; RL 5624)

BERNINI, *Fountain of Neptune* (Modena, Sassuolo, Palazzo degli Estensi)

PIETRO DA CORTONA (1596–1669)

Study for the Death of Turnus

Pen and brown ink and brown wash, with some red chalk. 163 × 237 mm

VERSO: *Figure studies.* Pen and brown ink, black lead and red chalk

The *Death of Turnus* was one of the episodes of the life of Aeneas selected for the decoration of the vault of the Gallery in the Palazzo Pamphili, Rome (see G. Briganti, *Pietro da Cortona*, Florence, 1962, pp.250–1). The overall subject-matter was chosen because of the legendary descent of the Pamphili family from Aeneas (cf. No. 78 above). The Palazzo was rebuilt to Borromini's designs for the Pamphili Pope Innocent X from 1648. The decoration of the Gallery was one of two projects commissioned from Pietro da Cortona by the Pope. In 1652 he prepared the cartoons for the mosaic decorations of the vaults of St Peter's for the same patron. Work on the Gallery extended from 1651 to 1654, the year before the Pope's death. The scene shown in this drawing was to occupy an irregular-shaped area at one end of the Gallery. Unlike the drawing, where Aeneas is shown centrally, in the fresco he appears to the left, with his sword arm raised. In the fresco the body of Turnus lies the other way round, with his legs facing out. The curved architectural setting of the composition is reminiscent of Pietro da Cortona's designs for the 'teatro' at the Palazzo Pitti, Florence (1640–7). Some of the drawings on the *verso* are evidently for the same decorative scheme. A preliminary study for *Juno and Aeolus* for one of the oval panels in the ceiling of the Pamphili Gallery is also at Windsor (BR 606).

CAT. 87 *verso*

PIETRO DA CORTONA, *Death of Turnus* (Rome, Palazzo Pamphili)

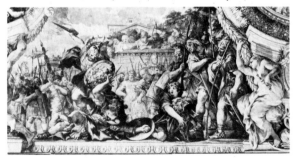

Provenance: King George III (Inventory A, p.111: *Pietro Beretino da Cortona.TOM.I.*, 'The Combatt of Aeneas and Turnus')

(BR 605; RL 4524)

DOMENICHINO, *The Last Communion of St Jerome*
(Rome, Pinacoteca Vaticana)

88 DOMENICO ZAMPIERI,
 called DOMENICHINO (1581–1641)

Study for 'The Last Communion of St Jerome'
Black and white chalk on blue paper. 390 × 314 mm
Watermark: similar to Heawood 1629 (Rome, 1602)

One of a group of thirty-four drawings at Windsor for
Domenichino's altarpiece of *The Last Communion of St
Jerome* (Rome, Pinacoteca Vaticana), commissioned for
the church of S. Girolamo della Carità, Rome, and dated
1614. What were presumably these same thirty-four
drawings were listed in the collection of Domenichino's
pupil and heir, Francesco Raspantino, and passed into
the Royal Collection via the collections of Carlo Maratta
and the Albani family. Thirty-two of these drawings are
noted in Inventory A, p.89. Other preparatory studies are
listed by Spear (R. Spear, *Domenichino*, New Haven, 1982,
p.176, under No. 41). The painting, which was
Domenichino's first altarpiece, was evidently the result
of painstaking preparation, and was immediately the
subject of critical discussion. It aroused favourable
opinions from artists such as Poussin and Sacchi, but
Pietro da Cortona stated that 'all the painters said bad
things about it'. The fact that several elements of the
composition rely heavily on Agostino Carracci's earlier
painting of the subject in Bologna (formerly Certosa,

now Pinacoteca) did not escape notice. Domenichino
owned several of Agostino's preparatory studies for the
painting. Of these only three copies appear to have
survived at Windsor (W 267–9).

Provenance: Francesco Raspantino; Carlo Maratta;
Albani family; King George III (Inventory A, p.96:
Domenichino. TOM XXXIV., 'A Study of S:ᵗ Jerome (in his
celebrated picture)')

(JP-H 1071; RL 1732)

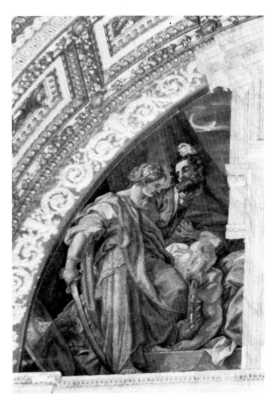

MARATTA, *Judith with the head of Holofernes* (mozaic; Rome, St Peter's, Chapel of the Presentation of the Holy Virgin)

89 CARLO MARATTA (1625–1713)

Head of Holofernes

Red and white chalk on blue paper. 330 × 258 mm

VERSO inscribed in pen and black ink: N.º 10 –

The decoration of the Chapel of the Presentation of the Holy Virgin (second on the left) in St Peter's, Rome, was Maratta's largest commission and occupied him for over forty years, remaining incomplete at his death (see J. K. Westin and R. H. Westin, *Carlo Maratti and his Contemporries*, exh. cat., Pennsylvania State University, 1975, pp.59–67). He was to provide painted cartoons for translation into mosaic for all the main wall surfaces of the Chapel. The lunettes above the altar were to contain depictions of *Judith with the Head of Holofernes* (for which the present drawing is preparatory), and of *Jael and Sisera*, for which two finished preparatory drawings also survive at Windsor (BR 293 and 294). This was the first area of the chapel to be worked on: the canvases for Maratta's painted cartoons were ordered in March 1674. However, work on laying the mosaics in this area was not commenced until 1686.

The compositional study for the *Judith* cartoon is in New York (Metropolitan Museum of Art; Westin, exh. cat., No. 38, Fig.45). There both the figure of Judith and the head of Holofernes appear frontally. In the finished cartoon (Rome, St Peter's, Benediction Loggia; *ibid.*, Fig.46) both are turned inwards, towards the centre. The present drawing was evidently made at an advanced stage, following this alteration. Other drawings for the composition are in Düsseldorf.

Provenance: Albani family; King George III (presumably among Inventory A, pp.107–10: *Carlo Maratti. TOM.I–VI.*)

(BR 288; RL 4166)

MARATTA, *The Madonna and Child appearing to St Francis of Sales* (Forlì, Galleria)

90 MARATTA

Study for St Francis of Sales

Red and white chalk on blue paper. 417 × 282 mm

A study for the painting of *The Madonna and Child appearing to St Francis of Sales* in the Gallery at Forlì, datable before 1691. The figure in the drawing is very close to that in the painting, although the Saint is there shown bearded. Other studies for the picture are at Düsseldorf (A. S. Harris and E. Schaar, *Die Handzeichnungen von Andrea Sacchi und Carlo Maratta*, Düsseldorf, 1967, Nos. 372 and 373).

Provenance: see under No. 89 (Inventory A, p.107: *Carlo Maratti.TOM.I.*, 'St Francis')

(BR 263; BM, p.92; RL 4128)

1 GIOVANNI BATTISTA SALVI
called IL SASSOFERRATO (1609–85)

The Penitent Magdalen

Black and white chalk on blue paper. Squared for transfer. 391 × 243 mm

Inscribed centre top, in pen and brown ink: 10

VERSO: *Standing female figure.* Black and white chalk. Squared for transfer

The composition for which the studies on both *recto* and *verso* of the present sheet are preparatory has not been identified. In their meticulous dry use of chalk they are typical works of Sassoferrato, who is represented by an unsurpassed group of sixty drawings at Windsor (BR 873–932).

François Macé de Lepinay has recently pointed out a possible connection between these drawings and an untraced painting formerly in the Veronici collection (letter to the author, 27 March 1985): 'VII – Crocifisso con la Maddalena – Qualche incertezza di modellato nella figura del crocifisso, ma buon partito di chiaroscuro. Bella la testa della Maddalena' (G. Vitaletti,

Il Sassoferrato, Florence, 1911, p.31). The artist's grand-daughter Angela (married to Filippo Veronici) was his principal heir (R. C. Ippoliti, 'I discendenti e l'eredità del pittore G. B. Salvi', *Arte e Storia,* XXVI, 1907, p.165).

Provenance: probably purchased by Richard Dalton in Rome for King George III (undated document RA Geo. 15602–3); King George III (Inventory A, p. 104: *Giovanbatista Salvi detto il Sasso Ferrato,* among sixty-seven 'Study's for Various Pictures of Madonnas, Saints &c: mostly copies from Raphael, Guido & others (as He was not fertile in Invention) with several portraits drawn from the Life.')

(BR 923; RL 6076)

92 GIOVANNI FRANCESCO BARBIERI
called IL GUERCINO (1591–1666)

Personification of Peace

Charcoal (partly oiled), and black and white chalk on green-grey paper. 395 × 321 mm

The figure of Peace touches a pile of armour and arms with the end of the lighted torch held in her right hand. The personification accords with that given in Ripa's *Iconologia:* 'Donna, che nella destra mano tiene una face accesa rivolta in giù, & sotto à quella vi e un monte di arme di più sorte' (A woman, who holds in her right hand a lit torch turned towards the ground, below which is a pile of arms of different kinds: C.Ripa, *Iconologia*, 1618, p.394). This and a pen and wash drawing of *Peace and Time* in Turin (Mahon 179) appear to date from about 1618/20. No related painting is known.

Provenance: Guercino's heirs, the Gennari; sold by Carlo Gennari, probably in 1763, to Richard Dalton, King George III's Librarian; King George III (Inventory A, p.67: *Guercino.TOM.X.*, 'Emblem of Painting')

(Mahon 180; M&T 147; RL 2876)

CAT. 93 *verso* (detail)

3 GUERCINO

Landscape with a walled town

Pen and brown ink. Partly surrounded by a framing line.
287 × 213 mm

VERSO inscribed in brown ink, in a seventeenth-century
hand (which is neither Guercino's, nor that of his brother
Paolo Antonio): 1635 / Sono in tutte Carte numero 32/
che fanno 32 disegni / Opera del Sig.ᵣ Gio: Francesco
Barbieri da Cento (1635. There are 32 pages in all, which
makes 32 drawings. The work of Signor Giovanni
Francesco Barbieri of Cento)

This drawing belongs to a group of landscape studies by
Guercino at Windsor, which were evidently intended as
works of art in their own right, rather than as
preparatory studies for paintings. The date of this series is
provided by the inscription on the *verso*, uncovered
during restoration work on the sheet in March 1985.

It is safe to assume that this and two other landscape
drawings at Windsor which are *en série* with it (RL 2761,
M&T 249; and RL 2763, M&T 248) were part of the group
of thirty-two drawings referred to in the inscription, all of
which were probably landscapes.

One of the difficulties in studying Guercino's land-
scape drawings has been the lack of fixed points around
which to assemble them, and hence the impossibility of
firmly establishing his stylistic development in this
genre. Indeed, only one other landscape drawing
appears to bear a date, that in the Uffizi, Florence (inv.
no. 590P), drawn in 1626. The significance therefore of
the date inscribed on the *verso* of this drawing is consider-
able and permits other landscape drawings stylistically
similar to No. 93, RL 2761 and RL 2763, of which there
are a large number, to be dated to the 1630s.

The upright format of No. 93 is rather unusual, but the
technique is entirely typical of Guercino's works. The
contours of the landscape are built up with interlocking
sections of parallel hatching, while the curving route of
the roadway leading to the gate of the town remains
white. It looks forward to the *vedute di fantasia* of Marco
Ricci.

Provenance: see under No. 92 (Inventory A, p.65:
Guercino. TOM. VII., nineteen drawings 'of landscapes.')

(Mahon 204; M&T 248; RL 2762)

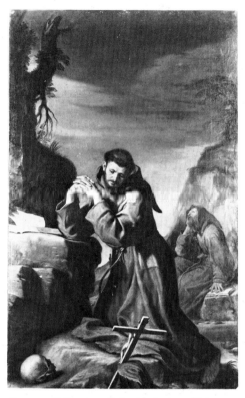

GUERCINO, *St Francis meditating in a landscape* (Bologna, S. Giovanni in Monte)

94 GUERCINO

St Francis meditating in a landscape

Pen and brown ink and brown wash, with traces of grey wash in the sky. 280 × 184 mm

This drawing is a preparatory study for Guercino's altarpiece of 1645 in the church of S. Giovanni in Monte, Bologna. There are several minor differences between the two, some of which recur if No. 94 is compared with a (lost) drawing by Guercino known from Bislinger's etching of 1781. Francesco Bartolozzi, who may have been instrumental in securing the purchase of the best part of the Casa Gennari collection for King George III, made a copy of this drawing which is now in the Lugt collection, Paris (Mahon, p.145).

Provenance: see under No. 92 (Inventory A, p.63: *Guercino. TOM. V.*, 'St Francis')

(Mahon 152; M&T 112; RL 2582)

GUIDO RENI, *St Dominic received into Heaven* (detail; Bologna, S. Domenico)

5 GUIDO RENI (1575–1642)

Music-making angel

Black chalk and charcoal, heightened with white on grey paper. 378 × 240 mm

This is one of a group of studies for the fresco of *St Dominic received into heaven* in the apse above the tomb of the Saint in S. Domenico, Bologna, on which Reni was engaged from 1613 to 1615. The angel shown here occupies a position below and to the right of the Saint. A comparable position on the left side is occupied by another angel, seen in a preparatory drawing in an American private collection. Reni's drawing for the central figure of the Saint is in the Louvre (D. S. Pepper, *Guido Reni,* Oxford, 1984, under No. 44, pp.229–30).

Provenance: [possibly among the Reni drawings which passed from the Bonfiglioli collection to Zaccaria Sagredo; Consul Joseph Smith;] King George III (presumably Inventory A, p.81: *Guido &c. TOM 6.* among '9 studies for Draperies. all these by Guido')

(KB 341; RL 3464)

96 GIOVANNI BENEDETTO CASTIGLIONE (c.1600–65)

Adoration of the Shepherds

Drawn in brown, red and blue oil paint, heightened with white. 362 × 250 mm

The 212 drawings by Castiglione in the Royal Library amount to over half of his surviving work as a draughtsman. A large number of these drawings (including Nos. 96 and 97) employ a medium that involved the suspension of pigment in linseed oil. This technique led to an increased freedom and richness of chiaroscuro effect, more typical of an oil sketch in the normal sense than of a drawing.

 This drawing is not known to be related to any finished painting. The figure of the Virgin appears to derive from the etching Bartsch XXI, p.15, No. 10. This study has been described as belonging to a small group of drawings of c.1648–55 employing a very diluted oil technique 'so that at first sight it looks like water-colour, and in some cases oil and water-colours are used on the same drawing'; owing to the 'considerable looseness in drawing . . . it is possible that they may be the work of a competent imitator' (BCS, *sub numero*).

Provenance: [Sagredo family, Venice;] Consul Joseph Smith; King George III (Inventory A, p.130: *Castiglione, TOM.IV.*, 'A Nativity')

(BCS 139; RL 4009)

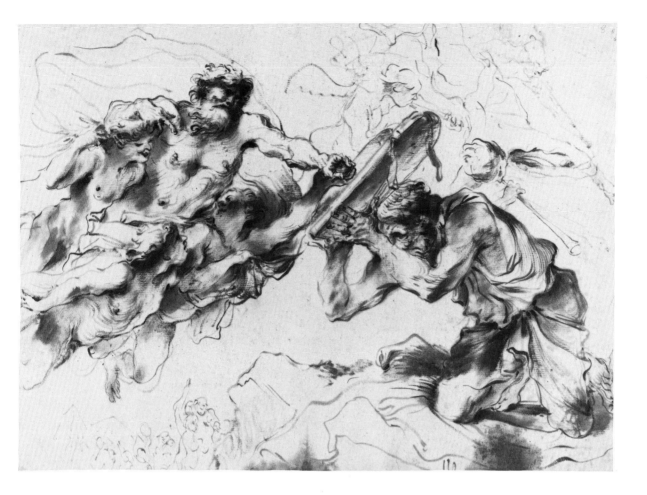

7 CASTIGLIONE

Moses receiving the Law (PLATE III)

Drawn in brown oil paint. 412 × 571 mm

Inscribed top right, in black lead: 8

'One of Castiglione's noblest and most original designs, [which] may date from the very last Roman years and shows other features which reveal Castiglione's sources at the time. The types of putti and the God the Father are strongly reminiscent of Bernini's sculpture, which Castiglione must have studied during the forties in Rome; but there are also echoes of Rubens, notably of the Circumcision which Castiglione would have seen in S. Ambrogio, Genoa. The *di sotto in sù* view of the heads of two of the putti and the particular method of dealing with the foreshortening involved are taken directly from this model, which Castiglione must have known since his youth' (BCS, p.16).

Provenance: see under No. 96 (Inventory A, p.131: *Castiglione. TOM. V.*, 'Moses receiving the Laws')

(BCS 128; RL 4037)

98 CASTIGLIONE

'Temporalis Eternitas'

Monotype (white on black ground). 296 × 202 mm

Inscribed on the base of the statue: GIO BENEDITVS /CASTILOGNE (the L and N reversed) / 1645

The monotype (a technique first practised by Castiglione) combines the techniques of drawing and printing. It involves taking a single pull from a metal plate on which a design has been drawn in printer's ink. No cutting, acid biting or engraving of the plate is required.

The present monotype is evidently derived both in form and content from Poussin's painting *Arcadian Shepherds* of c.1630 (Chatsworth, Devonshire Collection). The title of the monotype is as given in the related etching (Bartsch xxi, p.23, No. 25; see A. Percy, *G. B. Castiglione,* exh. cat., Philadelphia, 1971, E13, pp.140–1). It has been suggested that this should be translated with the verb 'est' interposed, meaning 'eternity exists in time'. The subject-matter of these related works has been much discussed. In general terms they refer to the transitory nature of earthly accomplishments. In specific terms, Castiglione's meaning appears to derive from passages in Cicero, Aristotle and St Thomas Aquinas (Percy, *loc.cit.*).

Provenance: see under No. 96 (the monotypes do not appear to be listed in Inventory A)

(BCS 215; RL 3946e)

99 STEFANO DELLA BELLA (1610–64)

Standing female figure in theatrical costume (PLATE V)

Pen with brown ink and grey wash over traces of black lead. 330 × 207 mm

This drawing dates from Stefano's years in Paris (1639–49) where he was involved in providing designs for a number of theatrical performances. During these years his figure style developed from its early dependence on Callot and Cantagallina, increasing in scale and breadth to drawings such as the present one, with 'a subtlety of pose which almost leads on to the eighteenth century' (BCS, p.91). Stefano's theatrical work in Paris remained a vital influence there after his return to Florence in 1649, and can be traced in the designs of French artists such as Gissey (e.g. No. 77) and Berain. The costume drawings in the British Museum, made by Stefano following his return to Florence, were recently the subject of a detailed study (P. D. Massar 'Costume Drawings by Stefano della Bella for the Florentine Theater' *M.D.*, vol. VIII, No. 3, pp. 243–66).

During his residence in Paris Stefano was also commissioned by Mazarin to design a number of sets of instructive playing cards for the use of the young Louis XIV. The figures in one of these sets (*Jeu des Reynes Renommées*), published in 1644, have certain generic similarities with the figure in the present drawing.

Provenance: one of a group of 152 drawings by Stefano at Windsor. King George III (Inventory A, p.122: *Stefanino della Bella.TOM.I.*, among sixty drawings relating to 'Some compositions and a prodigious variety of all kinds of sketches, of which those done with a pen are most admired')

(BCS 23; RL 4581)

THE EIGHTEENTH CENTURY

By 1700 all the traditional drawing techniques and media had been mastered by artists throughout Europe. The chief developments of the eighteenth century concerned experimentation with colour, whether by juxtaposing different shades of chalk (Nos. 101, 121 and 122), or through the new art of watercolour painting. The use of graphite (first discovered in Cumberland in 1560, but only widely available from c. 1700) facilitated the precise topographical touch of artists such as Thomas Sandby (No. 120) and Henry Edridge (Nos. 124 and 125).

With increased facility in draughtsmanship the use of sketchbooks (in which to record a fleeting gesture or pose) became more widespread. Drawings such as Nos. 102, 121 and 122 recall Caylus' (not entirely reliable) description of Watteau's method: 'most ordinarily he drew without object . . . His custom was to draw his studies in a bound book, in such a way that he always had a large number at hand.

ANTONIO VISENTINI
Title-page to volume of Sebastiano Ricci's drawings, formerly in Consul Smith's collection (detail of BV 532; RL 6990A)

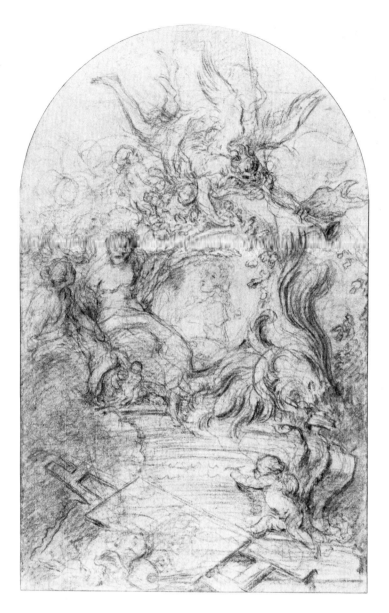

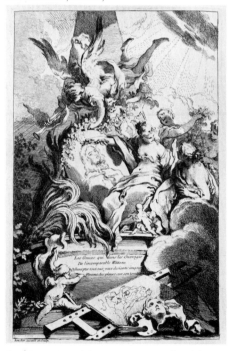

BOUCHER, engraved frontispiece to Jean de Julienne, *Figures de différents Caractères*, vol. II, 1728 (London, British Museum)

100 FRANÇOIS BOUCHER (1703–70)

Design for a frontispiece

Black chalk on blue paper. 460 × 294 mm (irregular)

VERSO: *Variant design for a frontispiece.* Black chalk

One of Boucher's first recorded commissions was concerned with Jean de Julienne's *Figures de différents Caractères de Paysages et d'Etudes,* which consisted of engravings of all the drawings bequeathed by Watteau to Julienne (and a small group of others) at his death in 1721. The frontispiece to volume II of this publication, issued in 1728, was based on the present drawing. A variant design for the frontispiece was recently revealed on the *verso* when the sheet was lifted from its old backing paper. The influence of Watteau on Boucher's art was profound, and with the impressions gained during his three-year stay in Rome (1728–31), provided the formative impetus for his mature style.

Provenance: King George III (Inventory A, p.103: *N. Poussin, le Seur &c. TOM. III.,* 'An ornamental sketch by Boucher')

(BF 311; RL 6180)

BERNARD PICART (1673–1733)

A Lady resting

Red chalk (two shades). 231 × 185 mm

Watermark: similar to Heawood 690 (Paris, 1689)

The attribution to Picart is based on affinities between this drawing and one in the Ashmolean, and with an engraving signed and dated 1703 showing (in reverse) the head and shoulders of the same lady. The Ashmolean drawing, a red chalk study of a group of figures for a *Fête Galante*, is signed and dated 1708, and is stylistically very close (K. T. Parker, *Catalogue of the Collection of Drawings in the Ashmolean Museum*, Oxford, 1958, vol. I, No. 544).

Parker described the Oxford drawing as demonstrating 'a remarkable anticipation of the style and subject-matter of Watteau'. Picart was a very productive engraver, and is represented by six other drawings in the Royal Collection (BF 342–9).

Provenance: unknown

(BF 343; RL 13103)

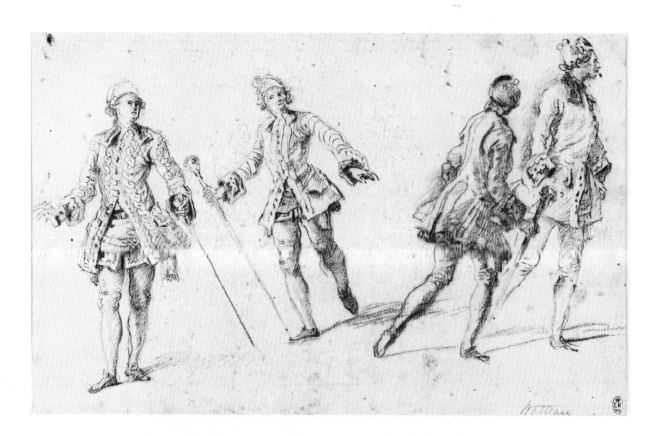

102 GIOVANNI PAOLO PANNINI (1691–1765)

Four studies of running footmen

Red chalk. 190 × 300 mm

Inscribed in black lead, by a later hand: Watteau

VERSO: *Two other figure studies.* Red chalk.

Watermark: *fleur de lys* in circle topped by letter A; compare Heawood 1569 (Rome, 1705)

A preparatory study for the painting of the *Duc de Choiseul leaving the Piazza S. Pietro* (Edinburgh, National Gallery of Scotland, on loan from the Sutherland Collection). That painting belongs to the series of four large canvasses commissioned from Pannini by the duc during his time as French Ambassador to Rome (1753–7). All four paintings were formerly in American collections; two are still in Boston and two (including the above) are now in Edinburgh (see F. Arisi, *Gian Paolo Panini*, Piacenza, 1961, Nos. 245–8). A large number of drawings used (sometimes more than once) in the different pictures of the series are contained in the sketchbook in the British Museum, to which the present drawing is related (No. 197.6.5). The old attribution to Watteau may be explained by the overtly and suitably French style employed by Pannini for the paintings in this series. The studies on this sheet were used for figures in the right foreground of the finished painting.

Provenance: Sir Thomas Lawrence (Lugt 2445)

(BR 560; RL 13107)

CAT. 102 *verso*

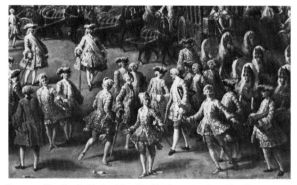

PANNINI, *The duc de Choiseul leaving the Piazza S. Pietro* (detail; Edinburgh, Duke of Sutherland Collection. On loan to the National Gallery of Scotland)

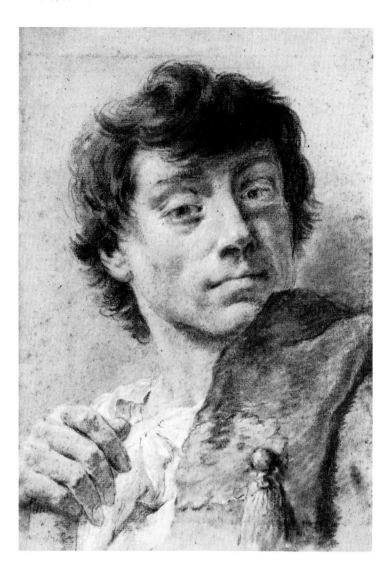

103 Giovanni Battista Piazzetta (1683–1754)

Idealized self-portrait

Black and white chalk on buff paper (faded from blue-grey: see right edge of sheet). 383 × 265 mm

One of an important group of thirty-six drawings by Piazzetta in the Royal Collection, which were presumably acquired *en bloc* from Consul Smith in 1762. They are not mentioned in Inventory A as they hung for many years in Buckingham Palace, with an attribution to Sebastiano Ricci. The exposure to daylight to which they were subjected at this time has led to the fading of the original blue of the paper to a dull buff. The majority of these drawings are finished chalk studies of heads rather than preparatory works for oil paintings. The present drawing has been identified as an idealized self-portrait of Piazzetta in the mid-1720s. 'For the modeling of the face, he smudged the black chalk and the white chalk

with the thumb, whereas in other areas he allowed it a full calligraphic vitality' (Knox 26, p.88). In its dramatic pose, the portrait is related to the etched self-portrait of 1738 (Knox 107).

Provenance: Consul Joseph Smith; King George III

(BV 57; Knox 26; RL 0780)

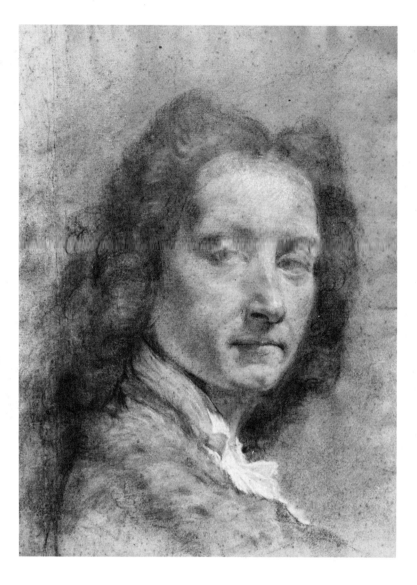

104 PIAZZETTA

Self-portrait (PLATE VI)

Black and white chalk, with some scraping out, on buff paper. 394 × 294 mm

Unlike No. 103, this is an objective self-portrait of the artist. The drawing was engraved by Giovanni Cattini in 1743, as the frontispiece to his series of fourteen plates after Piazzetta's heads, entitled *Icones ad vivum expressae*; this series was reissued in 1754, and twice during the 1760s (Knox 25). Knox has compared the age of the sitter in this drawing with that in the Albertina self-portrait of 1735, and concluded that this drawing must be around ten years earlier, c.1725. However it surely represents an older man than that portrayed (in albeit idealized guise) in No. 103, which he also dates c.1725. A date c.1730 is more likely for the present drawing.

Provenance: see under No. 103

(BV 29; Knox 24; RL 0754)

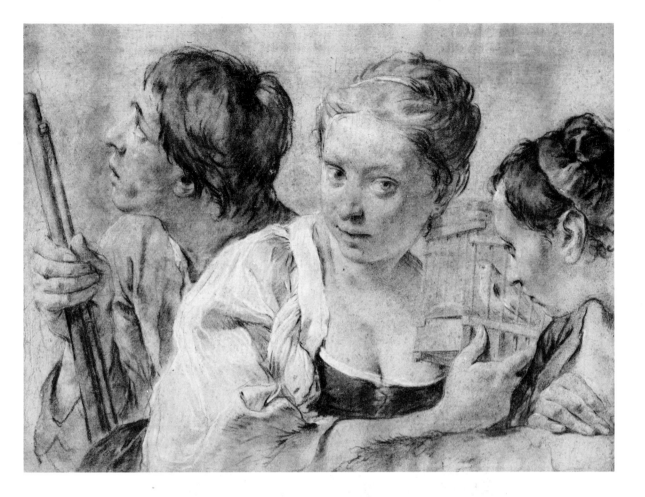

105 PIAZZETTA

Two girls with a birdcage, and youth with a staff
Black and white chalk on buff paper. 411 × 557 mm

One of a number of large fanciful drawings by Piazzetta at
Windsor, which were engraved by Cattini for the *Icones
ad vivum expressae,* first published in 1743. The plate after
the present drawing was dedicated to Prospero
Valmarana.

Provenance: see under No. 103

(BV 33; RL 01252)

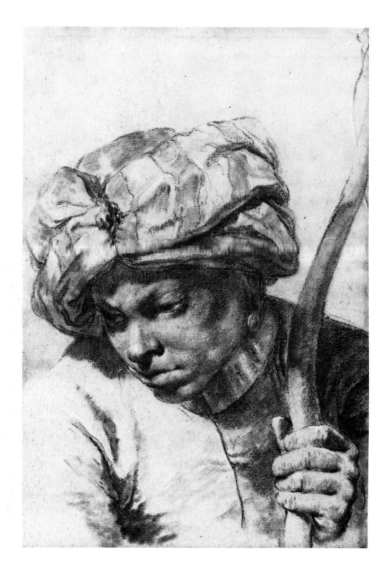

106 PIAZZETTA

A Moorish archer

Black and white chalk on brown paper (faded from blue:
see right and lower edges). 389 × 267 mm

The technique of this drawing as described by Knox
includes 'much smudging with the thumb, possibly
dampened, with redrawing' (Knox 42, p.120). That
author includes No.106 with the group of drawings of
c.1725, and discusses and illustrates a directly dependent
drawing at Cleveland, of around fifteen years later (Knox
43).

Provenance: see under No.103

(BV 34; Knox 42; RL 0755)

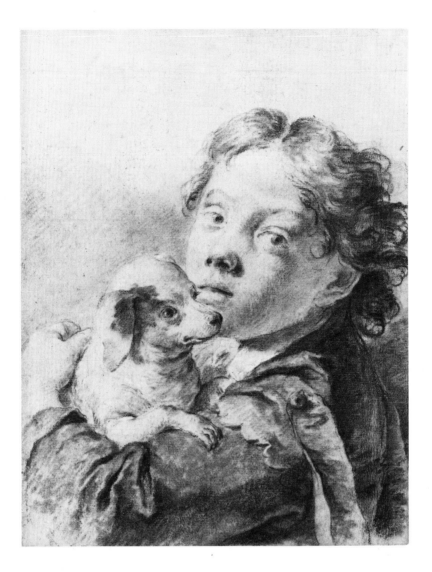

107 PIAZZETTA

Boy with a dog
Black and white chalk on buff paper (faded from blue:
see left edge). 384 × 301 mm

Although the date is probably close (c.1725), the tech-
nique of this drawing is rather different from that in the
previous sheets. More of the hatching lines have
remained visible, and have not been smudged. The same
head was used in Piazzetta's study of *A Boy with a Lute* in
Washington (Knox 41), dated by Knox to around fifteen
years later than the Windsor drawing. The latter was
developed into an oil painting in the Civic Museum at
Trieste, attributed to Domenico Maggiotto (Knox,
p.116).

Provenance: see under No. 103

(BV 55; Knox 40; RL 0777)

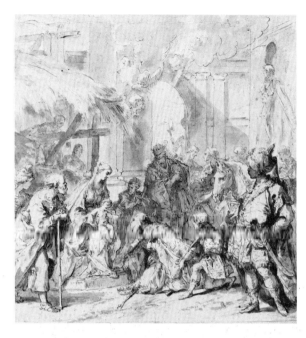

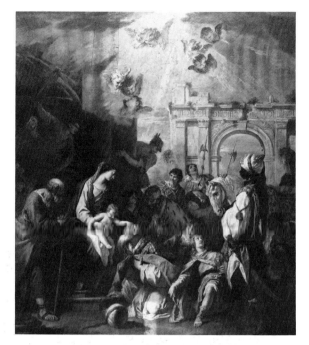

SEBASTIANO RICCI, *Adoration of the Magi* (detail; Levey 640)

108 SEBASTIANO RICCI (1659–1734)

Adoration of the Magi

Pen with grey ink and wash. 332 × 314 mm

VERSO inscribed: Nº. 2. / JS.

No. 108 has been removed from the volume of studies by
Sebastiano Ricci specifically for this exhibition. This
volume (vol.144) is the original eighteenth-century one
in which all 211 of the drawings arrived in the Collection,
and is inscribed on the spine SEBASTIA. / RICCI. /
BELLUNEN / SCHEDAE. Both the drawings and the oil
paintings by Sebastiano Ricci in the Royal Collection
(including that for which No. 108 is preparatory) were
formerly in the collection of Consul Smith (to whom the
verso inscription presumably relates), before being
acquired for King George III in 1762. The painting (Levey
640), one of several depictions of the subject by this
artist, is dated 1726. It belongs (with Levey 637–9) to a
series of seven New Testament pictures by Ricci, from
Smith's collection.

 The Ricci volume contained two compositional draw-
ings (including the present one) for the *Adoration,* and
fourteen other drawings related to the painting (BV 237–
52), many of which are mentioned in the anonymous
Descrizione of the paintings by Ricci in Smith's collection,
published in 1749. 'The series of sketches for the *Adora-
tion of the Kings* . . . shows how freely Ricci could create
variations for a group, a single figure, or a gesture. At the
same time they remind one how meticulous the artist
was in the evolution of a design. The final result may
suggest a *far presto* effect, but this impression is deceptive
and in fact Ricci worked out his compositions as carefully
as a French classical painter of the seventeenth century'
(BV, p.47).

CAT. 108 *verso* (detail)

Provenance: Consul Joseph Smith; King George III
(Inventory A, p.116: *Sebastiano Ricci,* among '209 [actu-
ally 211] Drawings amongst which are the studys for the
paintings in His Majesty's Collection.')

(BV 238; RL 7098)

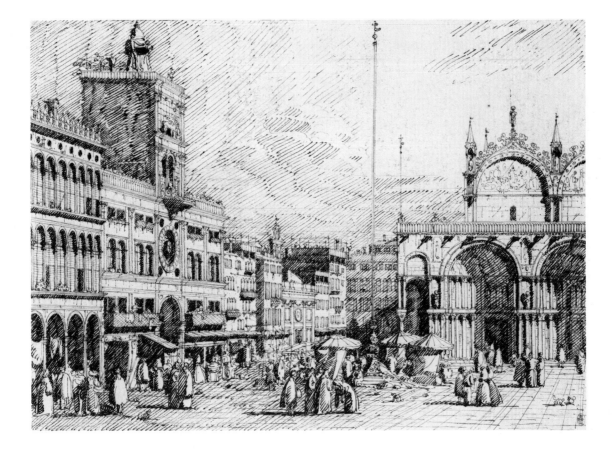

9 ANTONIO CANALE,
called CANALETTO (1697–1768)

La Torre dell'Orologio and Piazzetta dei Leoncini, Venice
Pen and brown ink over traces of black lead.
271 × 375 mm

One of a small group of Canaletto drawings at Windsor
'in the style of an etching', in which the composition and
technique have a compactness and density that is quite
distinct from the more sketchy style of the earlier draw-
ings (e.g. Nos. 110 and 111), and the later works in which
wash is frequently applied. A date in the late 1730s has
been suggested for the group. Figures play a relatively
important part in these views, in which shadows are laid
on with densely hatched parallel pen lines, contrasting
starkly with the sunlit areas represented merely by blank
paper.

There is an obvious relationship between this drawing
and a painting in the National Gallery of Canada (C/L
45). It is possible that this drawing, and others in the
same group (PC 26 and PC 29), were commissioned by
Consul Smith as records of paintings which he did not
own.

The crucial group of 143 drawings by Canaletto in the
Royal Collection was acquired *en bloc* from Consul Smith
in 1762. The discrepancy with the number (139) of

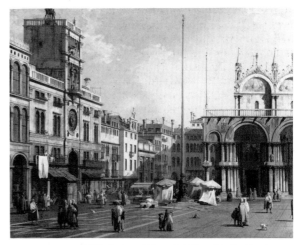

CANALETTO, *Torre dell'Orologio and Piazzetta dei Leoncini, Venice*
(Ottowa, National Gallery of Canada)

drawings given in the list inserted into Inventory A can
be only partly explained.

Provenance: Consul Smith; King George III (Inventory
A, p.116: *Antonio Canale*, among 139 'Drawings . . . – The
Drawings are the Studys of the great Collection of his
paintings bought by His Majesty of M:ʳ Smith of Venice.')

(PC 27*; C/L 539; Q's G 58; RL 7425)

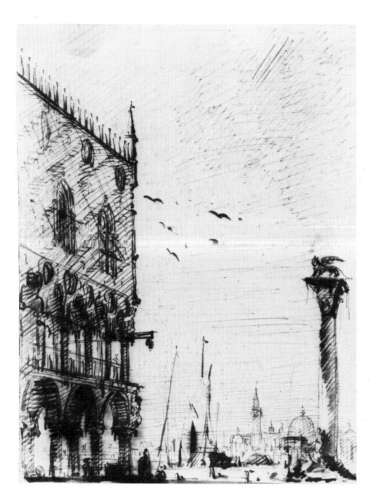

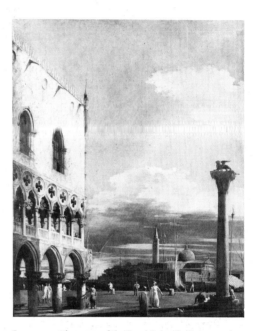

110 CANALETTO

*The corner of the Ducal Palace looking towards
S. Giorgio Maggiore*

Pen and brown ink. 232 × 176 mm

One of a group of seven early studies by Canaletto (including No. 111), all but one of which is at Windsor. When compared to the related oil paintings (formerly in Smith's collection) it appears that the drawings in the group may be temporary and summary notations of the content of the paintings, intended to clarify for either Canaletto or Smith the appearance of the projected series.

Both this drawing and a very similar study in the Ashmolean (C/L 543) may rely on Canaletto's swift and summary sketch on f.2 *verso* of the Accademia *Quaderno* for its main outlines. The drawings may be dated with reference to building operations on the steeple of S. Giorgio, which transformed the upper section from that shown here to a roofline with an onion-shaped profile. These operations began in June 1726 and were completed in 1728, the *terminus ante quem* for these views. They are related to one of the series of early canvases in the Royal Collection (Levey 382; C/L 55), in which the pulley emerging from the corner of the Palazzo Ducale is omitted, and the masts of the boats are shifted to allow for proper concentration on S. Giorgio beyond.

The paper used in the drawings of this series is thinner than that normally employed by Canaletto, and the acid ink has in areas completely eaten through the sheet. In addition, the old flour-paste adhesive has stained the paper in places.

Provenance: see under No. 109

(PC 4*; C/L 542; Q's G 47; RL 7446)

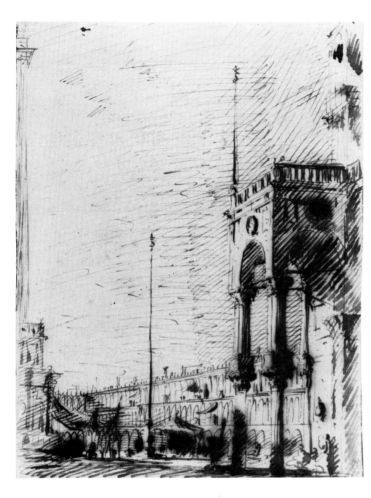

CANALETTO, *South-west corner of the Basilica, looking into the Piazza S. Marco* (Levey 380)

CANALETTO

The south-west corner of the Basilica, looking into the Piazza S. Marco

Pen and brown ink over black lead. 233 × 179 mm

From the same series of early views as No. 110, to which see note. The related painting is Levey 380 (C/L 33), which (finally) omits the side of the Campanile (to the left) and the awning and stall at the base of the flagpole, and includes figures which are absent in the drawing.

Provenance: see under No. 109

(PC 1*; C/L 532; Q's G 48; RL 7444)

112 CANALETTO

The Islands of S. Elena and La Certosa
Pen and brown ink over traces of black lead with grey
wash. 155 × 349 mm

This drawing belongs to a series of views of the outlying
regions of Venice and the lagoon, which are not
apparently related to finished works and which depict
unusual sites from unconventional viewpoints. The
medium employed is frequently a lightly coloured wash,
and the drawings appear to have been made from nature.
The present sheet was folded down the middle, which
suggests that it may have been taken from a sketch-book.

In this drawing the view is taken from the Motta di S.
Antonio to the church and monastery of S. Elena (on the
right) and the island and church of La Certosa (on the
left). In Canaletto's day S. Elena was a separate island,
divided by mud flats from the Castello region of Venice.
In this study, and the related one of the island of S. Elena
and the distant coastline of the Lido (PC 68), 'it was not
the delicately outlined buildings which principally inter-
ested Canaletto, but the elements – earth, air and water –
which meet so imperceptibly at the edges of Venice' (Q's
G, p.101).
Provenance: see under No. 109

(PC 67*; C/L 650; Q's G 71; RL 7488)

3 CANALETTO

Roman Capriccio: the Arco dei Pantani in fanciful setting

Pen and brown ink over traces of black lead with grey wash. Surrounded by black framing lines. 194 × 274 mm

One of the twelve drawings of Roman views in the Royal Library. Canaletto had visited Rome with his father early in his artistic career, when he produced the series of views now in the British Museum (C/L 713). There is no documentary evidence for a second visit. His later views of Rome (including the five large painted views of 1742 in the Royal Collection, and the drawings of a similar date) may have been made on the basis of engraved or drawn *vedute* by other artists; 'if he did not re-visit Rome, these drawings are a very convincing attempt to deceive the spectator into thinking that he did' (Q's G, p.109).

The Temple of Mars Ultor is seen through the opening to the left. In front of this is a low wall containing the Arco dei Pantani. These two features (which are included in the early sketch in the British Museum, C/L 713, No. 242) are topographically correct, but the tall vaulted structure and the low arch on the right are imaginary. The pen-work is very fluid and grey wash is now used to create a great range in the depths of shadow.

Provenance: see under No. 109

(PC 112*; C/L 783; Q's G 81; RL 7519)

114 CANALETTO

The Campanile damaged by lightning (PLATE I)

Pen and brown ink over traces of black lead, with grey wash. 422 × 292 mm

Inscribed in ink, top left: A di 23 aprile 1745 Giorno di S. Giogio Caualier / diede la Saeta nel Campanil di S. Marco (on 23 April 1745, St George's Day, a thunder-bolt struck the Campanile of S. Marco)

This drawing is unusual both in its size and upright format, and in the record that it provides of an historical event. The partially destroyed corner of the campanile is here shown under repair. A virtually identical view occurs in a drawing in the British Museum (C/L 533). Both were evidently made as finished studies. The fact that No. 114 belonged to Consul Smith, who was of English birth, and that the day of the damage to the Campanile (noted here) was that of the patron saint of England, may be relevant. Canaletto was to leave Venice for England soon after making this drawing: he is first recorded there at the end of May 1746.

Provenance: see under No. 109

(PC 55*; C/L 552; Q's G 85; RL 7426)

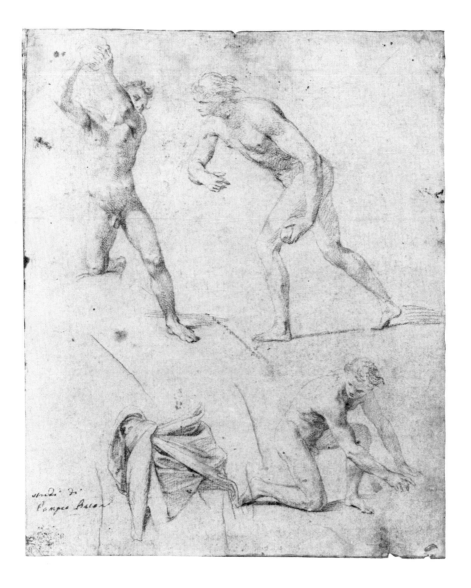

5 POMPEO BATONI (1708–87)

Studies of male nude and drapery

Red chalk on ochre-tinted paper. 227 × 187 mm

Inscribed lower left, in two different hands: Studi di; and: Pompeo Batoni

The poses and actions of the figures on this sheet appear to be connected with a subject such as the stoning of St Stephen. No oil painting related to these studies is known, although one is documented in Batoni's lifetime. An anonymous sale, held in the Rue Pavée Saint-Sauveur, Paris, on 18 May 1769, included as lot 48: 'Un Tableau sur toile peint par Batoni représentant le Martyre de S. Etienne dans sa bordure dorée, 2 pieds x 1 pied 7 pouces'.

This drawing is listed with one other by Batoni (BR 8), and five by Stefano Pozzo and others, in Inventory A. The circumstances of its acquisition are not known, although it is likely to have been acquired in Italy by the King's Librarian, Richard Dalton, who was possibly also involved in the commissioning of Batoni's portrait of the King's brother, the Duke of York, painted in Rome in 1764 (Royal Collection).

Provenance: King George III (Inventory A, p.128: *Moderna schuola Romana, TOM.I,* among '7 of Pompeo Battoni & Steffano Pozzi')

(BR 7; RL 6731)

CAT. 116

CAT. 117

116–8

GIUSEPPE MANOCCHI (1731–82)

Ceiling decoration (116)

Pen and brown ink with watercolour and bodycolour
over traces of black lead. 372 × 466 mm (area within
outer framing line 322 × 323 mm)

Inscribed in ink along left edge: Sofitto delle Vaticano –
Jo Giuseppe Manocchi Romano 1769.

Nos. 116–8 are self-evidently copies of Raphaelesque
ceiling decorations in the Vatican, rather than 'Designs
for ceilings' as they are described in the Phaidon cata-
logue. Comparison with the surviving ceilings in the
third loggie (on the top floor) of the Vatican shows close
similarities. These vaults were decorated from c.1560 to
1564 by artists continuing in the tradition of Raphael.
Giovanni da Udine's role in their execution ceased with
his death in the middle of August 1561. A little-known
artist, Sabaoth Denti, continued the work until his own
death in March 1563, and thereafter the decoration was
continued under the direction of Luzio Romano. The
main elements of frescoes, stucco and gilding, were
continued with great inventiveness, but keeping to the
same overall pattern, throughout the loggia (see B.
Davidson, 'Pius V and Raphael's Logge', *Art Bulletin*,
LXVI, No. 3, 1984, pp. 382 ff.)

 These drawings, and others by Manocchi in the Collec-
tion (of Renaissance ceilings in the Vatican and Castel
Sant' Angelo, and antique ceilings elsewhere in Rome),
could either have been acquired by Dalton in the late
eighteenth century, or by Prince Albert for his collection
of illustrations of the works of Raphael. Two other
drawings by Manocchi from the same series are now kept
with the Raphael Collection in the British Museum (Pf.
39, f.127). Both are inscribed 'Sofitto delle Vaticano', and
are signed and dated (1769 and 1770). Only one is listed

in Ruland's catalogue of the Raphael Collection (*The
Works of Raphael . . . as represented in the Raphael Collection
. . . at Windsor Castle*, privately printed, 1876, p.232).

Provenance: see above
(BM 283; RL 11603)

Ceiling decoration (117)

Pen and brown ink with watercolour and bodycolour
over traces of black lead. 370 × 463 mm (area within
outer framing line 335 × 335 mm)

Inscribed in ink along lower edge: Sofitto delle Vaticano,
Jo Giuseppe Manocchi Romano. 1769

Watermark: similar to Heawood 1838 (Amsterdam,
1769)

Provenance: see under No. 116
(BM 283; RL 11602)

Ceiling decoration (118)

Pen and brown ink with white chalk and black chalk over
traces of black lead. 478 × 746 mm (area within outer
framing line 360 × 710 mm)

Inscribed in ink along lower edge: Sofitto delle Vaticano
di Giovanni da Udine Jo Giuseppe Manocchi Romano
1770; numbered in black lead, top left: 5

Watermark: close to Heawood 1849 (no date)

The decoration of the corner areas in this drawing is close
to that in the bay with the fresco of *Abraham* (Genesis
XVIII), reproduced as plate IV in J. Ottaviani and
J. Volpato's series of engravings of the Loggie (Rome
1776–82). A more accurate drawing of this bay is given
in one of the two Manocchi drawings in the Raphael
Collection (Pf.39, f.127)

Provenance: see under No. 116
(BM 283; RL 11600)

119 Jacques Rigaud (c.1681–1754)

View of Claremont

Pen and black ink and wash. 288 × 488 mm

Watermark: similar to Heawood 1809 (early eighteenth-century)

This drawing belongs to a group of stylistically very similar topographical views made by Rigaud during his visit to England in 1733–4. By this date he had established a reputation for himself as both draughtsman and engraver of the plates in the series *Maisons Royales de France*. The circumstances of his visit to England are recounted by Vertue, under the date 1733: 'Mon.ˢ Rigaud about February from Paris came over here at the request of Mʳ Bridgman the King's Gardner, to be employed by him to make designs of Gardens. Views &c. of which at Ld Cobhams he has been some time [and has] made many drawings most excellently performd. he being perfect Master of perspective finely disposes his groups of Trees light. & shade & figures in a masterly manner. – some of the plates he has begun to engrave which is his Excellency also' (*Vertue III, W.S.*, XII, 1933–4, p.69). Elsewhere, Vertue notes that Rigaud 'was imployed to draw views for the Earl of Burlington. Duke of Newcastle and for Ld Cobham Gardens. in many views. staid here about 12 or 18 months and returned to Paris. Leaving Mr Bridgmans work not intirely finished' (*Vertue VI, W.S.*, XXX, 1948–50, p.194). Very little of Rigaud's work on the royal residences appears to have survived, although his view of the gardens at Hampton Court is in the British Museum. His work for Lord Burlington consisted of the eight views of Chiswick (in monochrome wash, as here), which are now at Chatsworth (see J. Carré, 'Through French Eyes: Rigaud's Drawings of Chiswick', *Journal of Garden History*, vol. II, No. 2, 1982, pp.133–42). His assignment for Lord Cobham resulted finally in the fifteen engraved perspectives of Stowe, following the preparatory studies (for all but one of the plates) in New York (Metropolitan

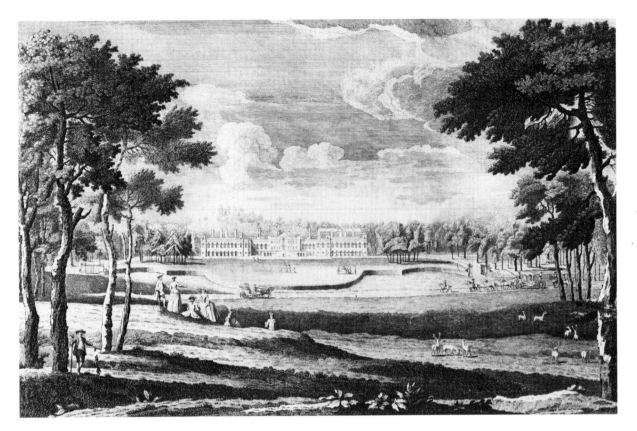

J. ROCQUE after J. RIGAUD, *Claremont* (engraving)

Museum of Art; Harris Brisbane Dick Fund, 1942: 42. 79).

No. 119 and a view of the Belvedere from the Bowling Green at Claremont (London, Victoria and Albert Museum, D.259–1890, PD 148), are apparently the only surviving evidence of Rigaud's association with the Duke of Newcastle, who had purchased the Claremont estate (near Esher in Surrey) from the architect Vanbrugh in 1714. Alterations and additions to the property (including the Belvedere) were soon designed and carried out by Vanbrugh himself. During the 1720s Charles Bridgeman (Rigaud's employer) laid out the new landscape garden, and his work was continued by William Kent (from 1729). The appearance of the estate in 1725 is known from the plan in Volume III of *Vitruvius Britannicus*, and in 1739 from Rocque's plan in Volume IV of the same series. The planting shown at either side of the forecourt, for instance, is closer to that in the earlier plan. The fact that the engraving of Claremont 'Taken and Publish'd' by John Rocque in 1750 (and engraved by J. Bonneau),

which corresponds with this drawing in many other respects, again shows different planting from that of No. 119, suggests that landscape alterations continued through the 1730s and 1740s. The obvious proximity of the two would seem to indicate that Rocque had access to No. 119 when making his engraving (see P. Willis, *Charles Bridgeman and the English Landscape Garden*, London, 1977, *passim*.)

Provenance: unknown

(OE 506; RL 17463)

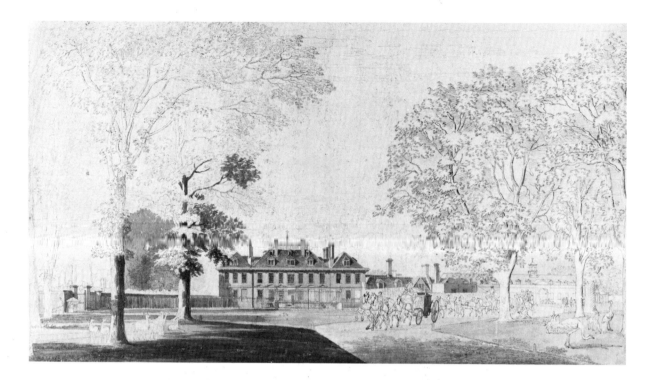

120 THOMAS SANDBY (1721–98)

The main front of Cumberland Lodge

Pen with black ink and grey wash over black lead. Squared for transfer. 311 × 560 mm

VERSO: indicated in black lead: The Lodge Windsor *George* Great Park; and Sandby 15/–

Watermark: similar to Heawood 1829 (Holland, 1743)

As is the case with No. 119, the monochrome colouring is typical of a drawing made in preparation for an engraving. In this case, the sheet has been covered with a grid of lines, to facilitate the transfer of the design to another sheet or to an engraver's plate. The finished engraving (by Mason), which follows this drawing very closely (except for the subsidiary figures) was included as No. 1 in the series of *Eight Views in Windsor Great Park*, published by Thomas Sandby to his own designs, using a number of engravers including his own younger brother Paul. The date of this series is usually given as December 1754, but as this was the date on the private subscription sheet, in which the titles of the prints differ from those finally published, it is likely to have been some time later. The series was republished by Boydell 1772.

Cumberland Lodge (totally rebuilt during the nineteenth century) was the seat of the Ranger of Windsor Great Park during the eighteenth century. From 1746 until 1765 it was therefore occupied by King George II's favourite son, William Augustus Duke of Cumberland, who was appointed to the Rangership following his successful campaign in Scotland against the Jacobite rebels. He is here shown seated in the first of the two carriages. The Duke was responsible for many important

MASON after THOMAS SANDBY, *Cumberland Lodge* (engraving)

architectural and landscaping works in the Great Park (including the original lay-out of Virginia Water), few of which survive and most of which have therefore been forgotten. The right portion of the stable block (still extant today), visible in the right middle distance, had very recently been added to pre-existing buildings to Henry Flitcroft's designs. Some of the Duke's ostriches and deer, and one of his eagles, are visible in the foreground. Thomas Sandby was active as a military draughtsman in Scotland from 1743, in which year he is first associated with the Duke of Cumberland. By 1751 Sandby was living for most of the year in Windsor Great Park, and was frequently visited there by his younger brother Paul.

Provenance: purchased for 15*s* by the Prince of Wales (later King George IV) from Colnaghi, 13 February 1805 ('Drawing by Sandby, the Lodge in Windsor Great Park'; RA Invoice 27293)

(OS 99; RL 14626)

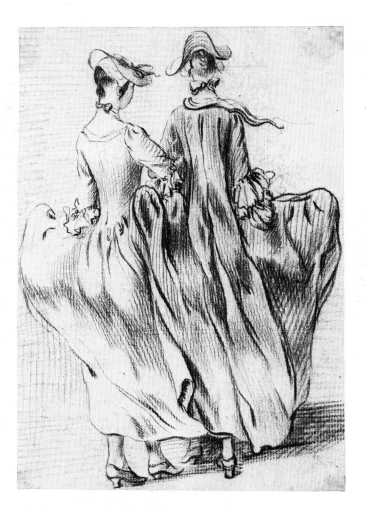

1 PAUL SANDBY (1731–1809)

Back view of two ladies
Red chalk (two shades). 189 × 138 mm

Both in technique and appearance this drawing has
much in common with French drawings of the early
eighteenth century. Compare the use of two shades of
red chalk with Picart's in No. 101, for instance. Paul
Sandby had an important collection of drawings and
engravings by Old Master and contemporary artists, and
from the collector's mark applied (Lugt 2112) and the
items listed in the catalogue of the sales of his collection
we can gain some impression of the influences that may
directly have been brought to bear on his art. (A number
of drawings attributed to Watteau have been stamped
with his mark, but these are all landscape studies.)

The figures in No. 121 reappear (rather less wind-
swept) in a late watercolour by Paul Sandby of *Somerset
House Gardens* in the collection of Sir Brinsley Ford. The
costume in both Nos. 121 and 122 is of the early 1750s.

Provenance: unknown

(OS 262; RL 14323)

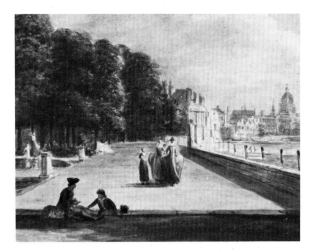

PAUL SANDBY, *Somerset House Gardens*, (detail; London, collection of
Sir Brinsley Ford)

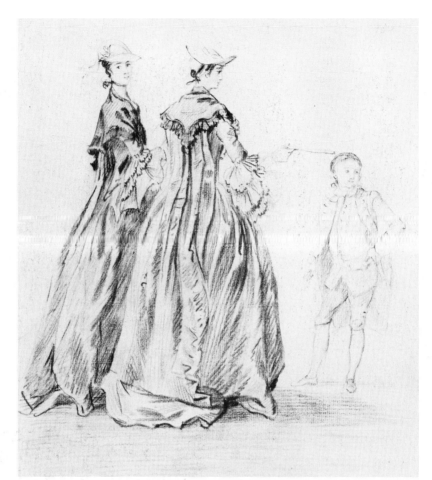

122 PAUL SANDBY

Two ladies out walking, and a boy
Red and black chalk. 197 × 175 mm
Inscribed top right, in red chalk: 15
VERSO: red chalk offset of a standing figure (?)

As is frequently the case with Paul Sandby's drawings,
the two main figures on this sheet were used more than
once in finished works by the Sandby brothers. One or
other (or both) appears in two of the prints in Thomas
Sandby's *Eight Views in Windsor Great Park* (see under No.
120): in the middle distance of the *Cascade and Grotto* (No.
4), and in the *View from the North Side of the Virginia River*
(No. 7). Both prints were engraved by Paul Sandby after
Thomas' designs. It is certainly therefore the case here,
and probably the case elsewhere in Thomas' *oeuvre*, that
the figures were added by Paul to Thomas' landscapes.

The rather French character of No. 121 is here replaced
by a neater, more English manner, demonstrating Sand-
by's powers of draughtsmanship at their best.

Provenance: unknown

(OS 263; RL 14324)

PAUL SANDBY after THOMAS SANDBY, *Cascade and Grotto, Virginia Water*
(engraving)

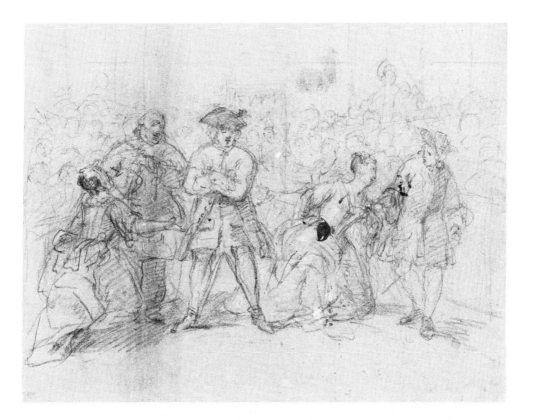

23 WILLIAM HOGARTH (1697–1764)

Scene in 'The Beggar's Opera'
Black chalk heightened with white on blue paper, with several flecks of oil paint in various colours. 371 × 489 mm

Watermark: close to Heawood 3020 (Amsterdam, 1702)

John Gay's play *The Beggar's Opera* was first performed, on the stage at Lincoln's Inn Fields, in 1728. It provided Hogarth with ideal subject-matter owing to its satirical and up-to-date theme. Hogarth's pictures (and this drawing) show Act III, Scene xi, in which Lucy Lockit and Polly Peachum beseech their respective fathers, the gaoler and the informer, to save the life of the highwayman Macheath, whom each supposes to be her husband. The audience is seen at either side and behind the actors. Hogarth executed at least six oil paintings on this theme between 1728 and c.1731. This drawing is preparatory for one of the earlier versions of the subject (see *William Hogarth*, exh. cat., Tate Gallery, London, 1971–2, Nos. 44–7), although the audience is here more numerous and arranged rather differently.

Provenance: Mrs Lewis; S. Ireland (sale, London, 6 May 1797, lot 134); in the Royal Collection by 1833 (J. B. Nicholls, *Anecdotes of William Hogarth*, London, 1833, p.401)

(OE 344; RL 13487)

HOGARTH, *Scene in 'The Beggar's Opera'* (Private Collection)

124 HENRY EDRIDGE (1769–1821)

Augustus Frederick, Duke of Sussex

Black lead, red chalk and coloured wash. 398 × 299 mm

Signed and dated, lower left, in grey ink: H. Edridge Jan.ᵧ. 1806

Prince Augustus Frederick (1773–1843), the sixth son of King George III, is here shown in the uniform of the Loyal North Britons, of which he was Lieutenant-Colonel Commandant. The drawing can probably be identified with Edridge's portrait of the Duke, specified as wearing this uniform, exhibited at the Royal Academy in 1806 (No. 604). Windsor Castle is visible in the background.

This drawing and No. 125 belong to the series of thirty-six portraits by Edridge in the Royal Collection, of which the majority depict members of the royal family. These were evidently taken 'from the life' and thus with royal consent, but the majority were purchased for the Collection by King George IV.

Provenance: undocumented (but see above)

(OE 215; RL 13869)

EDRIDGE

Princess Augusta Sophia

Black lead with grey and pink washes. 322 × 230 mm
Signed and dated in black ink, lower right: Edridge 1802

Princess Augusta Sophia (1768–1840) was the second daughter of King George III. Her surviving drawings and etchings include copies of works by Leonardo and Piazzetta in the Royal Collection (OE 11–14). Oppé suggested that the anchor locket worn by Princess Augusta in this (and other) drawings may relate to her love of the sea and her devotion to her brother the Duke of Clarence (later King William IV).

The diarist Joseph Farington noted in June 1802 that Edridge was at Windsor making drawings of the Princesses 'but is obliged to wait their time & has them not to sit more than an hour in a day'. In January of the following year he again noted that Edridge had been at Windsor for seven weeks making portraits of members of the royal family (*The Diary of Joseph Farington*, edited by K. Garlick and A. Macintyre, New Haven and London, Vol. V, 1979, pp.1790 and 1966). A decade later, Pyne described portraits by Edridge of the King, Queen, Princesses and Dowager Princess of Orange (plus four others) in the Yellow Bedroom at the Queen's House, Frogmore (W. H. Pyne, *The History of the Royal Residences*, Vol. I, London, 1819, p.20). The gothic tea house at Frogmore appears to be shown in the background of this drawing, which is one of six variants by Edridge of the same subject in the Royal Collection (OE 203–8). The artist exhibited portraits of Princess Augusta at the Royal Academy in both 1806 and 1815. One of these was bought by King George IV from Colnaghi on 23 July 1821 for 16 guineas (with other portraits by Edridge of Princesses Elizabeth and Mary, see OE 209 and 217; RA Invoice 28337).

Provenance: possibly purchased (with OE 209 and 217) by King George IV from Colnaghi on 23 July 1821 (RA Invoice 28337)

(OE 203; RL 13860)

THE NINETEENTH
AND TWENTIETH CENTURIES

The traditional drawing methods and media can be seen to have survived little changed until the present day, but the effects achieved are now varied. The importance of this historical tradition is self-evident in Strang's portrait drawings (e.g. No. 135), for which the typical Renaissance coloured ground is reintroduced. In Topolski's drawings pen and ink (No. 146) and black chalk (Nos. 147–9) are used with great vigour to give an intensely vivid and direct result. Earlier, black chalk and charcoal had been applied by Sargent to achieve an equally striking effect, by very different means. Queen Victoria herself had experimented with pastels (No. 128), under the very watchful eye of her master Landseer, in 1851. With the decline of large-scale figurative paintings, the preparatory role of drawing for paintings has also declined. But as an independent art form it can and does survive.

FAITH JAQUES
Vignette for Balmoral Guidebook (detail of RL 24428)

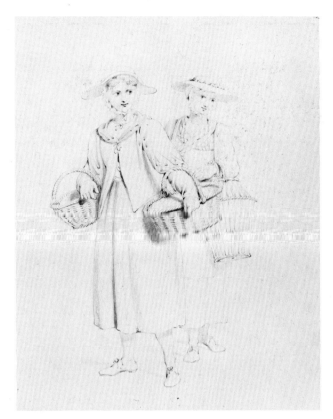

The first page of Richard Westall's album of sketches, inscribed by J. H. Glover

126 RICHARD WESTALL (1765–1836)

Two girls with baskets

Black lead, with red chalk. 255 × 185 mm

This study is mounted on to folio 12 of the first of two volumes of Westall's sketches in the Royal Library, containing respectively 43 'pencil drawings' and 24 'coloured drawings' for Princess (later Queen) Victoria to copy. The first page of Volume I is inscribed by J. H. Glover (Assistant Librarian and Keeper of Prints and Drawings, 1832–6, and Royal Librarian, 1836–60), as follows: 'Westall's Sketches Vol. I. Forty-three pencil Drawings by Richard Westall, R.A. Drawing Master to H.M. Queen Victoria and intended as Studies for the instruction of Her Majesty by whom they have all been copied.'

Westall's appointment as Drawing Master to the young Princess must have come as something of a surprise, for she appears to have been his first and only pupil. However, his essentially linear style, well-polished through his illustrative work, meant that he was ideally qualified as a teacher. Westall's lessons, twice weekly, for an hour, began in 1827 (when he was already in his sixties), and continued until his death in 1836. Regular references are made to them in the Princess' Journal, and from the sequence of dates on her copies after Westall's drawings (e.g. No. 127) we can form some impression of her activity and progress. Following Westall's death, in

the year before Victoria's accession to the throne, she noted: 'He was a very indulgent, patient, agreeable master, and a very worthy man . . . I have had every reason to be satisfied with him; he was very gentlemanly in his manners, and extremely punctual and exact in everything he did . . . He died in the *greatest* state of *pecuniary* distress' (RA QVJ 6 and 13 December 1836). Westall's portrait of Princess Victoria, commissioned by the Duchess of Kent, was exhibited at the Royal Academy in 1830, and is still in the Royal Collection.

Provenance: commissioned for the use of Princess (later Queen) Victoria

(OE 645; RL 25085)

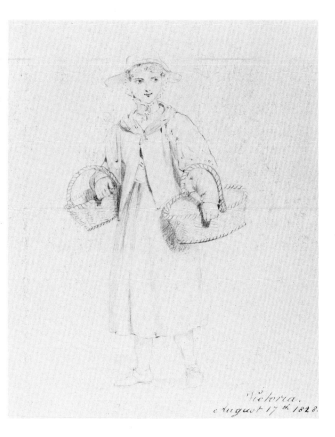

7 PRINCESS (*later* QUEEN) VICTORIA (1819–1901)
after RICHARD WESTALL
Girl carrying baskets

Black lead. 352 × 270 mm

Signed and dated, in pen and brown ink, lower right:
Victoria / August 17th 1828.

Like many of Princess Victoria's schoolroom copies after
Westall, only part of the original (No. 126) has been
reproduced. Nevertheless the result is a very competent
product by a child who was not yet ten years old.

The drawing is pasted onto folio 1 of an album of
sketches inscribed on the spine: MISCELLANEOUS DRAW-
INGS BY PCSSES VICTORIA & FEODORA. The contents must
all date from Princess Victoria's early years in Kensington
Palace, when her half-sister Princess Feodora of
Leiningen (1807–72) was her constant companion. The
date inscribed on this drawing, 17 August, was the
birthday of the Duchess of Kent, who was mother to both
Victoria and Feodora. Many of the drawings and water-
colours surviving from these early years are inscribed
with this date, and must have been carefully finished
specifically for presentation to the Duchess, then to be
preserved by her for posterity.

In parenthesis it is interesting to note that Princess
Feodora was herself a talented artist, at the head of a line
of distinguished amateur sculptors. She married Ernest,
Prince of Hohenlohe-Langenburg in 1828 and their son,
Prince Victor (who assumed the title Count Gleichen
following his morganatic marriage to Laura Seymour in
1861) was responsible for several noble pieces, including
the statue of King Alfred in the centre of Wantage,
Oxfordshire. His daughters Feodore and Helena were
both noted artists, and the former was responsible for No.
136 in the present exhibition.

Provenance: Duchess of Kent; Queen Victoria

(K14, f.1)

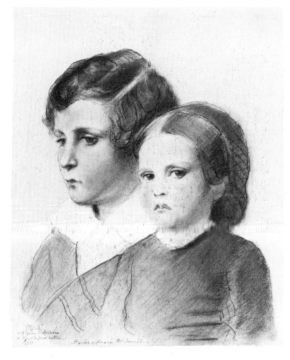

LANDSEER, *Archie and Annie MacDonald* (RL 20776)

128 QUEEN VICTORIA
after EDWIN LANDSEER (1803–73)

Archie and Annie MacDonald

Black, white and coloured chalks on grey paper.
464 × 384 mm

Inscribed in black chalk, lower left: VR del / copd from Ed
Landseer / & touched from nature / 1y / 1851; Archie &
Annie McDonald.

Queen Victoria's characteristically precise inscription
assures us that the model for this study was a drawing by
Landseer, still in the Royal Collection and mounted onto
the pages of one of the Souvenir Albums (RL 20776). The
commencement of Landseer's pastel is recorded in
Queen Victoria's Journal entry for 20 December 1850:
'Landseer came and drew Archie and Annie McDonald,
before me, in the "Painting Room" as we call it, – by way
of a drawing lesson, and a lovely sketch he made of them,
but it is not quite finished.' On 17 January the Queen
noted: 'Later in the morning finished the copy I have
been making of Landseer's drawings of Archie and Annie
Mcdonald, the children themselves sitting for me, which
they did very well'. The drawings were then shown to
Landseer, and were completed on 8 and 12 February
1851.

In 1836 the Duchess of Kent gave Princess Victoria a
portrait by Landseer of her favourite dog, Dash, as a
birthday present, and thus began a long association
between Landseer and the Court. Soon afterwards
(1837) Princess Victoria noted that Landseer 'certainly is
the cleverest artist there is', and compliments and com-
missions passed between them during the ensuing

decade. In 1850 Landseer began work on what might
have been the culmination of his royal association, a
painting to be entitled *Royal Sports*. In preparation for this
he made four portrait studies in pastel of the ghillies who
were to be shown accompanying the royal party. At
around the same time, Queen Victoria herself began to
learn to draw in pastel. She recorded in her Journal (24
March 1850): 'Tried to draw with chalks, Landseer
shewed me how to the other day in a few charming
sketches, executed in 5 or 10 minutes. It is wonderful to
see the effect he brings out with but a few touches.' The
Queen's copy, while being very competent, is rather
lacking in the polish and *sfumato* of the original.

John MacDonald, the father of the children shown in
this drawing, was himself portrayed by Landseer for
Royal Sports in September 1850. He came from the west of
Scotland and was appointed jäger to Prince Albert in
1848. In 1849 he travelled south with his family to live at
the Kennels in the Home Park, Windsor, where Landseer
and Queen Victoria presumably drew the children.
Archie, the third son (1842–90), was appointed ward-
robe man to the Prince Consort in April 1860 and jäger to
the Prince of Wales in 1862. Annie MacDonald was born
in August 1848 and died of tuberculosis in 1866. Queen
Victoria was particularly attached to the MacDonald
family, describing John as 'a remarkably tall and hand-
some man'. She made numerous *ad vivum* sketches of the
children; her painted portraits of the same two children
hang at Osborne.

Provenance: Queen Victoria

(K 141)

CARL HAAG, *The Prince of Wales and Prince Alfred with the jäger John MacDonald after salmon leistering* (RL 22057)

9 CARL HAAG (1820–1915)

The Prince of Wales and Prince Alfred with the jäger John MacDonald after salmon leistering

Black lead and black chalk, with watercolour additions.
505 × 355 mm

Inscribed (i) in black lead, top left: Their Royal Highnesses, The Prince of Wales and Prince Alfred guided by MacDonald / Retourning from Salmon Spearing on the River Dee, Balmoral / Painted by Command of Her Majesty / by Carl Haag / London July 1854; (ii) top right: Montag 9½; (iii) centre right, with the measurements of the figures: Hohe des Macdonald 6 fuss 3 zoll./H.R.H. Prince of Wales 4 – 7 – / H.R.H. Prince Alfred 4 – 3 –

The drawing is Haag's final study for the finished watercolour of the same subject at Balmoral (RL 22057). The royal party went salmon leistering on 9 September 1853. The Queen noted in her Journal that it was 'a gay and pretty scene. Mr. Carl Haag the artist, who is here, made several slight sketches. He was much struck with Mac-Donald carrying one of the boys through the water.' A month later, on the eve of the departure of the royal party for the south, Queen Victoria commissioned Haag to paint a watercolour to commemorate the salmon leistering party. According to the inscription on this drawing, the painting was carried out in London in July

1854. Haag was paid £75 for his work on 17 August, and the finished watercolour was presented by the Queen to Prince Albert one week later. The preparatory studies (No. 129 and RL 20762) were evidently acquired from the artist at the same time.

John MacDonald, father of the two children drawn by Queen Victoria after Landseer in No. 128, acted as Prince Albert's Jäger from 1848. He and the two royal princes are here shown wearing kilts of Balmoral tartan and glengarry bonnets.

Provenance: the finished watercolour (RL 22057), presumably with No. 129 and RL 20762, purchased by Queen Victoria for £75 on 17 August 1854 (RA PP2/7/4672)

(RL 17110)

130 GEORGE RICHMOND (1809–96)

Queen Adelaide

Black, brown and red chalks, heightened with white, on buff paper. 546 × 370 mm

Signed and dated lower left, in black chalk: Geo. Richmond delit 1845

Although Richmond was among the most fashionable of early Victorian portraitists, he received very few royal commissions. The drawing of Queen Adelaide (1792–1849) is listed in his 'Account Book', p.38, under 1845. The entry reads: 'The Queen Dowager [£] 30–0–0', with a note stating that the portrait was engraved. Richmond's diary (which survives, incomplete, at the National Portrait Gallery, with the 'Account Book') contains several notes relating to sittings with Queen Adelaide, including on 7 May 1845 'The Queen Dowager 12.30. next and other days 11.30'.

 J. Thomson's engraving of this portrait (published by Hogarth in 1846) was included as the frontispiece to volume 2 of W. and E. Finden's *Portraits of the Female Aristocracy of the Court of Queen Victoria* (1849), which was dedicated to the Queen Dowager. It shows the widowed Queen of William IV in her fifties. Winterhalter's oil painting of Queen Adelaide in 1849, the year of her death (version in the Royal Collection), shows an equally handsome but (typically for Winterhalter) rather less severe countenance.

Provenance: presumably Queen Adelaide; Queen Victoria.

(RL 13944)

HAYTER, *The Christening of the Prince of Wales* (detail)

1 GEORGE HAYTER (1792–1871)

Victoria, Duchess of Kent

Black lead, black chalk and watercolour, heightened with white, on buff paper. 410 × 278 mm

Inscribed in black lead, along lower edge: Her Royal Highness The Duchess of Kent Study for the christening of H.R.H. The Prince of Wales / George Hayter. 1844.

A preparatory study for the painting of the christening of the Prince of Wales, at St George's Chapel, Windsor, on 25 January 1842. At the time, Hayter was still working on his picture of the *Marriage of Queen Victoria.* Work on the *Christening* painting continued through the following four years, but it was not exhibited at the Royal Academy until 1859. The portrait of Queen Victoria's mother, the Duchess of Kent (1786–1861), was begun on 23 October 1844 and completed two days later. For the sitting on the 25 October the Duchess wore her christening costume. Hayter's diary records that the drawing was touched up on 9 March 1846, and presented to the Queen by the artist five days later.

Hayter's association with the royal family dates back to his appointment (in 1815), as 'painter of miniatures and portraits to the Princess Charlotte and Prince Leopold of Saxe-Coburg'. In 1833 he was commissioned by the latter (now King Leopold of the Belgians) to portray his niece, Princess Victoria, and in the following year Hayter's full-length portrait of Leopold's sister, the Duchess of Kent, was given by the Duchess to the future

Queen Victoria. On the latter's accession, Hayter was appointed 'Portrait and historical painter to the Queen'. Following Wilkie's death in 1841 Hayter became 'principal painter in ordinary to the Queen', and in 1842 he was knighted.

The Queen particularly admired Hayter's skill in taking portrait likenesses. In his teens, during his time at the Royal Academy Schools, he had won two medals for drawing after the Antique. This talent is clearly demonstrated in this portrait drawing, and was doubtless one of the contributing factors behind the choice of Hayter as Victoria and Albert's guide during their early attempts at etching in 1840.

Provenance: presented to Queen Victoria by the artist, 14 March 1846

(RL 14181)

E. M. WARD, *The Investiture of the Emperor Napoleon III with the Order of the Garter* (detail)

132 EDWARD MATTHEW WARD (1816–79)

Dr Samuel Wilberforce

Black and red chalks heightened with white, on buff paper. 469 × 346 mm

Inscribed (i) lower right, in pen and brown ink over black chalk: Bishop of Oxford / March 21st 1856 / E. M. Ward RA; (ii) by a later hand, in black lead: Dr Samuel Wilberforce

E. M. Ward was one of a number of artists invited to depict different events during the visit of the Emperor Napoleon III to England in 1855. He had been elected RA the previous year, following the successful exhibition at the Academy of a number of works with historical or literary subject-matter, including pictures for the Historic Gallery of the Palace of Westminster. Queen Victoria commissioned an oil painting from Ward depicting the *Investiture of the Emperor Napoleon III with the Order of the Garter*, an event which took place at Windsor Castle on 18 April 1855. The oil painting (for which No. 132 is a preparatory study) was not completed until 1860, although it was exhibited at the Royal Academy in 1858; it now hangs in Buckingham Palace. The artist made portrait studies of several of the participants between 1855 and 1858. Eleven of these studies, to which Ward devoted endless time and care, were purchased by Queen Victoria from his widow following the artist's suicide (RL 14001–13). A watercolour of the *Investiture* by G. H. Thomas was acquired for the Royal Collection in 1937 (RL 20054).

Dr Wilberforce (1805–73) attended the Investiture in his capacity as Chancellor of the Order of the Garter, an ex-officio duty then held by the Bishop of Oxford. He is here shown reading the Admonition, part of the Investiture ceremony. In his diary entry for the day Wilberforce recorded: 'At night the Queen spoke to me: "All went off very well, I think: I was afraid of making some mistake. You would not let me have in writing what I was to say to him. Then we put the riband on wrong! But I think it all went off very well on the whole"' (R. G. Wilberforce, *Bishop Wilberforce*, Oxford and London, 1905, pp.142–3). The third son of William Wilberforce, Samuel Wilberforce was ordained in 1828 and from the 1840s he made frequent visits to Windsor, where his sermons were much liked by the Royal Family. He was appointed Bishop of Oxford in 1845, and of Winchester in 1869; and gradually became acknowledged as the leader of the High Church party. Following his death there was some discussion as to whether he should be buried at Westminster Abbey. On 25 July 1873 Queen Victoria wrote of the proposal to Gladstone: 'The Queen thinks it would have been open to grave objections, for, while all concurred in thinking poor Bishop Wilberforce most agreeable, talented, and eloquent, many entertained grave doubts as to his conduct and views as a Churchman, which she must own was her own case, while others extolled him and rated him very high in that capacity. And such controversies would have been very painful' (*Letters of Queen Victoria*, 2nd series, vol. II, ed, G. E. Buckle, London, 1926, p. 269).

Provenance: RL 14001–14013 purchased by Queen Victoria from the artist's widow, March 1879, at £200 (PP VR PEA)

(RL 14011)

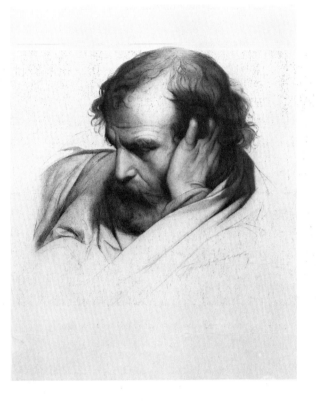

S. Jesi after P. Delaroche, *La Vierge à la Vigne*
(engraving)

33 HIPPOLYTE *called* PAUL DELAROCHE (1797–1856)

Head of St Joseph

Black chalk on cream paper, badly discoloured.
530 × 427 mm

Signed lower right, in black chalk: Paul Delaroche

This drawing is one of two studies in the Collection for Delaroche's picture *La Vierge à La Vigne*, painted in 1842 and purchased by Sir Thomas Baring. The Osborne Catalogue (1877) states erroneously that the picture was destroyed by fire in 1854, for in 1912 it was purchased from Lord Northbrook's collection by the Maharaja of Baroda. The composition is known from the engraving by S. Jesi, published in 1842. Both studies were purchased by Queen Victoria for presentation to Prince Albert: the second study represents the Virgin and Child (RL 17958B). In the late nineteenth century they hung in the Visitors' Sitting Room at Osborne, alongside other works by artists such as Corbould, Fripp, Callow, Copley Fielding, Haag and Carl Müller. Delaroche was a leading practitioner of the highly finished academic style, which flourished in France throughout the first half of the nineteenth century alongside the more romantic art of Delacroix and Géricault.

Provenance: with RL 17958B, purchased by Queen Victoria for £60; presented by the Queen to Prince Albert on 26 August 1849 (RA Add T 231/p.156 and L.C.O. 'Private Paintings')

(RL 17958A)

134 EDWARD BURNE-JONES (1833–98)

A female head

Red and white chalk, heightened with white, on rust-coloured paper. 461 × 302 mm

Signed (with initials) and dated, in red chalk: EB-J / 1896

This very typical product of Burne-Jones' last years is one of the few works connected with the Pre-Raphaelite movement in the Royal Collection. It reveals the lasting influence on Burne-Jones of Rossetti, one of the three founder members of the Pre-Raphaelite Brotherhood. Queen Victoria had no particular interest in the works of the PRB but was ultimately persuaded, on the advice of Gladstone, to confer a baronetcy on Burne-Jones in 1894. It comes as no surprise to learn that this drawing was not acquired until the following reign: it is almost certainly the 'Head in red chalk' purchased (with five other drawings by Burne-Jones) by Queen Alexandra in 1904.

Provenance: Ernest Brown and Phillips, Leicester Galleries, Leicester Square, London; purchased by Queen Alexandra, May 1904, at £89. 5s (paid in February 1905; RA Add A 21/8)

(RL 13392)

5 WILLIAM STRANG (1859–1921)

Edward Elgar

Black, white and coloured chalks, on pink washed paper.
433 × 280 mm

Signed and dated in black chalk lower left: W. STRANG /
JULY 1911; and inscribed by the sitter, in black lead:
Edward Elgar

The composer Edward Elgar (1857–1934) was appointed
to the Order of Merit in King George V's Coronation
Honours in June 1911. He was the first composer to be
admitted to the Order and, appropriately, had just writ-
ten the Coronation March, as he had written the Corona-
tion Ode for King Edward VII in 1902. In July 1911, Elgar
was portrayed by Strang, as part of his series of studies of
members of the Order of Merit, which was founded by
King Edward VII at the time of his Coronation in 1902
and was intended to give special distinction to those who
had rendered exceptionally meritorious service in the
Crown Services or towards the advancement of the Arts,
Learning, Literature and Science.

In 1906, Edward VII authorised the commissioning of
portraits of distinguished living men in pencil, chalk or
crayon. The King's original choice of artist for this series,
as well as for four portraits of senior members of his
Household, was Emil Fuchs, a German. However, the
Royal Librarian, John Fortescue (whose portrait Strang
etched in 1909), vigorously and successfully champ-
ioned the claims of William Strang not only as he con-
sidered Strang a superior artist but also as a means of

encouraging British artists, who had been neglected by
the Royal Collection for many years. It was Fortescue
also who interpreted 'distinguished living men' as the
Members of the newly-founded Order of Merit and
envisaged a continuing process as each new OM was
appointed; that idea was never wholly fulfilled and
eventually lapsed (RA X32/270–7 and W65/40 and 50).

Strang's fourteen portraits of members of the Order of
Merit (RL 13728–41) are dated between 1908 and 1914,
and include notable likenesses of Lawrence Alma-
Tadema, Thomas Hardy and Lord Kitchener. Each
portrait was signed by both the sitter and the artist before
being added to the Royal Collection.

Strang is now best known as a skilled etcher but was
also a prolific portrait draughtsman, and is estimated to
have produced over five hundred portrait drawings
between 1898 and 1909. C. R. Ashbee described these
drawings, which must surely have relied on a study of
Holbein's portrait studies (e.g. Nos. 47–51 above), as
having 'the quality of Dr. Johnson, they are lexico-
graphical' (*William Strang,* exh. cat., Sheffield, Glasgow
and London, 1980–1, p.22).

Elgar was knighted in 1904 and became Master of the
King's Musick in 1924. He was made a KCVO in 1928, a
Baronet in 1931, and a GCVO in 1933, the year before his
death.

Provenance: commissioned by King Edward VII for the
Royal Collection

(RL 13739)

136 FEODORE GLEICHEN (1861–1922)

The Honourable Venetia Baring

Black and white chalk on pink paper. 580 × 347 mm

Signed with monogram and dated 1912, in black chalk, lower left. Inscribed with sitter's name top left.

Countess Feodore Gleichen was the daughter of Prince Victor of Hohenlohe-Langenburg, third son and fourth child of Queen Victoria's beloved half-sister Feodora. Following Prince Victor's marriage to Miss Laura Seymour in 1861, which was considered morganatic by German law, he changed his name to Count Gleichen. Both he and his mother were amateur sculptors, and several works by them (in both bronze and marble) are in the Royal Collection. Feodore was born in London and studied art at the Slade School under Legros. She became widely recognised as one of the leading women sculptors of her day, and an award was named after her. Her portrait drawings of the Duchess of Devonshire, Earl Roberts, Sir Joseph Hooker and Florence Nightingale, dated between 1908 and 1914, are also at Windsor (RL 13649–52).

Venetia Baring (1890–1937) was the daughter of the 6th Baron Ashburton, and acted as Maid of Honour to Queen Mary from 1911.

Provenance: presumably Queen Mary

(RL 13648)

FRANK O. SALISBURY, *The Heart of the Empire* (detail)

7 FRANK O. SALISBURY (1874–1962)

Princess Marina, Duchess of Kent (PLATE VII)

Black and white chalks on grey paper. 629 × 483 mm

Signed in black lead, lower right: Frank O. Salisbury; and inscribed: H.R.H. The Duchess of Kent.

This drawing belongs to a group of portrait studies for Salisbury's large oil painting *The Heart of the Empire* (Royal Collection). The picture represents the National Thanksgiving Service at St Paul's Cathedral on 6th May 1935 for King George V's Silver Jubilee. It was described by Salisbury's biographer soon after completion in the following rather exaggerated terms: 'The commemoration of this Jubilee Service was to prove the artist's greatest triumph and the most difficult commission of his career' (B. Aquila Barber, *The Art of Frank O. Salisbury*, Leigh-on-Sea, 1936, p.44).

The moment and viewpoint finally chosen were during the service itself, showing the scene under the dome of St Paul's, with the Royal Family occupying the front rows of seating. The artist and his wife had a good vantage point, and he noted in his autobiography 'I was armed with small cards which I could get into my pocket and hold in my service paper, so that they were not obvious' (F.O. Salisbury, *Portrait and Pageant*, London, 1944, p.135).

Princess Marina (1906–68), daughter of Prince Nicholas of Greece, married King George V's fourth son, George, Duke of Kent (1902–42) in 1934. She and her husband were seated in the third row from the front during the Jubilee Service, two rows behind the young

Princesses. Salisbury records making life studies of all but one of the seventy-five people portrayed, before working them up in paint (sometimes with the help of his 'moving picture' camera). Each of the people portrayed signed the artist's lavishly bound volumes of 'Autographs of My Sitters'. Princess Marina's signature, with the date 1935, appears in volume 2 of these Autographs. Many of the cards (referred to above) and the portrait studies for this commission, and for Salisbury's other paintings, remained in his studio at the time of his death. The studies related to *The Heart of the Empire* were lots 172–215 in the recent studio sale (Christie's, London, 25 September 1985). Those of the future Edward VIII, the Duke of Kent and the Duke of Connaught are illustrated in Barber's book. Only the portraits of the Duke and Duchess of Kent appear to have survived in the Royal Collection.

Provenance: unknown

(RL 22688)

J. S. Sargent, *Henry James* (detail: London, National Portrait Gallery)

138 John Singer Sargent (1856–1925)

Henry James

Charcoal. 618 × 410 mm

Signed and dated, in charcoal, across lower edge of sheet: John S. Sargent 1912

Sargent's better-known half-length oil portrait of Henry James (1843–1916) was presented to the sitter by 269 English friends (including Sargent) on his seventieth birthday (in 1913), and was bequeathed by him to the National Portrait Gallery. No. 138 was probably the result of the unsuccessful attempt of Edith Wharton, the novelist, to arrange such a presentation among James' American friends the previous year; in spite of the supposed secrecy of that project, the sitter heard about it and the subscriptions were stopped on James' express instructions. The drawing was presented by the artist to the Royal Collection on 14 March 1916, two weeks after the sitter's death in London.

Sargent and James were old friends, sharing American parentage and a love of England (among many other things). In 1907 King Edward VII had suggested to the Prime Minister (Sir Henry Campbell-Bannerman) that Sargent be offered a Knighthood, describing him as 'the most distinguished portrait painter in England'. However, the artist refused to relinquish his American citizenship and was therefore forced to decline the

honour. Henry James on the other hand became a naturalised British subject in July 1915 and was appointed to the Order of Merit in the New Year Honours of 1916, very shortly before his death on 28 February. Because he was too ill to attend an investiture, the insignia of the Order was presented to him in bed at Carlyle Mansions, SW1, by Lord Bryce, OM, appropriately a former Ambassador to the United States. Sargent's presentation of this drawing may well have been made in connection with the royal decision to acquire (and sometimes commission) portraits of the holders of the Order (see No. 135).

As a postscript to this episode it is interesting to note that when Sargent's name was put forward as a possible recipient of the Order of Merit in 1911, King George V, who 'admired Sargent neither as a painter nor as a man', successfully resisted the proposal (R. Jenkins, *Asquith*, London, 1964, p.224, n. 2). Sargent's American nationality would not have been a bar to his receiving the OM as it was to his receiving a knighthood.

Provenance: (?) commissioned by Edith Wharton; presented to the Royal Collection by the artist, 14 March 1916

(RL 13682)

AUGUSTUS JOHN, *Robin* (London, Tate Gallery)

9 AUGUSTUS JOHN (1878–1961)

Robin

Black chalk. 280 × 240 mm

Signed in black chalk, lower right: John

The members of Augustus John's ever-growing family were frequently employed as models for his drawings and paintings. His oil painting of *Robin* in the Tate Gallery is one of his most successful portraits. It shows his third son (born 1904) at around the age of 8; the present drawing is probably slightly earlier. The artist referred to his son's later artistic products, which were abstract while his own remained very strongly in the realist tradition, in the following terms: 'It is true Robin himself *has* gone over the edge in a way, but I haven't lost faith in

him yet' (A. John, *Finishing Touches*, London, 1964, pp.106–7). During his time at the Slade School of Art, Augustus John was hailed as the greatest draughtsman since Rembrandt. The device of the face cast into heavy shadow by the hat rim has been frequently used by artists since the time of Rembrandt, and was also much employed by John around three hundred years later.

Provenance: purchased by Her Majesty Queen Elizabeth from the Redfern Gallery, 5 September 1941, and presented to the Royal Library

(RL 14764)

140 STANLEY SPENCER (1891–1959)

Portrait of a girl

Black lead. 356 × 251 mm

Signed and dated in black lead, lower right: Stanley Spencer / 1931–32

No. 140 belongs to the group of drawings, watercolours and prints which were presented to Her Majesty at the time of her Coronation. A further gift, also containing works from every Royal Academician, was made in the Queen's Jubilee year (see Nos. 141 and 145 below). The tradition for such presentations is not an old one. Before the present reign, the Royal Academy marked events such as Coronations, Jubilees, and royal weddings by the presentation of a signed illuminated address.

Spencer is probably best-known for his paintings of and for Cookham and Burghclere in Berkshire, where he lived for most of his life.

Provenance: presented to Her Majesty as part of the Royal Academy Coronation gift, 1953

(RL 23058)

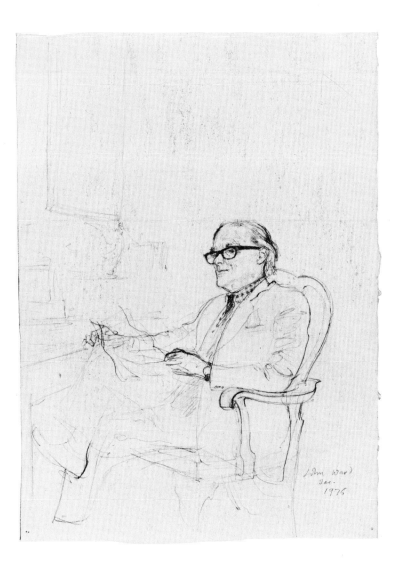

1 JOHN WARD (born 1917)

Sir Hugh Casson

Black chalk. 389 × 284 mm

Signed and dated in black chalk, lower right: John Ward/ Dec. / 1976

Watermark: Hand Made. The sheet stamped: R.W.S. 26 Conduit St. Guaranteed Pure Paper.

Sir Hugh Casson (born 1910) was elected RA in 1970. Earlier in the year during which this portrait was drawn, he was appointed President of the Royal Academy. The circumstances surrounding the portrait were described by the artist (in a letter to the author) as follows: 'As to how it was done: in the Secretary's room at the R.A. at the little desk (which is all the President gets) crushed away in a corner. It was done for the Jubilee gift box but on the spur of the moment. I had done another drawing but suddenly the thought penetrated my thick head that a portrait of the President would be the *obvious* thing and dear Hugh, as ever, made no fuss and sat for me for an hour or so.'

Provenance: presented to The Queen as part of the Royal Academy Jubilee gift, 1977.

(RL 22918)

142 GILBERT SPENCER (1892–1979)

Portrait of a woman

Brown chalk and black lead. 291 × 238 mm

Signed and dated in brown chalk across lower centre of sheet: Gilbert Spencer 1945. Inscribed in black lead lower right: 63

Gilbert Spencer first exhibited at the Royal Academy in 1932. From this date until 1948 he was Professor of Painting at the Royal College of Art. In 1950 he was elected ARA, and in the same year was appointed Head of the Department of Painting and Drawing at the Camberwell School of Arts and Crafts. He was elected RA in 1959, resigned in 1969, and was re-elected in 1971. His autobiography was published in 1974, and his biography of his brother Stanley appeared in 1961. It is possible that this drawing represents the artist's wife, Ursula.

Provenance: see under No. 140

(RL 23057)

143 EDWARD LE BAS (1904–66)

Portrait of a girl
Black and white chalk on pink paper. 289 × 239 mm
Signed in black chalk, lower right: Edward Le Bas

Edward Le Bas was a portrait, landscape, genre and still-life painter. He was elected ARA in 1943 and RA in 1954.
Provenance: see under No. 140

(RL 23044)

144 ARNOLD MASON (1885–1963)

Miss Winifred Knights

Black lead and grey wash on buff paper. 304 × 221 mm
Signed in black lead, lower right: Arnold H. Mason 1917

The sitter of this portrait drawing was the landscape and decorative artist, Winifred ('Jane') Knights (1899–1947), who was at the time a student at the Slade School (where Mason also had trained). In 1919 she won the Slade Scholarship, and in 1920 the Scholarship in Decorative Painting offered by the British School at Rome. Four years later she married (in Rome) W.T. (later Sir Thomas) Monnington (1902–76), who had won the same prize in 1922. The young Mrs Monnington is the principal figure in her husband's *Allegory* of 1924–6, now in the Tate Gallery (*Drawings and Paintings by Sir Thomas Monnington*, exh. cat., Royal Academy, London, 1977, No. 12). One of Monnington's many studies of Jane, dated 1934, was also included in the posthumous exhibition of his work. The entry for that drawing in the exhibition catalogue includes a list of Jane's own works (*ibid.*, No. 29).

An oil portrait of the same sitter by Arnold Mason, dated 1919, is among the collection of items concerning Winifred Knights in the Department of Prints and Drawings at the British Museum.

Arnold Mason was active as a portrait and landscape painter, and exhibited at the Royal Academy from 1919. He was elected ARA in 1940 and RA in 1951.

Provenance: see under No. 140

(RL 23047)

145 NORMAN BLAMEY (born 1914)

Seated female figure study

Black lead with coloured washes. 397 × 285 mm

Signed and dated in black lead, lower right: Norman C. Blamey September 1976

This study of the artist's wife, made at their home in north London, was drawn specifically for the Royal Academy Jubilee gift to Her Majesty. Norman Blamey was elected ARA in 1970 and RA in 1975, and received the Wollaston award (for the most distinguished work in the RA Summer Exhibition) in 1984.

Provenance: see under No. 141

(RL 22852)

FELIKS TOPOLSKI, *The Coronation Panorama* (detail)

146 FELIKS TOPOLSKI (born 1907)

Coronation Procession, Lords, Heralds, Yeomen of the Guard

Pen and black ink. 349 × 449 mm

Signed with initials in black ink, lower right: F.T.

One of a very large number of drawings made at the time of Her Majesty's Coronation in 1953, for which Topolski was appointed one of the official artists. During the dress-rehearsal (at which time No. 146 must have been made) he had a seat inside Westminster Abbey. On the Coronation Day itself he was outside, to witness the great processions to and from the Abbey. He wrote of the occasion: 'this parade (bracketed by the populace) gathered round the pivot of English hierarchy the utmost of the period's harmonies and contradictions, established prides and aspirations, the West and the East, the Left and the Right, the Two – and the Third World, and sent it all in a moving frieze (personified and haute-coutured for their roles of the manifest masters and the masterful) to pass in selective metaphors in front of me (as if solely for my wish-fulfilment) – the grand curtain-taking by protagonists of the multi-spectacle I had to circle the globe to watch in sequences. A miraculous gratuity. And a well-selected seat, sketchbook/pencils/pens/one-eye fieldglass at the ready . . .' (*Topolski's Buckingham Palace Panoramas*, London, 1977, pp.31–2).
 Many of Topolski's sketches of the Coronation were published, with the artist's commentary, in the first issue of his *Chronicle* (1953). In 1959 Prince Philip commissioned the artist to paint a large-scale panorama of the Coronation, using these sketches, for a ground floor corridor in Buckingham Palace. Part would be hung on a continuous stretch of wall, and part in the bays between the windows on the opposite wall. The content of No. 146 occupies the first section of the Panorama, at the right-hand end of the window wall. The scale of the figures is adjusted in paint, so that the Yeoman of the Guard become massive end figures; the other poses and costumes are also somewhat changed in the painted version.

Provenance: presented by the artist to the Duke of Edinburgh

(PP 232)

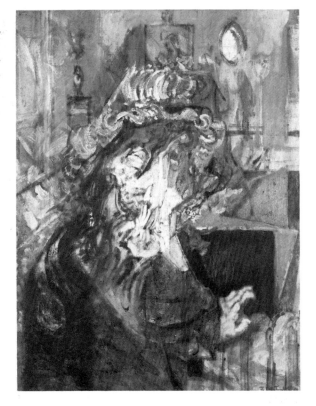

FELIKS TOPOLSKI, *Ivy Compton Burnett* (Austin, University of Texas, The Harry Ransom Humanities Research Center, Iconography Collection)

7 TOPOLSKI

Ivy Compton Burnett

Black chalk. 495 × 332 mm

Inscribed in black lead, lower right: Ivy Compton Burnett

Like Edith Sitwell (see No. 149), Ivy Compton Burnett (1884-1969; created DBE in 1967) was the subject of a broadcast interview with John Freeman on 'Face to Face' in 1959. Topolski was commissioned to make drawings of each of the subjects of these interviews to accompany the relevant programme. A preliminary visit to Topolski's London studio, when the sitter was accompanied by Charles Burkhart, has been described in some detail (C. Burkhart, *Herman and Nancy and Ivy*, London, 1977, pp. 97–8). The present portrait was evidently made in the drawing-room of Ivy Compton Burnett's flat in Braemar Mansions, which is clearly visible as the background to this drawing. This (and other studies made at the same time) was used as the basis for Topolski's portrait of the same sitter (dated 1962) in the series of twenty portraits of English writers commissioned by the University of Texas in 1961. No. 147 is reproduced in one of *Topolski's Chronicles* for 1962 (Nos. 22–24, 226–8, vol. X), with the artist's comment as follows: 'This issue is composed from a selection of drawings made while working on 20 paintings, containing 26 portraits of ENGLISH WRITERS, now in the possession of the University of Texas, U.S.A.' Topolski's

striking image of the seventy-five year old writer was recently described in the following terms: 'She emerges from the characteristic birds'-nest tangle of Feliks Topolski's drawing in the early 1960s [actually 1959] as a slightly hunched, pensive, sad but not at all stern and very old sibyl' (H. Spurling, *Secrets of a Woman's Heart: the Later Life of Ivy Compton Burnett 1920–60*, London, 1984, pp.264–5; reproduced p.254).

Topolski's first notable portrait drawings were of Bernard Shaw, and were made in the 1930s. Shaw described Topolski as 'an astonishing draughtsman . . . perhaps the greatest of all the impressionists in black and white' (*op. cit.* in No. 146, pp.15–16). Of his portrait sketches Topolski commented: 'I seldom draw a static scene; I draw badly when posed for – but, even when working on a sitter, I try to make it an encounter; and I have several "goes" circling round' (*ibid.*, p.28). The painted portait of Ivy Compton Burnett in Texas is considerably more abstracted than the drawing shown here.

Provenance: one of a set of thirty portrait drawings by Topolski purchased by Her Majesty in 1965.

(J149)

Feliks Topolski, *Herbert Read* (Austin, University of Texas, The Harry Ransom Humanities Research Center, Iconography Collection)

148 TOPOLSKI

Herbert Read

Black chalk with coloured washes. 436 × 297 mm

A portrait of Sir Herbert Read (1893–1968; knighted 1953), the writer on art, critic and poet, was also included in Topolski's series for the University of Texas in 1961. The artist made a number of drawings of each sitter before settling on the final position for the Texas painting. His drawings would sometimes also be used for other paintings, that were not sent to Texas. The portrait drawing of Sir Herbert Read reproduced in the 'English Writers for Texas' issue of *Topolski's Chronicle* (Nos. 22–24, 226–8, vol. X, 1962) employs a less striking frontal viewpoint. Another portrait, in chalk and wash, shows the same sitter in ¾-face (sold Sotheby, London, 7 Nov. 1973, Lot. 154, and *ibid.*, 1 February 1978, Lot. 231), that is roughly the same pose as that adopted for the Texas painting. Several other drawings of Read are still in the artist's possession.

Provenance: see under No. 147

(J 140)

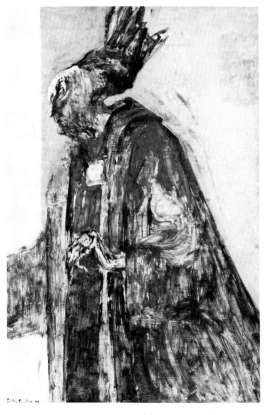

49 TOPOLSKI

Edith Sitwell

Black chalk. 494 × 332 mm

Signed in black chalk, lower right: Feliks Topolski. Inscribed in black chalk, lower left: Dame Edith Sitwell

The poet and critic Edith Sitwell (1887–1964, created DBE in 1954) was portrayed by Topolski on a number of occasions. One series of studies was executed, in Topolski's London studio, for her 'Face to Face' broadcast interview with John Freeman in 1959. 'Edith wore for this gentle ordeal a headgear she called her "bird-king's hat", and the Solongoi ermine jacket that she had recently bought from a Regent Street furrier for 271 guineas . . . All the *Face to Face* interviewees were the subjects of portraits by Feliks Topolski, which were used to introduce and close the programmes. He was the last of the many artists for whom Edith sat . . . It is a formidable picture: Topolski painted her in a crown, with hunched shoulders, so that she looks like an ancient crested bird of some exotic species' (V. Glendinning, *Edith Sitwell*, London, 1981, pp. 338–9). No. 149 was one of the studies made at this time. It was reproduced, greatly enlarged, in *Topolski's Chronicle* in 1960 (Nos. 21–24, 177–80, vol. VIII). With a much smaller portrait of

Christopher Logue it was presented, for an ironic contrast, under the heading 'English Poetry'.

Topolski's painted portrait of Edith Sitwell, dated 1959, is based on the 'Face to Face' studies (see *Faces of Authorship*, exh. cat., Humanities Research Center, Austin, Texas, 1968–9, No. 96). It belongs to the series of twenty painted portraits of English writers that Topolski was commissioned to paint for the University of Texas. The sitter did not see this painting before it was sent to America, but later received a small black and white photograph of it from the University of Texas. Although she did not inform Topolski of the fact directly, her friends understood that she was very unhappy with the result, which she interpreted as an 'unspeakable caricature'. The artist wrote explaining that he intended no caricature, but that in his portraits he sought to probe at the true character of the sitter. Edith Sitwell's reply, dated 7 September 1963, and written from her home in Hampstead, is quoted with the artist's permission:

Dear Mr. Topolski,

I was much moved by your very generous letter.

I should have answered it immediately I received it, but only the day before, I emerged from hospital after a very serious attack of pneumonia.

It is quite untrue that I do not admire and sympathise with your work (I had seen a great deal of this long before I came to your studio.) I sympathise with it, and I understand, I think I may say, the ethics of it.

The *one* exception (and that is neither your fault nor mine) was your portrait of me – and that was for *personal* reasons.

When I was nine years old, my extremly [sic] trying parents got it into their noddles that I am deformed (I have a slight curvature of the spine, which makes me stoop, and have extremely delicate bones.) They incarcerated me, therefore, in a sort of Bastille of iron, from my shoulders to the soles of my feet. Even my nose did not escape their attentions. Only my hands *did*, for some unexplainable reason.

One never recovers from the experiences of such a childhood, (lasting from nine to seventeen years old) therefore I am super-sensitive in some matters.

It would be a very great pleasure to me to see you again, if you can stand seeing a crippled old lady. (Owing to my Bastille-experiences, I cannot, at this time, move without being lifted.)

You must, please, forgive me. I now realise exactly what you were doing. I know how busy you must be. But it could be such a great pleasure to me if you could find time to ring up and suggest an evening (5.30-ish) to come and have a glass of sherry with me.

I shall hope very much to see you. . . .
Thank you again for your generous letter.
With my best wishes,
 Yours sincerely
 Edith Sitwell

In his reply (dated 14 September) to this letter, Topolski further explained his vision of the sitter: 'To me you have the rarest PRESENCE . . . This aura of yours (I see now in retrospect) must have been what led me to my painting: fragility, therefore style, therefore true authority' (quoted in Glendinning, *loc cit*.). Another portrait (in oil and acrylic) of Edith Sitwell, dated 1962, was lent by the artist to the *Images of Edith* exhibition (Sheffield, 1977, No. 25) and is now in the collection of the Polish National Museum, Warsaw.

Provenance: see under No. 147

(J 130)

An Appendix concerning Watermarks

13 LEONARDO

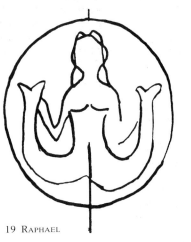

19 RAPHAEL

5 SIGNORELLI

16 LEONARDO

21 RAPHAEL

18 RAPHAEL

58 STRADANUS

20 RAPHAEL

22 MICHELANGELO

48 Holbein

49 Holbein

51 Holbein

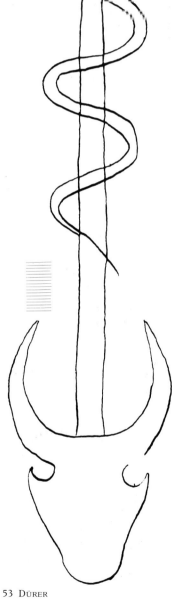

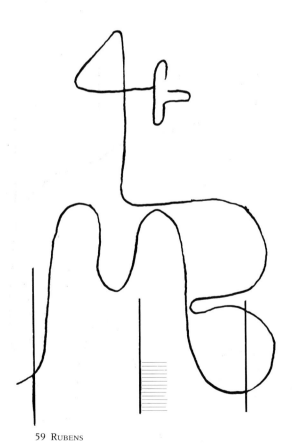

59 Rubens

53 Dürer

52 Anon. Fifteenth century
Flemish

72 Poussin

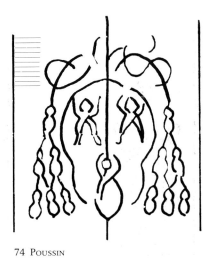

74 Poussin

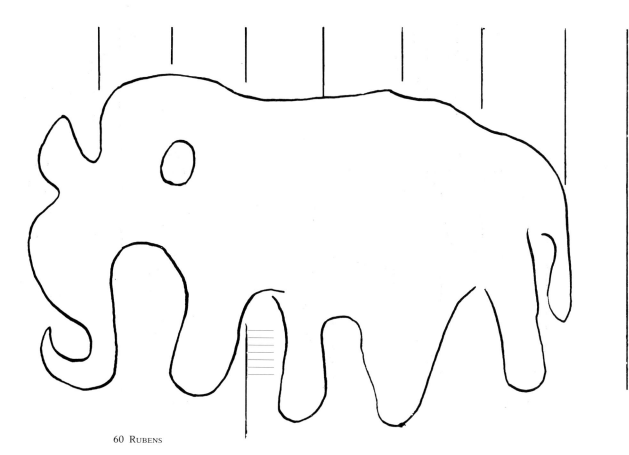

60 Rubens

118 Manocchi

117 Manocchi

118 Manocchi (countermark)

79 Claude

123 Hogarth

102 Pannini

119 Rigaud

120 Thomas Sandby

88 Domenichino

75 Quesnel

85 Bernini

101 Picart

63 Asselyn

Notes on the Watermarks

5. SIGNORELLI
Crossed keys in a circle
Related to Briquet 3862 (Catania, 1496)

This watermark has been much damaged and the distinguishing key features have been broken off. It is difficult to relate conclusively to any one mark in Briquet. The example quoted (Briquet 3862) does not appear in a framing circle.

13. LEONARDO
Fragment of a flower with seven petals
Briquet 6560 (Vercelli, 1473)

This watermark appears on a number of other Leonardo drawings in the Collection (see C&P, I, p.lxii).

16. LEONARDO
Ladder
Close to Briquet 5910 (Florence, 1473–4)

Two rungs on the ladder have broken off. This is an exclusively Italian watermark.

18. RAPHAEL
Anchor in circle surmounted by star
Similar to Briquet 481 (Arnoldstein, 1510–14)

This is another Italian watermark. An identical example is found on a Michelangelo drawing for the Sistine Ceiling (c.1511) in the British Museum (*BM Michelangelo*, No. 23).

19. RAPHAEL
Twin-tailed mermaid in a circle
Close to Briquet 13884 (Rome, 1501)

Our example is fractionally larger than Briquet's. Although a mermaid watermark was also used in France, the mermaid with a twin tail is peculiar to Italian paper and was commonly used within a framing circle well into the seventeenth century. This watermark appears on another Raphael drawing in this catalogue (No. 21), and also on a Michelangelo drawing of classical architecture (c.1515–18) in the British Museum (*BM Michelangelo*, No. 68/69).

20. RAPHAEL
Crossbow in a circle
Close to Briquet 746 (Lucca, 1469–73)

This watermark is much damaged, and the chain and laid lines are indecipherable. A Michelangelo drawing in the British Museum of c.1524–30 has a watermark of similar design, but larger format (*BM Michelangelo*, No. 100).

21. RAPHAEL
Mermaid in a circle
Close to Briquet 13884 (Rome, 1501)

Identical to No. 19 above, to which see note.

22. MICHELANGELO
Crossbow in a circle
Close to Briquet 748 (Rome, 1505)

This mark is badly damaged and is 4 mm smaller overall than Briquet's example.

48. HOLBEIN
Two-handled vase with flower
Briquet 12863/4 (The Hague/Utrecht, 1524/5)

This watermark appears on several other Holbein drawings some of which date from his first residence in England, and some from his second. In this instance the watermark may not be taken as conclusive evidence for dating Holbein's work to the earlier or later periods in England. We may only conclude that the paper Holbein used was to be found in England during the 1520s and 1530s, having been imported from France.

49. HOLBEIN
Two-handled vase
Variant of Briquet 12863 (The Hague, 1524)

The flower which should surmount this watermark seems to have been broken, otherwise it is very close to that in No. 48 above, to which see note.

51. HOLBEIN
Hand with flower
Close to Briquet 11341 (Lisieux, 1526)

There are no Holbein drawings bearing this watermark which have been surely dated to the artist's first residence in England.

52. ANON. FIFTEENTH-CENTURY FLEMISH
Gothic initial P
Close to Briquet 8531 (Cologne, 1481)

Differing slightly from the above in size. This watermark was commonly used in the Rhine area, as far south as Berne.

53. DÜRER
Ox's head with twisting snake
Briquet 15375 (Vicenza, 1492)

The chain and laid lines are indecipherable, and the sheet edge cuts the top of the watermark so that the existence of a cross is open to conjecture. See also catalogue entry.

58. STRADANUS
Small anchor in a circle
Unrecorded

59. RUBENS
Initials MB with the figure 4 (reversed) above
Unrecorded

60. RUBENS
Large elephant
Unrecorded

63. ASSELYN
Paschal lamb in coat of arms
Similar to Heawood 2843 (Holland/Schieland, 1648)

The watermark is much damaged.

72. POUSSIN
Haloed kneeling saint holding a crucifix, within a framing shield
Close to Briquet 7628 (Fabriano, 1602)

This watermark is 4 mm larger than Briquet's example, with only half as many laid lines to the inch. Another example of this watermark appears on an Italian late seventeenth-century drawing in the Lugt Collection (J. Byam Shaw, *The Italian Drawings of the Frits Lugt Collection*, Paris, 1983, No. 443). Heawood cites a similar watermark as his No. 1346 (Rome, 1570).

74. POUSSIN
Coat of arms
Similar to Heawood 796 (Rome, 1646)

75. QUESNEL
Bunch of grapes
Similar to Heawood 2088 (1572)

79. CLAUDE
Hills in a circle (fragmentary)
Similar to Heawood 921 (Rome, 1646)

85. BERNINI
Anchor in a circle with the initials L and M surmounted by a star
Close to Heawood 5 (Rome, seventeenth century)

This watermark appears on a drawing by Maratta in the Lugt Collection (*op.cit.* under note to No. 72 above, No. 169).

88. DOMENICHINO
Fleur de lys in a circle surmounted by a crown
Similar to Heawood 1629 (Rome, 1602).

101. PICART
Coat of arms with serpent and pendant star
Similar to Heawood 690 (Paris, 1689).

102. PANNINI
Fleur de lys in a circle surmounted by the initial A
Unrecorded, but similar in character to Heawood 1569 (Rome, 1705).

The fleur de lys is one of the oldest watermark designs and has continued to be in use for the longest time. It was used in Italy, France and Germany, but the fleur de lys within a circle is almost certainly an exclusively Italian watermark. The initial may refer to a particular district, or to a particular paper-maker.

117. MANOCCHI
Fleur de lys in a coat of arms
Similar to Heawood 1838 (Amsterdam, 1769)

118. MANOCCHI
Fleur de lys in a coat of arms, the initials G R beneath, and a counter-mark WHATMAN (partially visible)
Close to Heawood 1849 (no date), but differing in the omission of '& Co'.

During the seventeenth and eighteenth centuries paper-making ceased to be such a localised industry, and paper was imported and exported freely throughout Europe. Amsterdam started exporting to England at the beginning of the seventeenth century and many of the watermarks appearing on the papers from eminent Dutch paper mills were specifically designed for the British market (e.g. Britannia watermarks, and English coats of arms coupled with the countermarks of a Dutch mill). Little quality paper was made in England before the eighteenth century, when James Whatman opened a mill at Maidstone in Kent. Half the Whatman paper was made at the Kent mill and the other half at a mill in Holland. The watermarks varied accordingly: 'J. WHATMAN, Turkey Mill', and 'J. WHATMAN, LVG' (Lucas van Gerrevinck of Egmond a/d Hoef). With the onset of paper-making as a major industry, watermarks became more standardised, the same mark being used by many mills with only the countermark varying between the different mills. The fleur de lys in a coat of arms was particularly common on English papers in the eighteenth century, where it became known as the Strasbourg Lily.

119. RIGAUD
Coat of arms with fleur de lys and initials LVG below
Similar to Heawood 1809 (Holland, early eighteenth century)

The Strasbourg Lily watermark became very common in the eighteenth century. The symbols below the shield might take other forms or equally might be omitted. LVG (standing originally for Lucas van Gerrevinck) was also in common use as a countermark. See note to No. 118 above.

120. THOMAS SANDBY
Fleur de lys in a coat of arms with the initials LVG below
Close to Heawood 1829 (Holland, 1743)

123. HOGARTH
Initials P L
Similar to Heawood 3020 (Amsterdam, 1702)

The initials P L often appear to the sides of Propatria watermarks which emanated from Holland specifically for the British market (e.g. Heawood 353; London, 1699). Churchill cites this as the watermark of Pieter van der Ley, who started the first major paper mill in Holland at Zaandyk in 1665 (W. A. Churchill, *Watermarks in paper in Holland, England, France, etc. in the XVII and XVIII Centuries and their interconnection*, Amsterdam, 1935, No. 135). His watermarks occur frequently on the paper of seventeenth-century engravings and manuscripts in both England and Holland.

Index of Artists